Praise for *Integrated Dog Training*

"Michael Wombacher has a lovely attitude toward life and the joy that canine companionship can bring to it. Over the past twenty-five years, he has trained four of our poodles. They've all been happy and confident, beautifully behaved, and easy with family and friends. They've all learned fun tricks, but it's the affectionate steadiness he has instilled in them for which we are most grateful."

— Michael Tilson Thomas, artistic director of the New World Symphony, music director laureate of the San Francisco Symphony, and conductor laureate of the London Symphony Orchestra

"With decades of hands-on experience, Mike Wombacher is extremely talented. In this book, he brings this talent to bear on simplifying an often-confusing process. His methods and tools are broken down into bite-size lessons, and the included training plan makes them easy to digest. Mike understands that neither every dog nor every owner learns the same way. That's why he has provided multiple approaches to dealing with various training issues. This makes *Integrated Dog Training* both an essential guide for new dog owners and a must-have reference for professional trainers. Using these methods, anyone can learn to teach their dog impulse control and to look to them for guidance and authority. No other book out there more thoroughly captures the essence of communicating with your dog while training her to be a lifelong companion."

— Lauren Goldboss, founder and president of Who Let the Dogs Out, San Francisco

"Michael Wombacher has successfully trained many of my clients' dogs with a variety of behavioral problems, applying his well-rounded knowledge of what works and what doesn't. I have referred many clients to him over the years, and it has been a joy to hear about how much their dogs changed after a few training sessions. I have always admired him for his constant exploration of canine behavior and for integrating new techniques for evidence-based canine behavior modification. I loved reading through *Integrated Dog Training* and feel that every dog owner who wants a well-trained dog should read this book."

— Shruti Vaikhary, DVM, Camino Alto Veterinary Hospital, Mill Valley, CA

"I have known Michael Wombacher professionally for over two decades, going back to my days as a trainer and colleague of his in the San Francisco Bay Area. Mike always enjoyed a great reputation, and I would often seek his feedback on cases or the industry in general. I have never hesitated in referring clients to him, as I always had the utmost confidence that they would be learning from one of the best in the business. Mike's newest effort, *Integrated Dog Training*, is a great visual guide to training your dog, with easy-to-follow photo examples. I am looking forward to having our trainers recommend it as a supplement to our training program to our over 1,500 private training clients each year."

— John Van Olden, dog trainer and founder and president of Canine Trade Group

"Mike Wombacher's latest work offers the reader so much more than the typical 'how to teach your dog to sit, stay, and come' training book we usually expect. In this text, Mike offers us not only a cultural explanation of how we arrived at the current popular style of dog training but also a strong argument as to why this approach might be entirely wrong. He also outlines the social structure of the canine world and how recognizing the rules of this system allows dog owners to more effectively communicate and interact with their pets. Don't make the mistake of thinking that this book is all theory. It is filled with clear

directions and photographs to help both the first-time pet owner and the seasoned veteran to get their dog trained quickly and thoughtfully. As a business owner in the pet industry, I found Mike's approach of explaining not only the 'how' but also the 'why' especially helpful. This book will be required reading for all our employees and recommended to all our clients."

— Julien Pearl, founder and owner of AlphaDog Lodging in Mill Valley, CA

"Mike Wombacher's *Integrated Dog Training* is a sourcebook for people who love and respect their dog's essential nature and want tools beyond the dogmatic ideologies that are currently so pervasive. It offers a well-thought-out, easy-to-understand method for helping your dog live its best life."

— Sanford Johnson, founder and host of the *Talking the Dog* podcast

INTEGRATED DOG TRAINING

Also by Michael Wombacher

Good Dog, Happy Baby: Preparing Your Dog for the Arrival of Your Child

There's a Puppy in the House: Surviving the First Five Months

INTEGRATED DOG TRAINING

The Commonsense Visual Guide to Training *Any* Dog

MICHAEL WOMBACHER

New World Library
Novato, California

New World Library
14 Pamaron Way
Novato, California 94949

Photographs by Britta Stratton
Text design by Tracy Cunningham and Tona Pearce Myers

Library of Congress Cataloging-in-Publication Data

Names: Wombacher, Michael, date, author.
Title: Integrated dog training : the commonsense visual guide to training any dog / Michael Wombacher.
Description: Novato, California : New World Library, [2021] | Includes index. | Summary: "Drawing on two decades of professional experience, a popular dog trainer presents an array of field-tested techniques for training dogs of all breeds, ages, and personality types. The methods described emphasize positive reinforcement while still allowing for humane corrective tactics when needed. Contains photos and supporting text"-- Provided by publisher.
Identifiers: LCCN 2021014193 (print) | LCCN 2021014194 (ebook) | ISBN 9781608686520 (trade paperback) | ISBN 9781608686537 (epub)
Subjects: LCSH: Dogs--Training.
Classification: LCC SF431 .W6765 2021 (print) | LCC SF431 (ebook) | DDC 636.7/0835--dc23
LC record available at https://lccn.loc.gov/2021014193
LC ebook record available at https://lccn.loc.gov/2021014194

First printing, August 2021
ISBN 978-1-60868-652-0
Ebook ISBN 978-1-60868-653-7
Printed in the United States

New World Library is proud to be a Gold Certified Environmentally Responsible Publisher. Publisher certification awarded by Green Press Initiative.

10 9 8 7 6 5 4 3 2 1

My first foray into dog training came four decades ago. I adopted a demure German shepherd puppy named Smokey from a Miami rescue group when she was just over three months old. I was then in the thick of graduate school at Florida State University, working on a degree in international relations and economics. With a new semester fast approaching, we made off for Tallahassee, and I embarked on the first dog training adventure of my life.

Today, at sixty-one, I can look back to that initial encounter and trace an unexpected and profoundly rich life deep in the trenches with man's best friend.

Yet none of this loomed large in my career plans at the time. When Smokey and I first headed back to Tallahassee, I had big plans for the future. But life is full of surprises.

One arrived on the wings of transcendence on a lazy afternoon while hanging out with Smokey in my front yard. As we sat there just *being* together, we lazily caught each other's eyes. That's when, for some reason, the familiar boundaries of my mind were swept aside by an exhilarating expansion. I was overwhelmed as a profound awareness of the unity of all things welled from within. In the ecstasy of that realization I understood, in a way impossible to fully convey, that though Smokey clearly lacked my cognitive powers, we nonetheless shared a deeper *beingness* that closed any gap between us. What continued to reveal itself as our relationship evolved was that the connection we developed through working together allowed us to make this implicit insight increasingly explicit. That was the source of our bond. And it slowly propelled my life in a new direction.

Yet as our life together continued, I was soon faced with a truth difficult to square with the grandeur of that realization. Dog training at the time was a decidedly unpleasant affair. My first clue came when I called around to local training clubs and was informed that I couldn't begin training Smokey until she was at least six months old. Prior to that, I was assured, training a dog was impossible. Of course, today I know this to be an utter falsehood. I also understand the reason I received such deeply flawed advice, which had nothing to do with Smokey's ability to learn and everything to do with the harsh training methods then in vogue.

Given the level of punishment dished out in the name of training, dogs younger than six months simply weren't physically tough enough and sufficiently emotionally developed to handle it. All I knew then, however, was that I had to wait till Smokey was old enough, and then I enrolled her in what today would simply be called a "yank-and-jerk" training program.

Here's an example of how much fun this was. To teach Smokey her first command — sit — I slipped a choke chain around her neck and pulled straight up on her leash in order to, well, choke her. At the same time, I pushed her rear end to the ground. Once it was solidly planted, I simultaneously released the pressure on the choke chain and said the command "sit." The idea was that Smokey would come to understand that she could make the pain and discomfort of choking go away by sitting. Such "pain avoidance" was the central tenet of nearly all obedience training. And guess what. It worked and it worked well. But it was no fun for either of us. And it wasn't necessary.

In those days, the primary tools in the trainer's toolbox were a choke chain and a harsh, "show 'em who's boss" attitude. This had to do with a number of factors. First, this reflected humanity's long-standing view of animals as insensate brutes to be used for human ends with little moral concern for their well-being. This "livestock" attitude included dogs, even though it coexisted with sentimental portrayals and attitudes, which were embodied by fictional dogs like Rin Tin Tin and Lassie.

Second, formal dog training traced its roots to the training of military dogs, which are tough as nails and made to work in extremely high-stakes, life-and-death situations. In the military, circumstances require hard dogs that can withstand often severe training practices as well as trainers who are as unyielding with their dogs as drill sergeants with new recruits. However, after World War II, many military dog trainers returned to civilian life and took up careers as pet dog trainers, and they imported their war-hardened tactics, even though household pets don't need battlefield training.

Finally, around this time, some studies of the social interactions of captive wolves gave rise to the notion of the male "alpha dog" that lorded over his pack through brute displays of forceful dominance. Hence, most training programs told owners they had to dominate their dogs and "show 'em who's boss." This notion remains deeply embedded in popular culture. Even today, clients with unruly dogs often sheepishly confess, "I know, I've got to show him who's boss, but I just can't do it." People feel guilty that they don't have the stomach to "yank and jerk" their dog into submission for failing to comply with simple requests.

Thankfully, much has changed since then. In the last two and a half decades, a rash of new approaches to both training and behavior modification have emerged that emphasize "positive reinforcement." Simultaneously, the cavalier use of punitive training methods has increasingly come into question, on both moral and behavioral grounds, along with the appropriateness of the "dominance model" of dog training, in which the only "positive reinforcement" is freedom from pain. On the whole, this has been an important and positive move.

However, this shift has created its own discord and division due to an equally extreme swing in the opposite direction: Many today now feel that even the slightest use of "compulsion" or "aversives" is wrong and that dominance plays no role whatsoever in the social lives of dogs. With almost religious fervor, some take an all-or-nothing stance, dividing trainers and training approaches into either "punishment-based" or "reward-based,"

then demonizing the former while sanctifying the latter.

This book isn't the place to explore this in detail, but in my experience, life and dog training are rarely that simple. There are times when compulsion and aversive control, *thoughtfully applied*, can make all the difference in the success or failure of a training program. And the concept of dominance, reviled as it is in some corners, is alive and well, both as a social structure among dogs and between dogs and their humans.

But both concepts need a fresh interpretation if they're to be of any use in humanely training our dogs. With respect to the notion of dominance, an avalanche of well-established research across many species, including wolves and dogs, affirms that dominance is a critical social structure without which complex social organization would be impossible. The real question in the context of dog training is what we mean by the word *dominance*. What it explicitly does *not* mean is "dominating" a dog through routine displays of physical aggression or threats thereof. True dominance in a dog/human context generally involves the control and strategic doling out of high-value resources, which is an important insight in the context of dog training.

This insight has overwhelming support from academic research. I once asked Dr. Robert Sapolsky, one of the world's leading ethologists and neurobiologists — for whom I've had the privilege of training three dogs — whether he agrees that all social mammals are acutely aware of social status at all times. "Oh, without a doubt," he responded, not missing a breath. I received much the same response from ethologist Dr. Marc Bekoff in a series of email exchanges. Dr. Bekoff has a lot to say about the subject, both in his *Psychology Today* blog as well as in his recent books.

People who claim that dominance plays no role in the lives of wolves and dogs often point to studies by the world-renowned wolf researcher L. David Mech. However, Mech himself bemoans that his research has been grossly misrepresented by dominance deniers for decades. In one of Dr. Bekoff's blog posts, he recounts a conversation

with Mech in which Mech states plainly, "I do not in any way reject the notion of dominance."

To drive his point home, Mech began a 2010 study with the opening line: "Dominance is one of the most pervasive and important behaviors among wolves in a pack."[1] He then described a wolf who physically dominated a subordinate by pinning him to the ground for fully six minutes, and who then repeated the same behavior with several other pack members multiple times *in a single day.*

In support of Mech's conclusion, Dr. Bekoff added that dominance denials are "thoroughly inconsistent with available comparative data and well-accepted evolutionary theory....[Countless studies] make it abundantly clear that denying the existence of dominance can be taken to constitute pseudoscience."[2]

However, just because dominance is part of the social organization of canines doesn't mean we should use physical domination in dog training. Among dogs and wolves, while dominance sometimes involves physical displays, most often it doesn't, and it is not associated with aggression nor with causing physical harm. Don't get me wrong: I think it is a wonderful thing that over the last three decades dog training has mostly abandoned physical dominance as a central strategy. But life is complicated, and so we need to be thoughtful and methodical when considering the most effective and humane ways to foster a healthy, successful relationship between a human and a dog.

The Development of Integrated Dog Training

This brings me back to my story. In 1994, by an unexpected stroke of circumstance, after nearly a decade in corporate servitude, I entered the world of professional dog training. This was at the crux of the transition from the old-style "yank-and-jerk" methodologies to the much kinder approach that's emerged since then. As a result, poised at the nexus of intersecting forces, I had the good fortune of being tutored by a broad spectrum of mentors, each with decades of experience running the gamut

from traditional to modern. I spent nearly a year apprenticing with one trainer before finally having the nerve to test my newfound knowledge against reality.

That reality — people with time and financial constraints paying me for timely, effective help with their dogs — made me instantly grateful for the eclectic education I'd received and the well-stocked toolbox to which I had access. As the years rolled on, that eclecticism was continually buttressed by my relentless study of new approaches, my continuing mentorship with more experienced trainers, and most importantly, my own growing body of experience, which grew at a rate I never anticipated. This process of accumulating knowledge, constantly adjusting my training style, and experimenting with novel approaches still continues to this day.

Today, I call my approach Integrated Dog Training. By giving it a name, I'm not trying to brand "my system" and claim some sort of exclusive authorship. Rather, this method reflects what has emerged for me organically out of my deep care for dogs, lots of hands-on training, and the critical knowledge I've gained from various fields, including ethology, psychology, canine cognition, and so on. Integrated Dog Training recognizes that dogs, like humans, are complex, multidimensional creatures whose behaviors must be addressed with a complex, multidimensional training program equal to the challenge. It takes into account the many factors influencing any training situation and builds integrated programs that intelligently address them. These include managing a dog's social status and considering her disposition, temperament, and general abilities; the urgency of the training situation; the temperament of the owner and their physical abilities and aptitude for training; and the availability of time and money or anything else that impacts a situation.

Ultimately, my goal is to train dogs in a way that both respects the transcendent revelation of existential unity I experienced with Smokey four decades ago while effectively communicating critical concepts to a dog whose quality of life depends on understanding them. This can create a tension

during training, and indeed during any human-dog relationship. The tension arises from the fact that such communication sometimes requires some form of imposition on the dog by the human. Most of the time, dogs can be taught what to do, and to do it enthusiastically, through "positive" enticements, like food rewards and praise, but occasionally training involves some form of compulsion (physically demanding a behavior) or aversion (using something unpleasant to discourage a behavior). What's best and most effective is a moment-to-moment balancing act that depends on the dog, the situation, and the people involved.

In fact, in some ways, Integrated Dog Training has already been systematized and formalized in a set of protocols commonly known as the LIMA principles. LIMA stands for "least intrusive, minimally aversive." But even these protocols, well-intentioned as they are, have been rightly criticized as being overly uniform and simplistic because they don't consider the training context prior to the imposition of a very linear set of principles.

To address this, Pet Partners, one of the world's largest organizations training service dogs, has collaborated with some of the industry's most experienced trainers as well as animal behavior and welfare experts to develop guidelines for the application of LIMA principles when confronting real-life training challenges. They did this because many service dog organizations had attempted to remove all compulsion and aversive control from their training programs, *but they consistently failed to produce the kind of reliability that was critical if their dogs were to bear responsibility for human welfare.*

After much deliberation, they produced a document that outlines humane standards for the dog training profession.[3] This not only provides a detailed series of guidelines concerning the appropriate use of aversives and how best to discuss them with clients, but it also provides a flexible flow chart that takes into consideration a variety of criteria when deciding if and how best to include aversives in a training program. Of course, the only trainers actually possessing the competence to appropriately apply the LIMA principles are integrated dog trainers who have learned how to use

aversives both sparsely and skillfully in a reward-based training program.

Steven Lindsay, perhaps the world's leading authority on all things to do with dog behavior, training, and neurobiology, has also chimed in.[4] His implementation guidelines, should a training situation call for compulsion or aversive control, are grounded in an insight that has massive support from data accumulated over decades: Once a dog understands the consequences of her actions and is able to control the outcome based on her own informed choice, levels of stress related to the possibility of either compulsion or aversive control dissipate to insignificant levels.

Better yet, new, desirable behaviors are quickly learned and positively reinforced. According to Lindsay, when understood in this way, *neither rewards nor aversives are seen as descriptions of something we do to our dogs but more as outcomes the dog herself controls.*

Both Pet Partners' and Lindsay's insights illustrate just how far the conversation around dog training has come since the days when I trained Smokey under the stern gaze of a "yank-and-jerk" trainer forty years ago. Back then, most training programs were composed of 90 percent compulsion and pain avoidance, most of which was unapologetically harsh. Today, the average ratio of positive reinforcement to either compulsion or aversive control in an Integrated Dog Training program is approximately 97 percent to 3 percent — an almost perfect inversion. In many cases, aversion and compulsion aren't needed at all, and when used, both are relatively benign, especially when measured against old-school standards. The goal is never to be physically painful, just sufficiently annoying so that a dog seeks to avoid that consequence. That's a world of difference!

In other words, today, a culture-wide concern over animal welfare has raised important questions about how to best relate to dogs and offered new insights and methodologies about how to best train them. Integrated Dog Training reflects that world and so does this book.

For instance, the most aversive techniques in this book are so-called body blocks — in which the

trainer interrupts a dog's behavior by stepping in front of her to block the dog's progress or impulse — and mild to moderate snaps on a leash, which are designed to interrupt behaviors and shift attention, *not to hurt or punish*. Further, both of these are only suggested in certain situations and only when other approaches have already been tried and found wanting. As you'll see, even when these strategies are used, they exist within a larger context of abundant positive reinforcement, which forms the core of any Integrated Dog Training program.

The goal of this program is to provide efficient training results using methods that are kind and fun while maintaining structure, guidance, and authority. In my experience, this approach leads to an ever-deepening and lifelong friendship, which is what I've been interested in since day one.

That said, I want to be clear that this book does not advocate a "one true way" training approach. Integrated Dog Training recognizes that different dog/owner combinations require different training approaches. No single approach will always be best in every situation, so what people need most of all are options. That's what I want to provide, so that you can decide for yourself what is best in your situation and for your dog. Trust in your own intelligence and compassion to make appropriate choices about what to pull from this toolbox to meet your needs.

This dog training approach is certainly not the only one available. But it has worked well for me and thousands of clients, in part because it continues to evolve. For now, this is the best of what I've learned in the forty years since Smokey and I sat together in Tallahassee and enjoyed *being* in each other's company. And it will hopefully help you get excellent control over your dog while forging a deep bond that will last a lifetime. I look forward to sharing it with you.

A Few First Principles

Before diving into the actual training, there are a handful of key principles worth exploring. They form the foundation not only of a solid training program but of a rich, mutually rewarding relationship between you and your dog.

The first is so central that I usually introduce it during the first session. "If you had to net dog training out to a single core principle," I'll often say to the dozen or so new puppy owners eagerly circled around me on the floor trying to manage squirming puppies, "it would be teaching your pups to exercise impulse control and check in with you in relation to things that matter. Everything else flows from that."

Then, once your dog understands the consequences of her actions and is able to control the outcome based on her own informed choices, levels of stress related to the possibility of aversive control quickly diminish to insignificant levels. *Simultaneously, new, desirable behaviors are quickly reinforced and learned.* In this context of copious positive reinforcement, aversive control, *should it be necessary*, becomes rapidly *self-extinguishing*. The pup's confidence in her ability to control her life by avoiding undesirable outcomes while generating desirable ones is consistently developed. This process, in turn, steadily deepens the dog's connection with her owner, who is, after all, the gateway to such learning.

Of course, this process takes time. A young puppy's ability to exercise impulse control is as limited as her understanding of why she should do this in the first place. To a puppy, life is composed primarily of the interplay between a series of sensory impressions and hardwired, knee-jerk responses called "fixed action patterns." Equipped with this sensory/cognitive toolbox, puppies set out to explore the world. They see a four-hundred-dollar pair of Italian shoes, and every impulse in them screams: "Get it, shred it!" And so they do.

That's why, after introducing this concept, I always begin my basic puppy course teaching the off command (using exercise 50, "Introducing Off"). The off command means "leave that alone — now!" The beginning off exercises introduce impulse control in a very limited context and are enormously useful in managing a pup that's constantly into everything. I often joke that some pups probably spend the first few weeks of their lives thinking that "off" is actually their name.

But pups learn that, when they hear "off," they have a choice. They can continue as intended or retreat from the temptation — there is a fork in the road with wildly divergent consequences. In this way, they learn to have more control over their own experience. This makes their life increasingly intelligible, and they learn that attention to the owner increases that intelligibility. That's a big deal!

And it leads to the next set of core concepts — the relationship between "transactional" and "relational" training and the connection between them. A great deal of training, especially at the early stages, is strictly transactional. Show the dog a treat, and when the dog performs a desired exercise, deliver the treat. That's a transaction. Transactional training, at least in an Integrated Dog Training program, is how just about everything is introduced, reinforced, and learned.

Relational training is more subtle. It involves the kind of relationship that you develop with your dog, and it comes into play as you need to strengthen the dog's behaviors in order to produce reliability in increasingly challenging situations. The most effective way to begin to develop the relational dimension of dog training is through the strategic control of high-value resources — precisely the same arrangement that's found in displays of "formal dominance" and "formal submission" that regulate social hierarchies in all sorts of animals, including wolves and dogs.

The interplay between transactional and relational training is subtle and deeply interwoven. Take the off command. There are many ways to introduce this, most of which, at the beginning, are transactional. But the deeper impression left in the dog — that attention to the owner helps increase the intelligibility of the world — is relational. In this case, both happen simultaneously.

In other cases, the difference between transactional and relational is less subtle. The question is, especially if you don't have a treat, will your dog perform an exercise when there's something else she would rather do? This is a critical juncture in training and the place where most owners experience the greatest frustration. At this point your dog must learn to perform even in the absence of key motivators. Will she? The answer comes down to relational training, which is built upon ample transactional training.

As with the use of aversion in training, there is disagreement among today's trainers about this. Some claim that a dog's willingness to perform obedience commands — or not — is *never* a statement on the relationship with the person. If a dog is not performing, they argue, that's simply because she needs more reinforcement, that is, transactional training. All training, they argue, is strictly transactional.

Moreover, the notion of other social factors playing a role in learning is routinely derided. Two notions targeted for special scorn are that of dominance and the idea that a dog could "respect" her owner. According to such trainers, there are no stubborn dogs, simply dogs that haven't been sufficiently reinforced. Training, they argue, is only a transaction, never a statement on the dog/human relationship.

From the perspective of Integrated Dog Training, this is simply not true. Basically, the transactional stage is the beginning stage. I tell my puppy students that nothing their dogs are learning at this stage rises to the level of commands. These are training *exercises.* Commands come later and introduce the concept "you must." That's a whole other level of understanding for the dog. On top of understanding what's being asked, they must learn the additional concept "you have to." That's the crux of the transition between transactional and relational. That transition is forged from numerous elements.

The first is impulse control. Another involves taking exercises learned transactionally — such as to sit for a treat, along with down, stay, and so on — and using them in what's often called a "learn-to-earn" program. For instance, once dogs learn sit, I instruct owners to ask them to sit in exchange for anything of value to the dog, such as a toy, game, treat, walk, or even a simple pat on

the head. Right from the very beginning, I want to imprint upon the dog that "you do for me before I do for you." Such ritualized behaviors cement social structure by routinely acknowledging and reinforcing appropriate flows of authority.

Integrated dog trainers understand this and look to apply these principles across all aspects of their relationship with their dogs. They're also constantly working with the dog to find out what most motivates her, to use that motivation to develop the dog's "drive," and then to engage in an ongoing process of managing distraction levels, the flow of rewards appropriate to each level, as well as their physical engagement with the dog. While all this may sound confusing at first, it won't after you finish this book.

One thing that quickly becomes apparent in this process is that some dogs are, in fact, more stubborn than others. If your dog is of the more compliant variety, then lots of positive reinforcement may be enough to accomplish all your training needs. That's fantastic!

Meanwhile, others may find positive reinforcement isn't enough, despite some strident claims to the contrary. That's where the distinction between transactional and relational training becomes especially important. With such dogs, you must be more creative and experiment with approaches while embodying the spirit of the LIMA principles. The long-term goal is always to train for reliability in the face of unpredictable circumstances, and this process is often more art than science. That's why for many of this book's exercises I provide multiple ways of teaching them, and you must determine what combination will work best for your dog and your situation.

To me, Integrated Dog Training is about understanding that, while leadership is crucial, it isn't imposed through brute displays of force or threats. Rather, it's established through a skillful control of resources combined with appropriate social symbolism in order to teach dogs to exercise impulse control and check in with us concerning things that matter. Further, if some type of aversive control is ever called for, it is done in the least-intrusive way and within the larger context of massive positive reinforcement.

Now, it's time to start training. I've divided types of commands into parts and arranged the exercises in a logical sequence, but they aren't necessarily or always meant to be done in order. You may not need to start with exercise 1 and go through all the rest in a linear way, one by one. For instance, if your dog already knows certain behaviors or commands, you might skip these and focus on new ones. And if you are training your dog for the first time, please review the "Session Plan" at the end of the book before starting. This organizes the exercises into an actual training program, with day-by-day suggestions for what to do and in what order, using effective, bite-size routines that will add up quickly to a beautifully trained dog that loves working with her owner. Let's dive in.

Endnotes

1. L. David Mech and H. Dean Cluff, "Prolonged Intensive Dominance Behavior Between Gray Wolves, *Canis lupus*," *Canadian Field-Naturalist* 124, no. 3 (2010): 215–18, https://pubs.er.usgs.gov /publication/70037810.

2. Marc Bekoff, "Dogs Display Dominance: Deniers Offer No Credible Debate," *Psychology Today*, July 7, 2016, https://www.psychologytoday.com/us/blog /animal-emotions/201607/dogs-display-dominance -deniers-offer-no-credible-debate.

3. *Professional Standards for Dog Trainers: Effective, Humane Principles* (Renton, WA: Delta Society, 2001), https://www.scribd.com/document/71491384 /Professional-Standards-for-Dog-Trainers-2001.

4. Steven R. Lindsay, *Handbook of Applied Dog Behavior and Training, Vol. 3: Procedures and Protocols* (Oxford, UK: Blackwell Publishing, 2005).

As the old saying goes, "A journey of a thousand miles begins with a single step." These exercises are the first steps your dog will learn in a journey that will last your whole lives together.

However, it's important to understand that these are just "exercises." Through these beginning exercises, you and your dog will learn a common language. The point is to make these exercises as easy for your dog to learn as possible, and to make them enjoyable, so that your dog learns to love training. Don't worry about how many times you have to practice, how long your dog takes to learn them, or whether she does it perfectly every time. I can tell you right now she won't.

When you practice, treat the sessions more like play, not "commands." There's an enormous difference between exercises and commands! For an instruction to become a command, your dog has to not only understand the exercise but also the concept "you must." And you won't introduce this concept until later in the training.

A lot of people assume that if their dog has performed an exercise twenty or thirty times, she should "have it" and perform it reliably every time. Then, when she predictably doesn't, they become frustrated or angry and say things like, "My dog is stubborn," or "She's trying to be alpha over me." She's not, and such reactions can foster an unnecessarily adversarial relationship that's inappropriate at this stage.

So have fun, make it easy, and when the time is right, you and your dog will be ready to take training to the next level.

In dog training the first step is sit. It's a simple exercise that not only teaches your dog to sit but also introduces the whole idea of learning. She'll begin to understand that when you engage with her in a particular way — waving a treat around and making sounds — you're looking for a specific response. Once she gets this, she'll learn to pay attention in a more focused way. Before you start, review the sidebars below on timing and treats.

"Sit!"

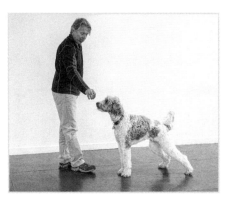 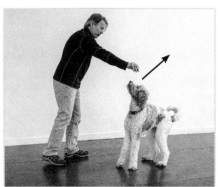 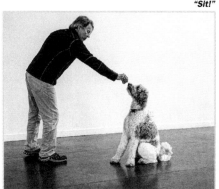

Get your dog's attention with a yummy treat that she really likes. If you're having a hard time keeping her attention, use a better treat. Keep your dog's attention on the treat by holding it close to her nose. DO NOT say, "Sit."	Slowly move the treat over your dog's head, and keep bringing it back over your dog's head until she starts tilting backward. Still DO NOT say, "Sit."	Once your dog actually sits, say, "Sit," but ONLY ONCE. Release your treat simultaneously.

⭐ What If My Dog Isn't Interested in Treats?

While most dogs get pretty excited over the right treat, for some dogs treats just aren't a big motivator. So now what?

You have several options. First, experiment with not feeding your dog breakfast and then using her kibble throughout the day as training treats. This way your dog will be significantly hungrier throughout the day and much more receptive to training. If kibble doesn't work, try some higher-value treats. Then, come dinnertime, you can assess how much your dog has eaten during the day and determine an appropriate meal size.

An interesting side benefit of this approach is that behaviors learned during a period of deprivation tend to penetrate dogs more deeply and are better retained than behaviors taught in a period of abundance.

An alternate approach is to explore different motivators for your dog. For example, some dogs are significantly more motivated by toys and games than by treats. If your dog is one of these, try using a ball as a motivator. See part 6 for more on this.

Adding Watch

Why teach "watch"? Teaching a dog watch helps her to understand that she should look at you after following an instruction. It's a form of impulse control and checking in with you. Of course, in the beginning, your dog is watching the treat, not your face. However, in time this habit can become so well-established that your dog will simply do it any time she has performed something for you.

"Watch!"

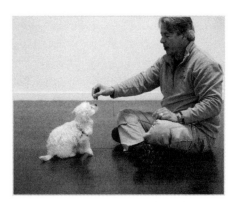 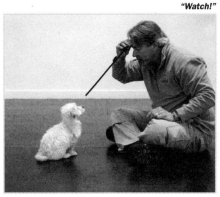 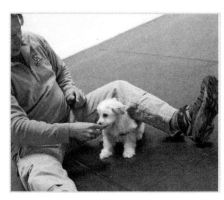

With your dog in a sit, rather than release the treat…

…bring your treat up to your forehead and say, "Watch."

As soon as she looks at your forehead, deliver your treat.

⭐ **On the Early Timing of Words and Treats**

When you're first introducing a new behavior, it's important NOT to chant the phrase associated with the behavior you're trying to teach. Instead, lure the dog into the position you're looking for — in this instance, to sit — and say the word *once* as your dog commits to the behavior. Remember, you're trying to teach your dog to associate the word "sit" with the action of sitting. In the beginning, if you chant the phrase over and over, it can make it more difficult for your dog to identify the word with the desired action.

However, this is only true in the very beginning of introducing a new concept. Generally, after a dozen or so repetitions, the association becomes established, and you can use the word as a cue to let your dog know what you're looking for.

The next step is introducing down. Often it's helpful to introduce this exercise on slick floors such as tile, hardwood, or linoleum, as it's sometimes easier for a dog to slide into down initially. Once they've understood the basic concept, work on whatever surface you like. Remember, say the word "down" only once, and only after your dog moves into the correct position; see the sidebar "On the Early Timing of Words and Treats" (page 3).

"Down"

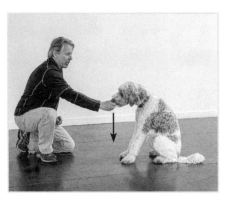

With your dog in a sit position and her attention on the treat, *slowly* draw the treat to the ground, luring her to follow. If you lose her attention, either slow down or use a better treat.

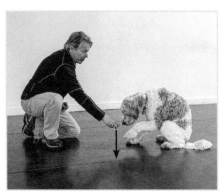

Be sure to bring the treat straight down. If you bring it forward, your dog will likely stand up.

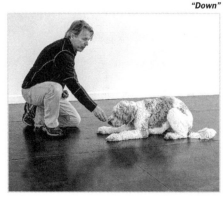

As her elbows touch the ground and she commits to the behavior, say, "Down," but ONLY ONCE. Do not repeat or chant "down." The point is to associate the down position with the sound "down" and the treat (see sidebar, previous page).

Down: Under the Leg

If your dog's rear end keeps popping up — which is a common problem for dogs whose legs are shorter than their body, such as dachshunds and French bulldogs — try this alternate approach. Some dogs don't actually have to collapse their front legs in order for their nose to reach the ground for the treat, so they'll often just sit sniffing or hoist their rear end. Repeat this sequence five to ten times, and you should be able to dispense with the under-the-leg gimmick.

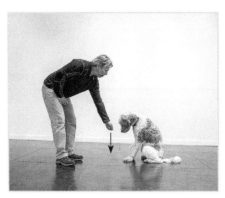

From a sit...

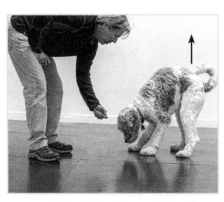

...some dogs will stand as you lower the treat to the floor.

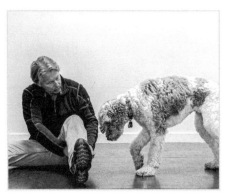

If so, sit on the floor with your dog to the side and raise your leg. Hold a treat under the raised knee.

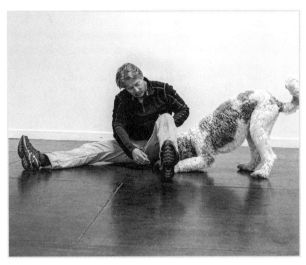 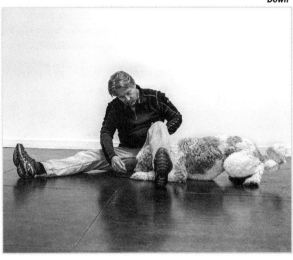

Lure her so that she slowly bends down to get her head under your leg, and keep pulling the treat forward until your dog's rear end goes down.

Once her rear end hits the ground, say, "Down," but ONLY ONCE.

Once you've gotten this far, lure your dog farther under your leg.

Then slowly lure her back *halfway* into a sit, but *before she locks her elbows out…*

…lure her back into a down. Then give her the treat.

⭐ Note

As you're luring your dog under your leg, be sure not to put too much downward pressure on her shoulders. This can kick in the "opposition reflex," and she'll resist upward, which defeats the purpose of the exercise.

With your dog in a down, practice bringing her back into a sit before releasing the treat. This builds your first training sequence — "puppy push-ups."

"Sit"

 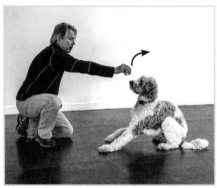 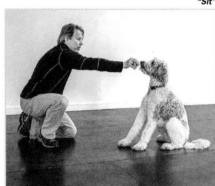

After your dog reaches the down position, simply keep the treat close to your dog's nose.

Then *slowly* bring the treat back up and over your dog's head…

…and keep going till she's back in a sit. Say, "Sit," and deliver the treat.

⭐ Make It Easy for Them

When you're just getting started with training, it's important to set your dog up for success and repeat that success often. In other words, make it impossible for your dog to fail by keeping the exercises so simple that failure just isn't possible.

This is extremely important in order to build your dog's confidence and enjoyment of the process and also to learn without impediment. Repeated success creates a groove in your dog's mind that will become easy for her to fall back into once the level of difficulty increases and once you teach the concept "you must," when your expectation of compliance or obedience creates new pressure.

You might ask yourself, "Why bother teaching my dog to stand?"

The stand command is a useful exercise in its own right, one whose value you will appreciate later. It's particularly helpful when using the stay command (see part 5). For now, don't gloss it over. Make sure your dog solidly holds the stand for a moment while you deliver the treat.

"Stand"

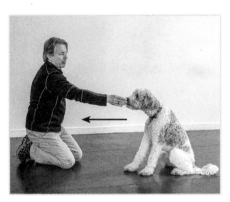

With your dog in a sit, keep the treat very close to her nose without releasing it.

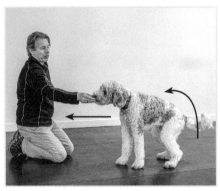

Slowly pull the treat straight forward to lure your dog into a stand.

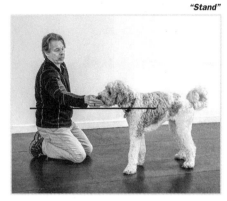

Make sure that the treat is level with your dog's nose *and* that you're pulling it forward parallel to the ground. Once your dog is in the stand, say, "Stand," and deliver the treat.

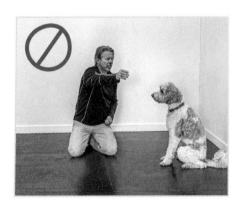

DON'T DO THIS: If you bring the treat above the natural level of your dog's nose, she will tend to hold a sit. Here the treat is too high, so she doesn't move forward into a stand.

Stand to down opens the door to a number of advanced commands. In the beginning, people often gloss over this exercise because they don't see the point. Don't do that! Stand to down sets up down out of motion (exercise 23), which is essential when establishing distance control and emergency stops (see part 9).

"Down"

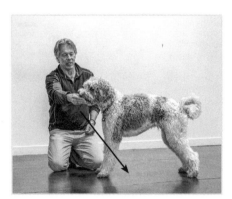

While your dog is in a stand, push the treat slightly backward under your dog's chest...

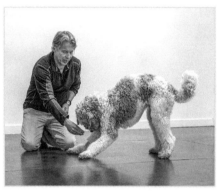

...and targeting the area between her legs.

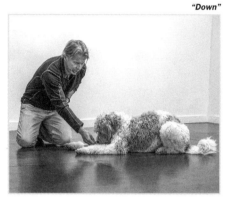

Keep lowering the treat to the ground, and when your dog commits to the behavior, say, "Down," but ONLY ONCE, and release the treat.

⭐ Note

If your dog keeps backing up to get the treat rather than going down, try the under-the-leg trick (see "Down: Under the Leg," pages 4–5). Once your dog gets that right, return to practice this.

"Stand"

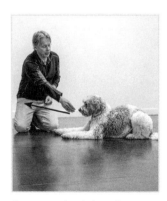

Once your dog is in a down, keep the treat close to her nose and *slowly* move it away at a slightly upward angle. If you lose her interest, you've probably moved the treat away too far and too fast.

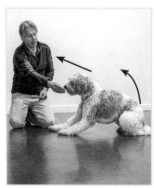

Keep slowly moving forward and upward...

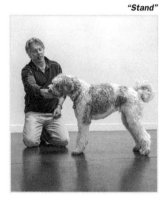

...until she comes up into a stand. Say, "Stand," but ONLY ONCE, and release the treat.

DON'T DO THIS: If you raise the treat too far above the level of your dog's nose, she'll be likely to sit rather than stand.

Once you've practiced the first six exercises individually and your dog understands sit, down, and stand as cues (see "On the Early Timing of Words and Treats," page 3), it's time to run them together and create your foundational training routine. In essence, you want to move between all the positions interchangeably and establish a smooth rhythm between any and all combinations. This is the foundation for hand signals (in part 2), and you should NOT move on to those until your dog can cruise through any configuration of this routine with ease.

In addition, you want to start asking for more performances of an ever-increasing number of behaviors before delivering a treat. And you want to vary the order. For instance, in the first sequence shown here, you would go through a sit-down-sit-stand sequence before delivering the treat. Once this is established, practice a stand-down-stand routine, as in the second sequence, and so on.

"Sit" *"Down"* *"Sit"* *"Stand"*

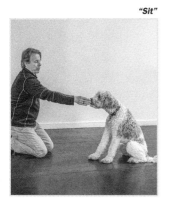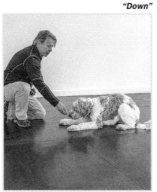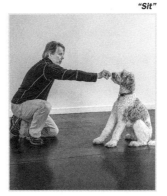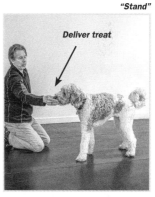

Deliver treat

Keep varying and extending the sequence of behaviors, and do not move on to hand signals until you can get your dog to give you ten performances in any order for a single treat.

"Down" *"Stand"*

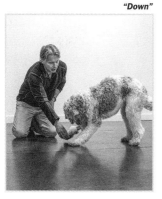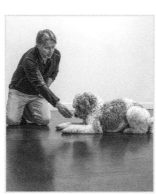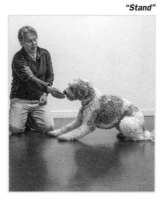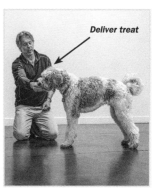

Deliver treat

Notice in this sequence that the command is said at the same time as the hand movement. At this point, you no longer have to wait to say the command until your dog commits to the behavior. The word itself should start to cue your dog to what's wanted, along with your hand movement.

Once your dog has mastered the foundational sit-down-stand routine, you're ready to add hand signals.

The use of hand signals starts to separate sits, downs, and stands into independent concepts in your dog's mind, and they begin building the bridge from "exercises" to "commands." Hand signals also change the way you use treats in order to begin reducing your reliance on them.

The full transition to hand signals involves three stages. Each stage works with the exercises you've learned so far — sit, down, and stand. That makes for a lot of exercises to repeat with only minor variations, and it may seem a bit tedious in the beginning. But trust me, if you systematically follow these routines, you'll have your dog responding to hand signals in no time, and you will have paved the way for genuine "commands."

Please don't hurry through these. Make sure you've nailed each stage in all its variations before moving on to the next. Remember, you can't build a solid house on a shaky foundation. If you encounter trouble with hand signals, or seem to be moving too fast for your dog, go back to exercise 7, "Building a Routine," until your dog follows you consistently and reliably.

In theory, it doesn't matter what gestures you use for hand signals. The important thing is that each motion is easy for you to do and easy for your dog to understand. Other people and trainers sometimes prefer other gestures, and you can add more hand signals as training continues, but I find these three work best for the three main commands: sit, down, and stand.

Sit

To issue the sit hand signal, begin with your hand at your side and simply sweep your arm upward as shown.

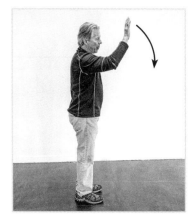 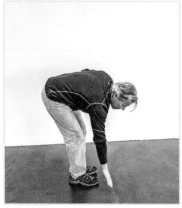

A Preliminary Form of Down

You have to teach the down hand signal in two steps. Initially, do the motion as shown here: With your arm raised, palm out, bend over so you can lower your hand all the way to the ground with the treat. Why do this preliminary version first? Because the final version of the down hand signal (which appears next) demands that your dog move away from the treat to get the treat. This makes no sense initially, since every other exercise (except stay, later) asks her to move toward the treat to get the treat.

Only when she's nailed this should you move to the final down hand signal.

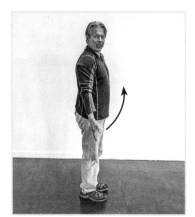

Down

The final hand signal for down is the opposite of sit. With your hand raised, simply sweep it straight down until your hand is comfortably at your side.

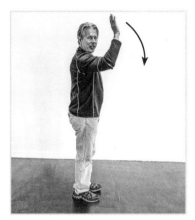

Stand

With your hand somewhere near your dog's nose, pull it away in a line level with her nose and parallel to the ground with your palm facing her. Remember, if you bring the treat and hand signal above the plane of her nose, she will tend to crane her neck up and sit.

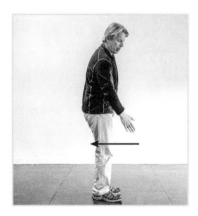

Holding the Treat

As you introduce hand signals with your dog, shift the position of the treat in your hand. Don't hold it between thumb and forefinger — where the visual emphasis is on the treat and much less on the hand. Instead, hold the treat between your forefinger and middle finger — where the visual emphasis is much more on the hand and less on the treat.

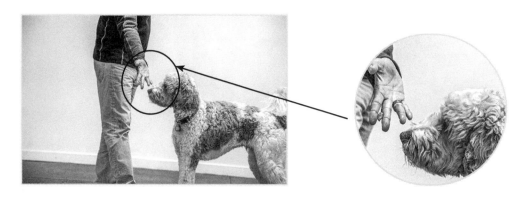

The first stage of introducing hand signals is the simplest: You hold the treat between the fingers of your signal hand, and when your dog performs correctly, you give her that treat as her reward. You should go through all of the routines in this stage in this way before moving on to stage 2.

In addition, use your tone of voice and certain phrases that function as "positive and negative markers" (see sidebar below) to convey your level of approval or disapproval and to enhance your communication.

Stand to Sit

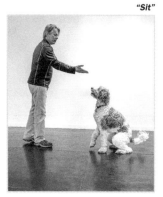

"Sit"

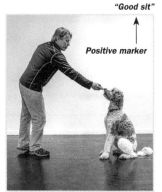

"Good sit"

Positive marker

Put the treat between your first two fingers and hold your hand flat in front of your dog, getting her attention while in stand.

Move your hand up in front of your dog while keeping her attention and simultaneously saying, "Sit." If you've taught her sit with a treat, she will move back into sit.

Once she's in sit, give her the treat while saying, "Good sit." This functions as a "positive marker" that helps your dog understand when she's done what you've asked for.

⭐ Positive and Negative Markers

Positive and negative markers are auditory aids to help your dog understand when she's gotten something right or made a mistake.

For instance, if your dog has properly performed a command, your positive marker might be an enthusiastic "good." This is particularly helpful when working with your dog from a distance, since you can't deliver a more physical reward quickly (like a pat or a rub). Some people use clickers for this (see "A Note about Clicker Training," page 18), but in this book, we're not using clickers, only verbal markers.

On the other hand, a negative marker is a phrase uttered in a sharp tone of voice that helps your dog understand when she's made a mistake. The most common is "ah-ah." This is extremely helpful to your dog, especially when you're not near her, to help her understand where the problem is. For more about this, see "On Using Negative Markers" (page 59).

The intelligent combination of positive and negative markers — along with tone of voice (see "The Importance of Tone of Voice," page 16) — dramatically facilitates learning and profoundly strengthens the communicative and emotional bonds between dogs and their owners.

Sit to Down

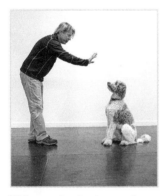

With your dog in sit, use the treat between your fingers to get your dog's attention.

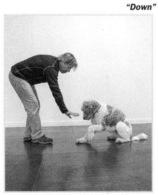

"Down"

While saying, "Down," slowly sweep your hand down in front of your dog's nose and all the way to the ground.

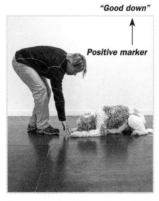

"Good down"

↑ **Positive marker**

Once your dog is in down, DO NOT put the treat into your dog's mouth.

Instead, open your fingers so that the treat drops to the ground and pull your hand away. Have your dog pick up the treat from the ground. This is **VERY IMPORTANT:** You want to teach your dog to orient to the ground rather than to your hand.

⭐ Note

Eventually, to avoid bending over to deliver the treat, try the alternate method that delivers the treat from behind the leg; see exercise 13, "Down without Bending Over."

✪ The Importance of Tone of Voice

Dogs will never understand human language. However, they can easily learn to recognize words, and they definitely understand the tone with which words are uttered.

In general, dogs have three tones of voice that they commonly use to communicate with other dogs: high-pitched and upbeat, midrange and level, and low and rumbling. These mean pretty much what you'd think. High-pitched and upbeat is happy and playful. Midrange and level communicates a range of more level emotions. Low and rumbling is threatening or angry.

Of course, dog communication involves a full spectrum of much more subtle emotions and meaning, and to understand what dogs are expressing, we always have to consider multiple factors, including body posture, social context, and more.

However, for the purposes of training, we can take a page from their communicative repertoire and adapt it to our interactions to improve the quality of our communications.

In the context of commands and markers, this means that, for a positive marker, you should use an upbeat, high-pitched tone of voice. For a negative marker, use a low, reprimanding tone of voice. And for general instructions, use an ordinary but commanding tone that is slightly weightier and more attention-getting than your ordinary tone of voice.

Down to Stand

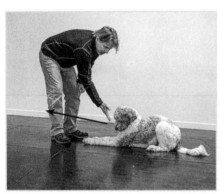

With your dog in a down, use the treat between your fingers to get her attention.

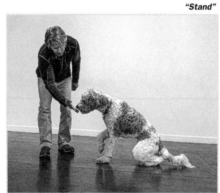

"Stand"

Slowly move the treat away from your dog's nose and slightly upward, but parallel with the floor, while saying, "Stand."

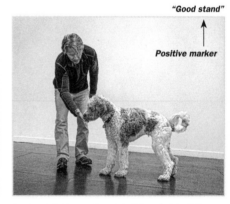

"Good stand"

Positive marker

As your dog stands, say, "Good stand," as a positive marker and deliver the treat.

Stand to Down

People commonly overlook practicing down from a stand, since they aren't sure why they'd ever need the dog to lie down from a stand. Don't do that! This exercise leads to a much more advanced and very important exercise called "Down Out of Motion" (exercise 23), which is used in both heeling and recalls.

"Down"

With your dog in stand, hold the treat in your raised hand slightly above her head.

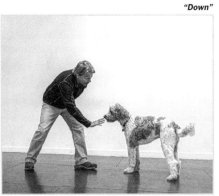

Say, "Down," and sweep your hand down in a smooth arc past her nose.

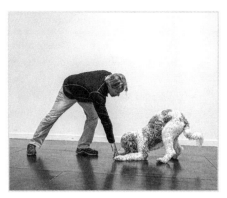

Bring your hand all the way to the ground, but do not release the treat...

"Good down"

↑

Positive marker

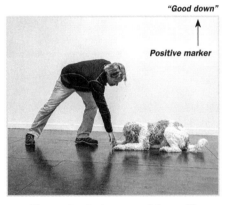

...until your dog is down on all fours. Then say, "Good down," ...

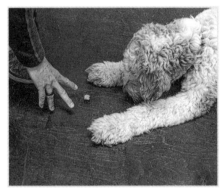

...and leave the treat on the ground for your dog. DO NOT let her take it from your hand.

Down to Sit

"Sit"

"Good sit"

↑

Positive marker

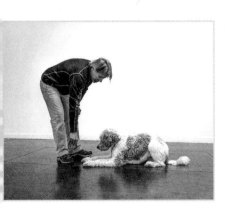

With your dog in down, get your dog's attention on the treat.

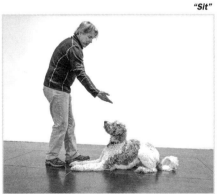

With your palm facing your dog, and while maintaining her attention on the treat, sweep your hand up and above her head while saying, "Sit."

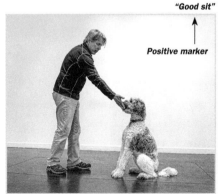

When your dog comes to a sit, say, "Good sit," linking the behavior to your positive marker.

✪ A Note about Clicker Training

Anyone who's perused today's training landscape will have come across "clicker training." Clicker training was originally used in marine mammal training, but in the early 1990s it came into vogue as part of dog training.

A clicker is a "secondary reinforcer." The primary reinforcer is a treat. The secondary reinforcer marks the moment that a dog performs a desired behavior with a metallic clicking sound. It builds a bridge to the primary reinforcer by marking the appropriate behavior and letting the dog know that a treat is coming.

I learned clicker training early in my apprenticeship when I clicker trained several hundred dogs. However, I dropped clickers because I found that their "marking and bridging" functions could easily be served with a well-timed "good girl." Sure, the clicker is a more precise and distinct sound than a human voice, and it definitely helps people become more conscious of their own timing.

But I didn't feel that these advantages outweighed the extra burden on my clients. Most had enough difficulty managing a dog, a leash, and a treat. Freighting them with an extra training tool and pile of concepts didn't seem worth it. That's why I haven't included the use of clickers in this book. Instead, I emphasize how to effectively use positive and negative markers in conjunction with treats.

That's not to say that clickers don't work. They do work. They're just not necessary. This isn't just my opinion. It's also the finding of a study performed at the University of Wisconsin that found that dogs taught without clickers learned their task equally quickly as their clicker-trained counterparts and that *the clickers added nothing at all*.

In fact, clickers can distract the owner from more direct interactions with their dog. That's because it's easy to get so fixated on the click-treat sequence that one misses a whole host of other cues and signals that would strengthen their connection with their dog and eliminate the need for gimmicks.

To be clear, I don't oppose clicker training. Clickers are especially useful for dog enthusiasts competing in any number of dog sports, which require precise control at a distance. However, most people aren't "dog enthusiasts" in that sense. They're just everyday people trying to get their dogs trained. Instead of a clicker, just use well-timed praise.

Once your dog has mastered the stage 1 hand signals, and she can move through them as readily as she did when you were luring her around by the nose in the part 1 exercises, then you're ready to move on to stage 2 of hand-signal training.

In the second stage, you introduce a little sleight-of-hand. You continue holding a treat in the signal hand and use it to lure your dog. However, you also hold a handful of treats in your other hand, which you keep either behind your back or to your side, where it's not so obvious to your dog. You'll continue luring your dog with the treats in the hand-signal hand but start rewarding her with treats from behind your back.

Eventually, as you repeat these exercises, your dog will start ignoring the treat in your signal hand — even though it's still functioning as something of a lure — and begin looking for the treat from the opposite hand. That's the bridge to getting rid of the treat in the signal hand altogether, which is stage 3 of hand-signal training.

For these exercises, hold one treat in your signal hand, and hold a large pile of treats in your other hand.

Hide these other treats behind your back, but have them ready to use.

Stand to Sit

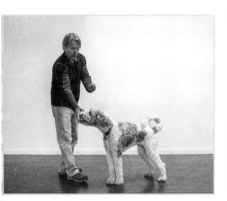

"Sit"

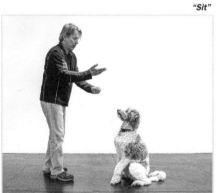

"Good sit"

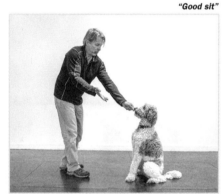

With your dog in stand, get her attention with the treat in your signal hand. Hold a handful of treats in your other hand, which is held behind your back or to the side.

Give the hand signal and say, "Sit," at the same time.

As your dog sits, deliver your treat from the hand behind your back (NOT from your signal hand). As you do, say, "Good sit," as a positive marker.

Sit to Down

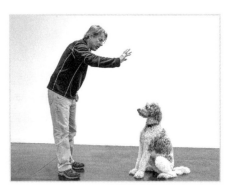

With your dog in sit, get her attention with the treat in the signal hand, while holding more treats in your hidden opposite hand.

"Down"

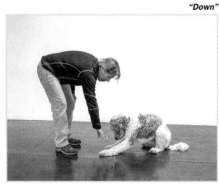

Sweep your signal hand down in front of your dog's nose while saying, "Down."

"Good down"

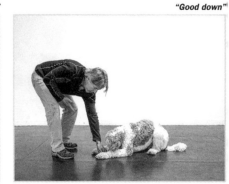

When your dog is down, say, "Good down," and place a treat on the floor between your dog's feet **from the opposite hand**, while removing your signal hand with its treat. Remember, don't feed your dog out of your hand! Let her pick the treat up off the floor.

Down to Sit

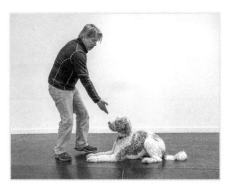

With your dog in down, get her attention with your signal hand.

"Sit"

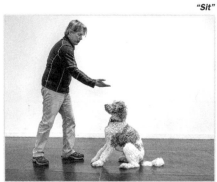

Sweep your hand upward while saying, "Sit."

"Good sit"

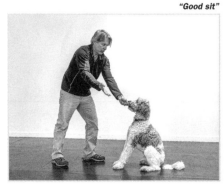

When your dog sits, say, "Good sit," as a positive marker and deliver a treat **from your hidden, opposite hand.**

Sit to Stand

"Stand"

"Good stand"

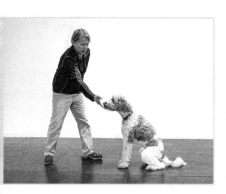 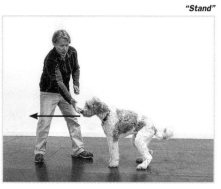 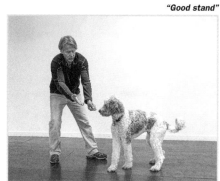

With your dog in sit, get her attention with the treat in your signal hand.

With your palm facing your dog's face, pull the treat away from her nose and parallel to the ground while saying, "Stand."

As your dog stands, deliver the treat **with your opposite hand** and say, "Good stand," as a positive marker.

Stand to Down

"Down"

"Good down"

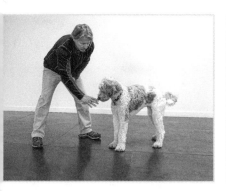 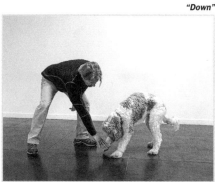 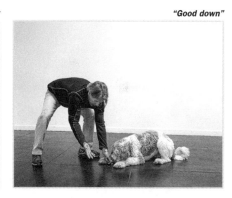

With your dog in stand, get her attention with your signal hand.

Sweep the signal hand down to the ground and say, "Down."

When your dog is down, deliver the treat from your opposite hand while saying the positive marker, "Good down."

You should only move on to stage 3 hand signals once your dog is by and large ignoring the treat in your signal hand, since she now knows that the treat reward will be coming from the opposite, hidden hand.

In stage 3, you remove the treat from your signal hand altogether. You still use that hand to give the hand signal while saying the command, but you only deliver the treat from the other hand. At this point your dog will be cuing on the signal hand and assuming that a treat will be delivered from the other hand. In other words, she will have begun to understand hand signals, and she will understand the words "sit," "down," and "stand" as separate, stand-alone concepts rather than as part of a rote routine (the way they are introduced).

One more thing: In stage 3, start to vary how often and how many treats you give. Still deliver treats fairly frequently, but not every time, and once in a long while give a lot (especially if your dog has either given an exceptional performance or had a breakthrough on something she's struggled with), and make these differences unpredictable. Your dog should still expect treats while no longer knowing exactly when and how many she'll get. In behaviorist jargon, this creates a "random schedule of reinforcement" (see sidebar on page 23), and this should continue for the rest of training.

Stand to Sit

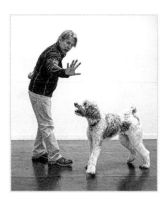 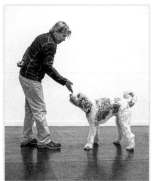 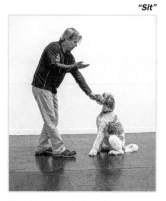 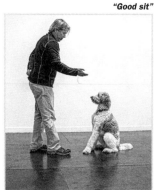

"Sit"

"Good sit"

Have no treats in the signal hand, and hold several treats in your opposite hand, held to the side or behind the back.	With your dog in stand, get her attention with your signal hand. Even though it no longer holds a treat, your dog won't care, since she knows that treats now come from your opposite hand.	Give the hand signal and say, "Sit."	Once she's in the sit, issue your positive marker — "Good sit" — and deliver the treat from behind your back.

⭐ Random Schedules of Reinforcement

A central component of positive reinforcement–based learning is moving from a steady schedule of reinforcement to a random schedule of reinforcement.

In part 1, you initially use a regular schedule of reinforcement. After each performance of a single command like sit, your dog is rewarded with a treat. Then you ask your dog to complete a sequence of commands before releasing a treat, which introduces a bit of randomness.

Once you start stage 3 hand signals, and you have successfully removed the treat from the signal hand, adopt a random schedule of reinforcement. That means varying when you deliver a treat and the size of the reward. At this point, don't give a treat after every successful exercise, or only give a treat after several successful performances in a row, and occasionally, such as when your dog hits a new level of performance with a concept she's struggled with, give her a "jackpot": a special, high-quality treat or much more than normal.

Interestingly, this will actually increase your dog's motivation *significantly* even though she is getting decreasing treats for the same work. This is one of the core insights of "operant conditioning," which behaviorist learning theory brought to the world of dog training in the 1990s.

The powerful motivation generated by random schedules of reinforcement has been studied with scientific precision in gambling. If a slot machine always spits out two quarters for every quarter someone puts in, this doubles their money, but eventually this becomes so boring that people will quit despite doubling their money.

On the other hand, if a slot machine gives nothing the majority of the time, occasionally returns several quarters, and once in a blue moon rewards someone with an avalanche of quarters, the person will sit there all day long (or until they lose all their money).

That's the power of a random schedule of reinforcement.

And you can harness that power when training your dog to get steadily improving levels of motivation and performance even while thinning out the treats.

For instance, from now on, ask for three performances before delivering a treat, then five, then just two, and so on. And when your dog does something really well, hit them with a rare avalanche of treats. Throughout the rest of this book, continue to apply these principles to every new training context.

Sit to Down

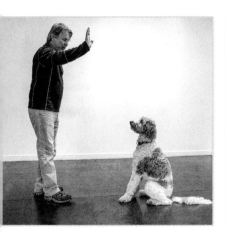

With your dog in sit, raise your signal hand without holding a treat.

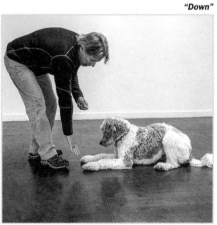

"Down"

Say, "Down," and sweep your hand down in front of your dog's nose and to the floor.

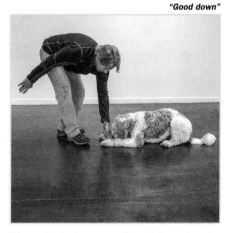

"Good down"

When she is down, say, "Good down," and deliver the treat between her feet from the opposite hand.

Down to Sit

Dogs commonly have trouble going from down to sit. If that happens, see exercise 12, "Down to Sit: Adding a Foot Nudge."

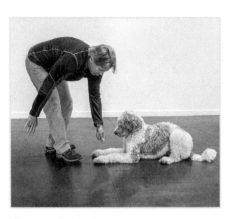

With your dog in down, get her attention with your signal hand.

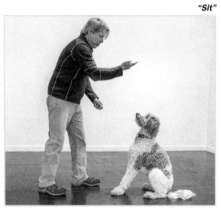

"Sit"

Sweep your hand up in front of her face while saying, "Sit."

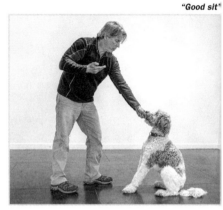

"Good sit"

Once she's in the correct position, deliver the treat from your other hand and say, "Good sit."

Sit to Stand

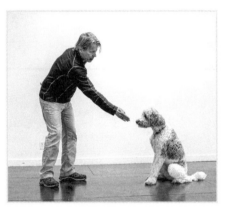

With your dog in sit, get her attention with your signal hand. You can hold your thumb in the middle of your palm to give the impression that a treat might be there.

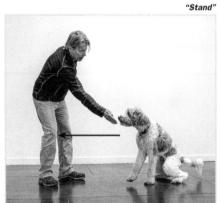

"Stand"

Sweep your hand, luring your dog forward, while saying, "Stand."

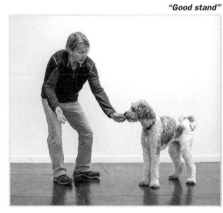

"Good stand"

Once in stand, deliver your treat from behind your back and say the positive marker, "Good stand."

Stand to Down

This exercise introduces a second hand signal for down — a large, sweeping motion in which your signal hand starts relatively high over your dog's head, then sweeps down in front of her face and to the ground. This sets up the field hand signal for down — a hand raised straight over your head that your dog can see at a distance. This is very useful when teaching down-stays (see part 5), emergency stops (see part 9), and distance downs (see part 12).

It's absolutely key in this exercise that your dog NOT sit on her way to the down. She should simply drop straight into down. If your dog always has to sit before dropping into a down, it will be very difficult for her to learn to do this at a distance out of a full run.

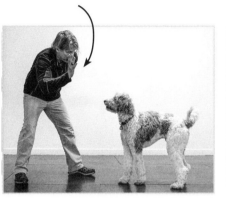

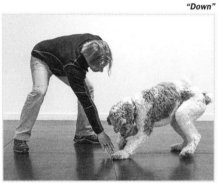
"Down"

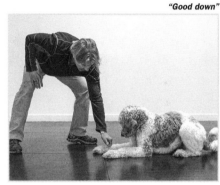
"Good down"

With your dog in stand, raise your signal hand relatively high over your dog's head. (For a better image of the hand signal, see the first photo on p. 29.)	Sweep the hand down to the ground in front of your dog's nose while saying, "Down."	Once she's down, deliver your treat onto the ground from behind your back and praise with your positive marker, "Good down."

Down to Stand

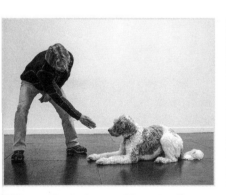

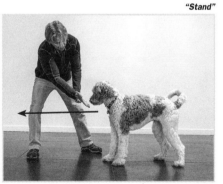
"Stand"

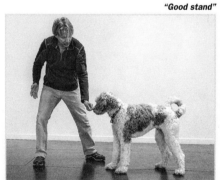
"Good stand"

With your dog in down, get her attention with your signal hand; you can center your thumb in your palm to give the impression of a possible hidden treat.	Move your hand forward while saying, "Stand." Be sure to keep the treat level with her nose. If she cranes her head backward, she will tend to sit instead.	Once she's in stand, deliver your treat from the other hand and say, "Good stand."

⭐ Note

In the three images above (and some others), notice that the opposite hand holding the treats is not hidden behind the back. It doesn't necessarily need to be, so long as the hand with the treats is not distracting your dog from the signal hand. If she gets distracted, then move the treats behind your back.

Some dogs may have trouble popping to a sit from a down. If that's the case with your dog, add a little nudge from the front of your foot to the front of your dog's foot. That usually does the trick. Remember: Nudge her foot. DO NOT step on her foot.

If a nudge doesn't work, and your dog still keeps backing up, try placing her with her rear end in a corner so that there's no place for her to back up. And if *that* approach doesn't work, see exercise 39, "Using the Leash to Demand Sit."

With your dog in down, place your foot about an inch from hers.

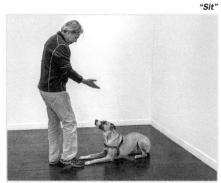

Say, "Sit," while giving the hand signal…

…and nudge her foot with yours. Most dogs will back away from the nudge into a sit.

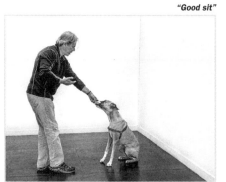

Once in a sit, deliver the treat and say, "Good sit."

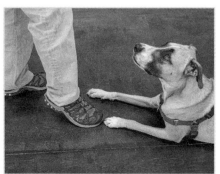

To nudge, push your foot forward like this.

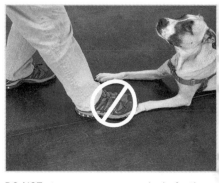

DO NOT step on or over your dog's foot!

One hand signal that can hit a bit of a snag is teaching down without bending over to touch or point to the ground (see exercise 8, "The Three Main Hand Signals"). That's because, when you just lower your hand to your side to signal down, without bending over, you're actually asking your dog to move down and away from the treat, which makes no sense to her at this point. With every other hand signal, your dog follows the treat to get the treat, and she may continue to do that with this hand signal. Here's a technique for correcting that.

When Down Doesn't Work

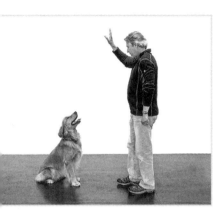

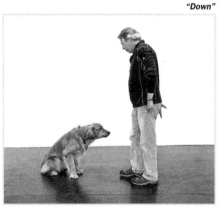

"Down"

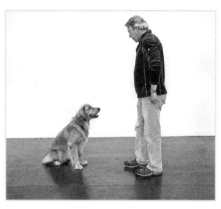

Here's the problem: First, I raise my hand to deliver the hand signal.

Then I sweep my hand down past her nose and say, "Down." At first, she starts to go down...

...but she pops back up confused when my hand returns to my side, since I didn't bend over to lead her all the way to the ground.

The Behind-the-Leg Trick

To overcome this little snag, follow this multistep process. First, practice the "Sit to Down" sequence under "Hand Signals – Stage 1" (page 15) until your dog always hits the ground quickly and is also *always looking at the ground*, and not at your signal hand, for the treat. Remember, this won't work if you give the treat from your hand. Place the treat on the ground for your dog to scoop up on her own.

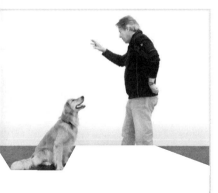

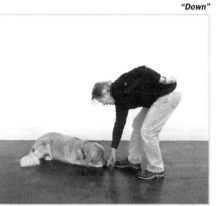

"Down"

"Good down"

Start by using the "down" hand signal to bring your dog all the way to the ground.

Be sure to drop the treat on the ground and make her pick it up from there. DO NOT give her the treat out of your hand. You want your dog to begin to anticipate the appearance of the treat on the ground, not in your hand. That's the whole point of this exercise!

Once your dog is performing this smoothly, do the same thing, but instead of going all the way to the ground, sweep the treat behind your calf and hide it there. If your dog has come to anticipate the treat on the ground, she'll go all the way down. Once she's down, toss the treat from behind your calf into the area between her feet.

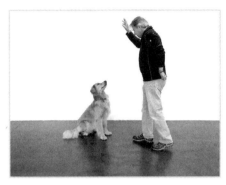

With your dog in sit, get her attention on your signal hand.

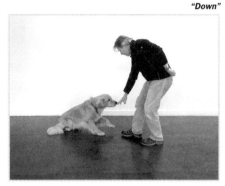

"Down"

Sweep your hand down past your dog's nose and say, "Down."

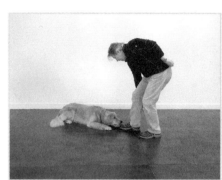

However, DO NOT go quite all the way to the ground.

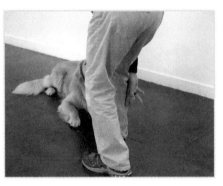

Rather, bring your signal hand with the treat behind your calf and hide it there.

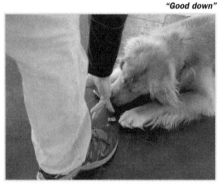

"Good down"

Once your dog is down, toss the treat into the area between her feet and say, "Good down."

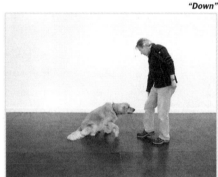

"Down"

Repeat this procedure…

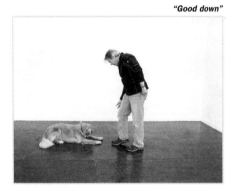

"Good down"

…and each time hide your treat a bit higher behind your leg until you're not bending over at all. Soon your dog will be hitting the downs without you bending over.

✪ Note

During this exercise, your dog might freeze as if stumped or confused. If this happens, so long as your dog seems to be concentrating, it's *extremely important to be still and quiet* and not say a thing. Your dog is trying to work out the problem. She is not being stubborn, stupid, or distracted. If you repeat "down" or the environment has a lot of distracting noises, it will break your dog's concentration and she'll give up. Learn to recognize such moments. Often, after as long as even a full minute, your dog may simply drop into the down, at which point you must enthusiastically praise her after delivering the treat. Of course, if it becomes apparent that she's given up, is distracted, or starts looking at other things, reboot the exercise and try again. For a video of this exercise, please go to my website at https://www.doggonegood.org/training-video-series/ and see video 12.

In the same way that going from sit to down without bending over can present a short-term challenge, so can going from sit into a down if there's any distance between you and your dog. Even though it's exactly the same exercise, for some reason being two feet away can completely throw a dog off. So we sometimes have to slow down and gradually introduce the notion that "down" still means "down" even though we're five feet away.

Also, if your dog has trouble as you increase the distance, cut the increments in half and try again. Take your time with this. Progress might seem halting in the beginning, but your dog will soon figure it out.

Sit to Down

"Down"

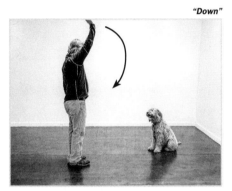

With your dog in sit, hold treats behind your back in your opposite hand, then use your signal hand to indicate down and say, "Down," as usual.

"Good down"

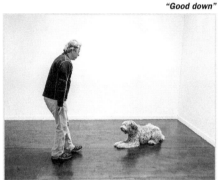

When your dog is down, say, "Good down," as your positive marker…

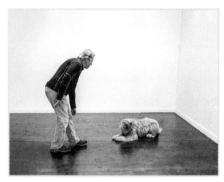

…and then toss a treat between your dog's feet from your opposite hand.

⭐ **Note**

In this exercise, you use your positive marker ("Good down") to let your dog know when she's hit precisely the right spot, and then you reward her with a tossed treat a moment later. The positive marker builds a bridge in your dog's mind between the proper behavior and the reward, allowing you to reward her a moment after she's actually performed.

"Sit"

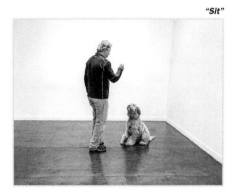

Reset your dog into sit, and repeat this routine a number of times, until your dog's got it.

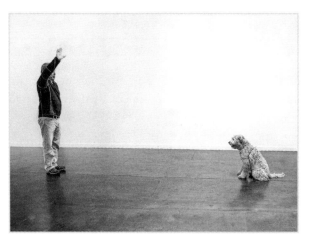

Then move a foot or two farther away and repeat the exercise.

"Down"

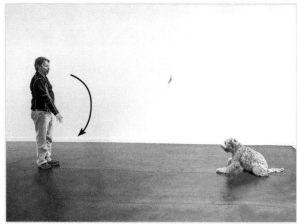

Use the hand signal and say, "Down," and wait until your dog is down.

"Good down"

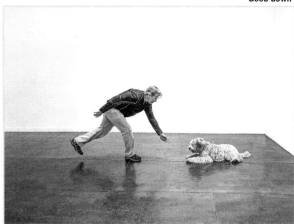

As soon as she's performed, say, "Good down," and immediately take a very long step toward her and toss the treat between her feet. Then continue this process: Repeat the exercise at one distance, and then add a little more for the next round, until your dog is successful when you're at least five or six feet away.

⭐ On Hyperspecificity

Some years ago, while researching another book, I ran across Temple Grandin's book *Animals in Translation*. It's a fascinating read for many reasons. But one thing that got my attention was her description of Australian cattle dogs on working ranches in Australia.

These dogs had no problem relating to a man on a horse, since they'd seen "horsemen" daily since their first moments alive. However, in many cases, these same dogs needed to be systematically socialized to a man who was not on a horse, even if it was *the same man*. That's because dogs have a hard time generalizing from specifics to entire categories. So a man on a horse is one thing and a man not on a horse is another, and Australian cattle dogs needed some extra work to make the connection.

That's precisely what I think is going on when dogs get confused about the down command the first time it's given at a distance. Of course, they can be taught that "down" means "down" no matter how far away a person is, but it takes a little extra work.

Stand to Down

Teaching stand to down at a distance is essentially the same as sit to down. Simply repeat the sequence at ever-increasing distances, and if your dog has trouble with a certain new increment, cut it in half and try again. However, for this exercise, you and your dog need to be familiar with stand-stay (exercise 32). Please don't overlook this exercise, as it sets the stage for emergency stops (see part 9) and distance downs (see part 12). It's also extremely handy for grooming and examination.

"Stand"

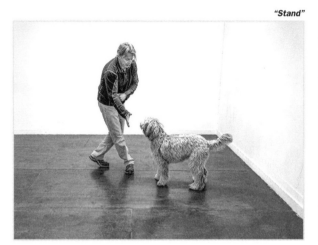

Using a treat, lure your dog into stand.

"Stay"

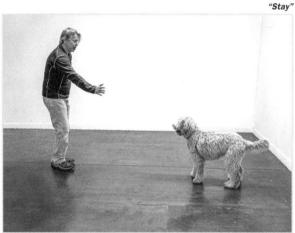

Then say, "Stay," and put some distance between you.

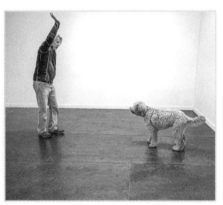

Be sure to have your treat in the opposite hand, held behind the back or off to the side.

"Down"

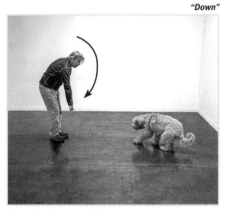

Give the down hand signal and say, "Down."

"Good down"

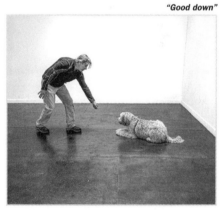

When your dog is down, say, "Good down," then step forward and deliver your treat into the area between your dog's feet. Then repeat this sequence, continuing to add distance in small increments with each repetition.

If Your Dog Moves Forward while Adding Distance

Sometimes when working on stand to down at a distance, your dog will move forward toward you rather than hold a stand-stay. This is natural; she's used to doing downs and receiving treats near you. Here's how to correct this issue. This exercise involves two techniques you haven't used so far: a body block (see "On Body Blocking," page 63), and a negative verbal marker (see "Positive and Negative Markers," page 15, and "On Using Negative Markers," page 59). Review these before you begin.

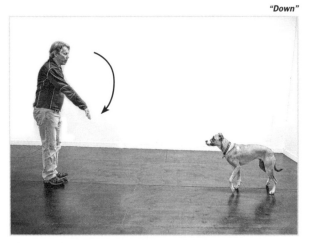

"Down"

With your dog in stand at a distance, deliver your hand signal as you say, "Down."

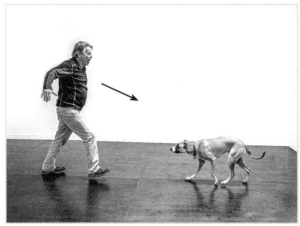

If your dog moves toward you, lunge toward her, blocking her advance, and at the same time...

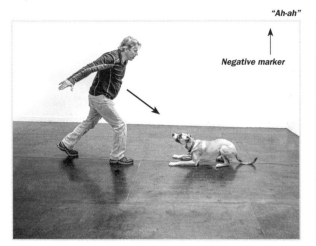

"Ah-ah"

Negative marker

...issue your negative verbal marker by saying, "Ah-ah." Usually, your dog will shrink back in surprise and mild shock and drop back into down.

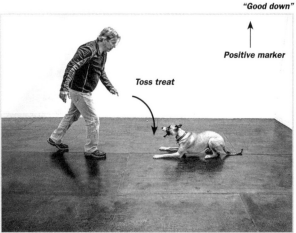

"Good down"

Positive marker

Toss treat

At this point, say, "Good down," as a positive verbal marker, and give a treat. Then rinse and repeat until your dog is holding her place and dropping into down out of a stand when you ask for it from a distance.

Once sit, down, and stand are well established with hand signals, it's time to move on to heeling — a very difficult exercise to do well. What's its purpose? The most obvious is to teach your dog to walk alongside you nicely without pulling on the leash regardless of surrounding distractions.

But there's a deeper dimension. When done well and no longer dependent on treats, heeling is a profound expression of teamwork and partnership. After all, it's a lot to ask a dog to slow their natural pace to match yours and to perfectly ignore all the things she finds compelling in order to give the bulk of her attention to you.

That's why solid heeling, more than just being a well-mastered technical skill, is in great measure an expression of connection between you and your dog.

Heeling is conventionally done on your left side. Of course, there's no reason you can't heel on your right. I just recommend that you pick a side and stick to it. Such regularity always makes everything more intelligible to your dog. In this book, heeling is always on the left.

In addition, I suggest introducing heeling in a controlled environment with no distractions and using high-value treats (like string cheese). This way you don't need to use a leash, and that's what most of the photos in these exercises show: how to teach heeling without a leash. That said, you can use a leash with all these techniques if you want, and if you do, exercise 20 shows how to eliminate the leash once your dog has learned to heel reliably.

A New Treat: String Cheese

String cheese makes an excellent treat for helping with heeling. First of all, most dogs love it. Second, when you hold a piece of string cheese between thumb and forefinger and then in front of your dog, she can simply nibble little pieces off the end. Since those pieces more or less melt in her mouth, she doesn't really have to chew them, and crumbs are unlikely to fall on the ground to distract her from heeling. All of which makes for more focused attention and tighter heeling.

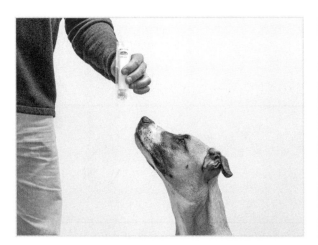
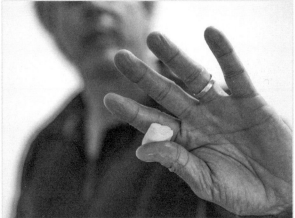

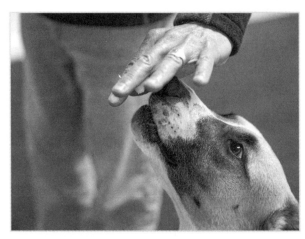

First Steps

Heeling is neither a stationary nor a moving command. It's a position relative to your body. And that position is in an imaginary box tightly against your left (or right) side. So if your dog is sitting nicely next to you as in the first image below, she's heeling. The trick is to keep her that tightly aligned through all manner of motion. And that's no easy feat.

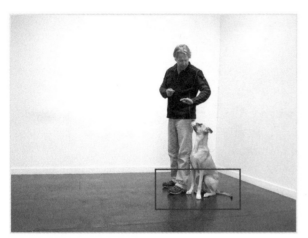

With your dog sitting on your left side, get her attention on your treat.

"Heel"

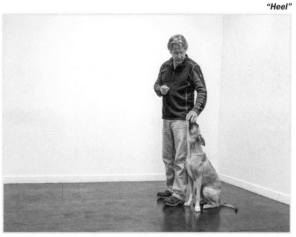

Put the treat right on her nose and half a second before taking your first step, say, "Heel." This gives your dog a moment to know you're about to walk and then to step in sync with you.

"Good heel"

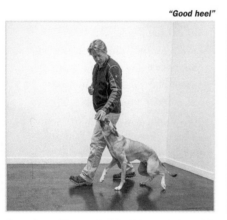

Step first with your left foot. Dogs take a lot of cues from our feet, so stepping off with the leg on the same side as your dog gives her an additional cue to start moving. As your dog moves with you, say, "Good heel."

"Good heel"

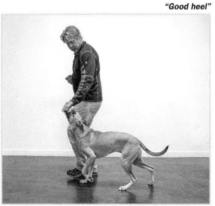

As you walk, let your dog take little nibbles on your treat and say, "Good heel." You want her to associate her position next to you with the word "heel."

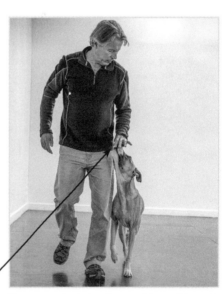

Keep your dog's head turned inward toward you as you walk.

Be sure in the beginning to keep the treat right on your dog's nose to help keep her connected with the exercise. You can thin this out fairly soon and teach her to focus on your hand rather than the treat. But start like this.

When heeling, right and left turns present some special challenges. In a perfect world, when your dog is heeling, she's supposed to be in an imaginary box just left of your left knee. That means that even when you make a turn, your dog should never leave that imaginary box. But when turning either right or left, your dog has to make speed adjustments in order to stay tight with you through the turn. Here's how to make right and left turns.

The Right Turn

Making a right-hand turn is a very short and tight move for you. All you have to do is quickly pivot on your feet and turn around. However, your dog, if she's going to stay in that imaginary box on your left-hand side, will need to speed into the turn in order not to fall out of position.

"Good heel"

Begin with your dog tightly focused on the treat in your hand. Say, "Good heel," as your positive marker.

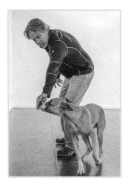

As you make your right turn, continue to lure her through it. If she's sufficiently motivated by the treat, she should be driving hard into the turn at this point.

As soon as your turn is completed, let your dog take two or three healthy bites off the string cheese or whatever you're using. You want your dog to associate a right-hand turn with an extra-large treat. This will help keep her focused and learn to cut the tightest possible turn with you.

⭐ Mix It Up and Change Pace

As you develop a heel routine that includes walking in a straight line and turns, add complexity by changing your pace. Remember, the challenge is to teach your dog to stay with you in an imaginary box on your left-hand side NO MATTER WHAT. So the minute you've got your routine down, begin changing your pace to challenge your dog. First, walk at a normal pace. Then, without much cue, slow down to a geriatric walk. Then shift to power-walk mode, and then back to normal. Mix it up and keep it challenging.

⭐ What If My Dog Falls Out of Position?

Up to this point in training, the emphasis is on positive reinforcement. However, if your dog falls out of position, use your negative marker, "ah-ah" (see "On Using Negative Markers," page 59). Then use your treat to lure her back to the proper spot. Perhaps adjust your pace and pattern to make it a bit easier, and practice more at that level before mixing things up and increasing the challenge.

The Left Turn

The left turn presents precisely the opposite problem of the right turn. In this case, in order for your dog to stay in that imaginary box on your left side, she needs to slow down in order to let you go around her.

"Good heel" "Good heel" "Good heel" "Good heel"

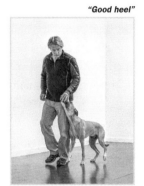 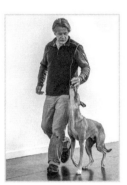 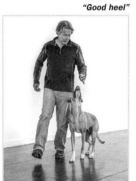 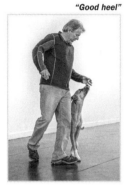 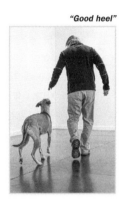

Begin with your dog in heel and tightly focused on the treat in your hand. Say, "Good heel."

As you approach your left turn, pull your treat up slightly (almost like a hand brake in a car). This will help slow down your dog; in time, this motion will cue her that a left turn is coming.

Once your dog has slowed down, begin your turn by stepping across the front of your dog with your right leg. She'll be able to see this coming, and this becomes another cue about the impending left turn.

Continue to move through the turn, keeping your dog tightly focused on the treat.

Through the entire exercise, talk to your dog and praise her with "good heel."

Finish in a Sit

When practicing heeling, always finish in a sit. To do this right, timing is key. You have to say "sit" *just before* you come to a halt. This will cue your dog that you're about to stop and enable her to do the same at precisely the same moment. If you miss this timing, your dog will always tend to sit slightly out of step and a little ahead of you.

"Sit" "Good sit"

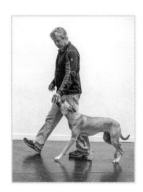 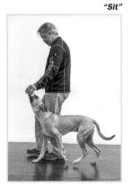 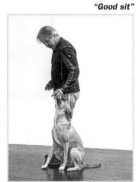

As you walk, make sure your dog is tightly focused on the treat.

Just before you come to a halt, say, "Sit," and pull your treat hand up and back over your dog's head, as if you were pulling the hand brake on a car.

As her rear end hits the ground, deliver the treat and praise with a "good sit."

⭐ **Note**

Heel is an exercise that has duration over time, so deliver the positive marker "good heel" repeatedly throughout the exercise, especially when delivering the treat.

Encouraging and praising your dog throughout this exercise is very important. Remember, you're demanding a very high level of attention from her. That means that you have to give quite a bit of attention yourself. Relationships are a two-way street, and this exercise has both transactional and relational components.

In other words, DO NOT be quiet and semi-engaged during this exercise or your dog will lose interest, and that'll be on you.

The next step in heeling is to reduce the reliance on treats. To do this, teach your dog to target the treat in your hand and maintain her focus there even when she's not able to continually pull off bits of the treat. You can also start closing your hand more and more until the treat is hidden in your fist. This forms a transitional point in which your dog targets your fist on the assumption that there's a treat. From there, you can move more effectively into a random schedule of reinforcement (see "Random Schedules of Reinforcement," page 23). In other words, start delivering treats at random intervals while also varying the size of the reward. Provide "jackpot" rewards at moments when your dog is doing well. This way you're reinforcing desirable behavior.

The sequence shown here is just an example; repeat this exercise as often as you like, and work on left turns, right turns, and changing your pace to keep it interesting and challenging for your dog. Also, use your best judgment to evaluate how often to reward her. If you're constantly losing her attention, use a better treat or increase the frequency of rewards, then later try spacing out the increments between rewards again.

In addition, if she's not doing well, such as by veering from your side in pursuit of something more interesting, say "ah-ah" as a negative marker, and then use your treat to get her attention and to refocus her on you.

In sit, get your dog's attention with the treat between your fingers.

Bring the treat up along your waist, and close it within your fist, while keeping her attention focused on it.

"Heel"

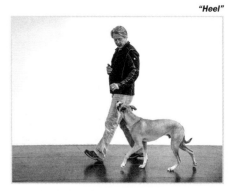

Say, "Heel," and begin walking, practicing the heel exercise as before. See how long you can walk and keep her focused during the heel. Remember, lure your dog through turns by bringing the treat closer to her nose.

"Good heel"

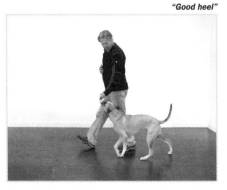

Periodically while heeling, reward your dog with a treat, all the while trying to extend the periods between rewards, but without losing your dog's focus during heeling. Keep reinforcing her attention on the treat while delivering treats randomly.

"Sit"

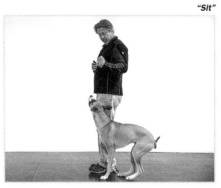

As always, finish in a sit...

"Good sit"

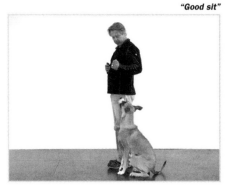

...and reward with a treat and a positive marker, saying, "Good sit."

Once your dog has learned to reliably target the treat without having to be constantly fed in order to keep her attention, move the treat to the opposite hand, which will remain largely tucked away on the other side of your body. As with exercise 10, "Hand Signals Stage 2: Giving the Treat from the Opposite Hand," the whole point is to get your dog to orient to your target hand while learning to expect her treats from elsewhere. With practice, this gets her to target your hand and follow it regardless of the presence of a treat. This will make it easier for you to help her maintain the proper position by simply guiding her, while also continuing to reduce your reliance on treats till you gradually fade them out. This is another important step in the transition from exercises to commands.

Treats here

No treats here

If you heel on the left, move the treats from your left hand to your right hand. If you heel on the right, vice versa.

During heeling, still hold out your target hand, now without treats, while keeping the opposite hand, which is holding treats, held back.

Switching Treat Hands During Heeling

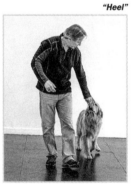
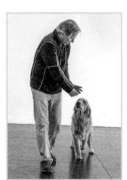
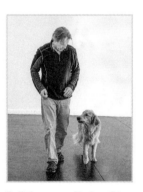
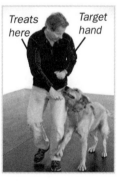

"Heel"

Treats here *Target hand*

Get your dog's attention with the treat in your target hand and say, "Heel," like usual.

As you start to walk, switch the treat from the target hand to the opposite hand.

Pull the opposite hand to the hip opposite to your dog. Continue heeling as before, and keep your dog's focus on your treatless target hand. Now, however, you can use the empty target hand to reach down and physically praise your dog for maintaining the proper position. If she starts to cross over to get the treats in your opposite hand, bump her back into position with your left leg.

At periodic intervals, reward your dog with a treat from the opposite side of your body.

Even as you give the treat, simultaneously work to keep her focused on your target hand, then continue heeling.

The Finished Product

Pretty soon it should start looking something like this.

"Heel" *"Good heel"* *"Heel"*

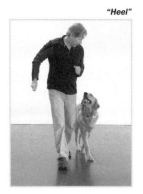
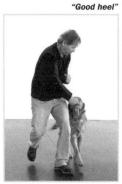
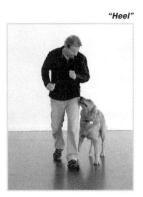

Once you've established the basic pattern, start adding turns. Keeping your dog's attention through a turn while also keeping her in the right spot in relation to you is one of the most difficult aspects of solid heeling.

The Left Turn

"Heel"

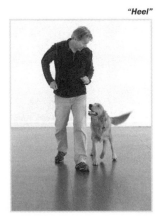
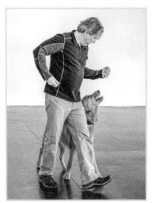
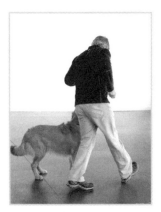
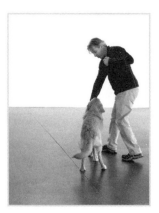

While heeling in a straight line, keep your dog's attention on the target hand and keep the treats in your opposite hand.

Maintain her attention on your target hand as you move into your left-hand turn.

As you finish your turn...

...reward from your right hand. Rinse and repeat.

The Right Turn

"Heel"

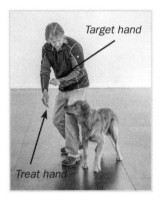
Target hand
Treat hand

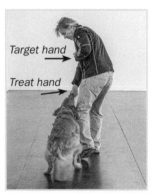
Target hand
Treat hand

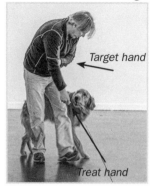
Reverse angle
Target hand
Treat hand

While heeling in a straight line, keep your dog's attention on the target hand and keep the treats in your opposite hand.	Maintain her attention on the target hand as you move into your right-hand turn…	…and as you finish the turn, reward with the treat from your right hand.	…reward from your right hand. Rinse and repeat.

If I introduce heeling in a more-challenging environment, such as outside or with potential distractions, then I usually keep the dog on a leash simply in order to keep her from running off and to reorient her back to the treat should she lose her focus. But once I've done a fair amount of work on this, including the exercises on the preceding pages, I begin fading the leash out. If up to now you have been using the leash to teach heeling, here is one neat trick for getting rid of the leash.

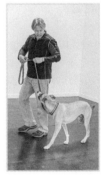
"Heel"

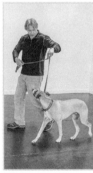
"Good heel"

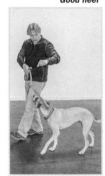
"Good heel"

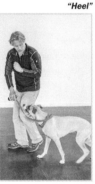
"Heel"

"Good heel"

"Good heel"

While heeling with your dog, hold the leash in your left hand, keeping it very loose.	As she's focused on you, lift the leash with your left hand…	…and begin to sling the leash around her neck as you walk. Use your voice and positive markers to keep her attention on you, so that what you're doing with the leash doesn't distract her.	After about three wraps, or when the leash is mostly around her neck…	…let go of the leash, all the while making sure to keep her attention on you.	You can keep her attention with treats, a ball, or simply verbal praise. It all depends on your dog and your training so far. If she drifts, then quickly grab the leash, reorient her to you, practice with her while holding the leash for a bit, and then try it again.

"Good heel"

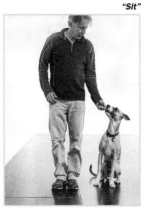

"Sit"

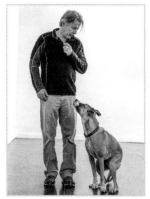

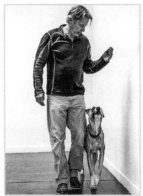

Here's the problem: You're walking along in a nice heel...

What you want is for your dog to stop at your side, like this.

...but when it's time to sit, your dog swings wide to get a better look at you.

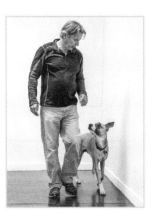

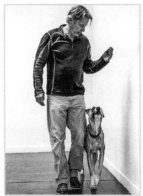

To fix this, end your heel while walking alongside a wall or any other barrier, such as a curb or a stop sign.

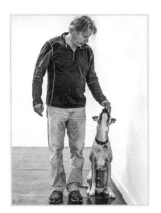

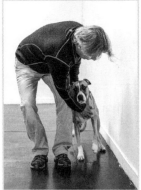

Blocked against the wall, your dog can't swing out wide and will sit properly. Deliver your treat...

...and lavish her with physical praise.

⭐ Using Multiple Motivators

Dogs, like people, can be motivated in various ways. The three most common positive motivators for dogs are treats, toys and games, and physical affection.

Everyone these days is familiar with the use of treats as a motivator, as most dogs will respond to them enthusiastically. However, do not overlook the power of toys, games, and physical affection when it comes to motivating your dog. For more on this, see part 6, "Using the Ball as a Motivator: The Basics." And if your dog is less than enthusiastic about treats, see "What If My Dog Isn't Interested in Treats?" (page 2).

For instance, in this sequence, I not only reward my dog with a treat; I take the time to bend down and give some lavish physical affection.

DO THIS OFTEN! Physical praise and affection are enormously powerful motivators. This may seem obvious, but particularly when people use clickers as secondary reinforcers (see "A Note about Clicker Training," page 18), they can overlook the bonding or relational dimension of reward-based training.

Introducing heeling with small dogs can present some special challenges due to the fact that it's very uncomfortable to bend over so far in order to lure them along with a treat. This is where it's really important to use a killer treat to help your dog target it and maintain her focus while moving. Also, you'll have to alternate between reaching down and sticking your treat right in your dog's face to refocus her and then bringing it back up to your waist in order to help her learn to target the treat. If this gets tedious or painful, try the peanut-butter-on-the-spoon trick, described next.

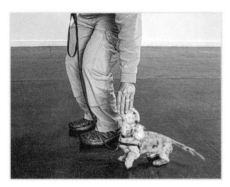

Before starting your heel, focus your dog on the treat in your target hand.

"Heel"

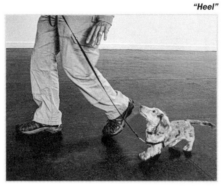

Once you've got her focus, pull the treat up to your waist, maintaining your dog's attention, and say, "Heel." This teaches her to target your treat throughout the heel exercise. Maintain her focus as you walk.

"Good heel"

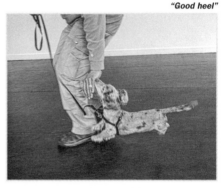

At any point, feel free to deliver a treat and say, "Good heel," to help maintain her enthusiasm. If you're upbeat and animated, there's a good chance your dog will be also. This one went airborne with enthusiasm during our photo shoot.

"Sit"

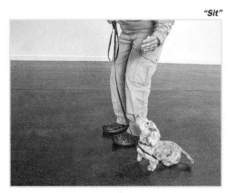

As you get ready to stop, maintain your dog's attention on the treat and pull it back over her head while saying, "Sit."

"Good sit"

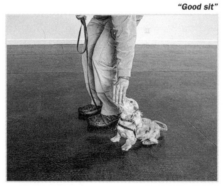

The moment she's hit the sit, say, "Good sit," and deliver the treat.

During turns, maintain her focus as in previous exercises. Often, this means bending down to deliver a treat as you move through the turn. In this picture, I'm halfway between having just put the treat on the dog's nose and pulling it up to my waist again.

The Peanut-Butter-on-the-Spoon Trick

Bending over to teach a small dog to heel can get really old really fast, especially if you're very tall or have back or mobility issues. Here's an old-school trick to help introduce heeling to small dogs. All you need is some peanut butter, a cooking spoon, and a sense of humor. Once you've done this a while, you should be able to have your dog target the treat, as in the previous exercise.

Start with some peanut butter on a long spoon.

"Heel"

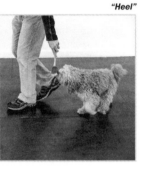

Then simply lure your dog with the peanut butter in precisely the same way as with a larger dog. Get her focus and say, "Heel," as you start walking.

"Sit"

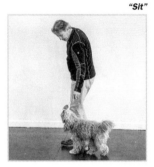

Before you stop, bring the spoon back over your dog's head and say, "Sit."

"Good sit"

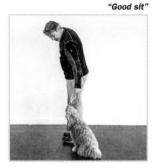

Then the moment she sits, give the reward, and say, "Good sit."

Once you've established your basic heeling routine, there's a twist you can add to your heeling practice that will come in handy later when you introduce off-leash distance control (such as for exercise 63, "Distance Downs and Emergency Stops"). Essentially, you want your dog to learn to drop straight into a down out of the heel position rather than simply sitting. This can sometimes be tough to introduce because most dogs have practiced sit from walking so many times that it's simply second nature.

"Good heel"

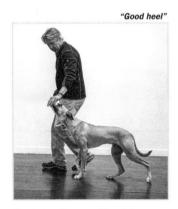

Begin heeling, and heel for some time, incorporating turns and changes of pace as usual. At random intervals, also add down out of motion, as follows.

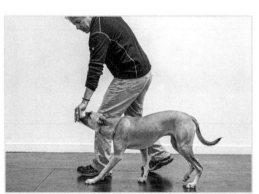

Keep the treat firmly fixed on your dog's nose and drive your hand straight to the ground. Be sure NOT to move your hand away from your dog's nose. You want to lure her all the way to the ground and target the area just between her feet.

"Down"

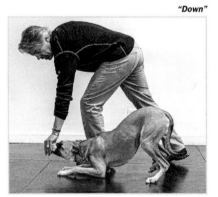

As you do this, say, "Down." DO NOT pull the treat out in front of her, which will generally cause her to walk forward. When you target the area between the feet, your dog will tend to stop and drop.

When your dog is down, say, "Good down," and place the treat on the ground between your dog's feet, so she orients to the ground for the treat. As before, DO NOT deliver the treat from your hand!

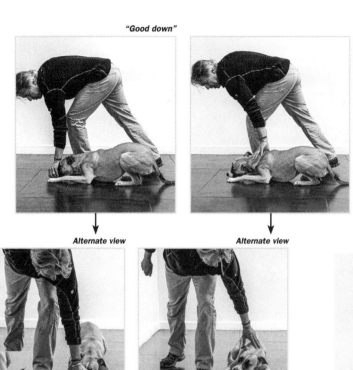

"Good down"

Alternate view *Alternate view*

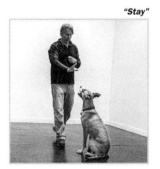

Finally, add physical praise and affection as multiple motivators to help drive your dog and keep her connected with you.

⭐ Note

From this down, if you like, you can also transition immediately into a stay (see part 5). This will set up the sequence for your emergency stops and distance downs.

Heeling is a position relative to your body, and this series of exercises is designed to help your dog understand this. Before being able to do this, however, your dog must already know stay (see part 5), so teach that first. For more on the recommended order of training exercises, see "Session Plan" at the end of the book.

Heeling from Various Angles

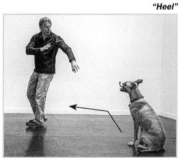

"Stay" *"Heel"* *"Good heel"*

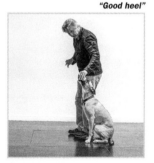

Begin by saying, "Stay," and back away from your dog.

Once you are some distance away, turn your back to her and say, "Heel." Guide her in with a treat at an angle that will make it easy for her to slip into position next to you.

Finish by saying, "Good heel," rather than "sit." At this point, you are trying to merge the two concepts together.

Work this from varying angles. This makes it increasingly easy for your dog to learn to target that imaginary box on your left-hand side as the heel position, regardless of whether you're moving or stationary.

"Stay"

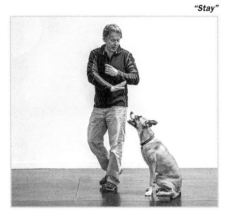

Begin with a stay and back away from your dog.

"Stay"

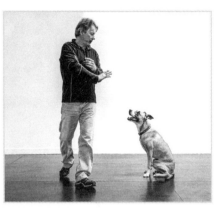

Keep your stay hand signal up…

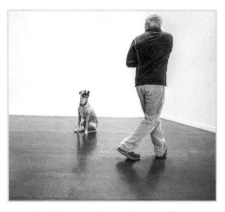

…and walk around your dog at different angles.

"Heel"

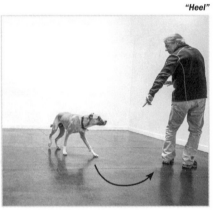

"Good heel"

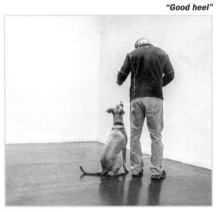

At random intervals, say, "Heel," and guide your dog to you with a treat.

"Stay"

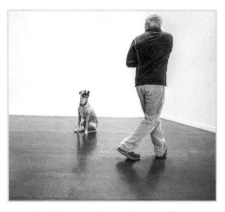

Rinse and repeat. Be creative and make it increasingly challenging for your dog.

"Heel"

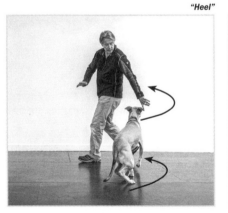

"Heel"

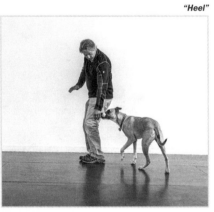

"Good heel"

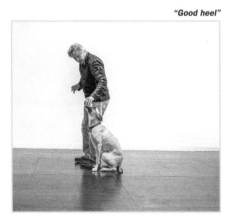

One very effective version of teaching your dog to come to heel from different positions is the "fancy finish." While fancy finishes are not a "must-have" exercise, they are cool. And I think cool counts.

That's not to say that fancy finishes have no useful function. They're great for maneuvering your dog into a ready-to-work position next to you in tight spaces, such as busy streets, shopping malls, and airports.

Fancy finishes can be done to the left and the right.

Please note that additional exercises to help troubleshoot and improve the fancy finishes can be found on my website at www.doggonegood.org/book-bonus. In particular, these exercises will show you how to use a leash to help teach the fancy finish to dogs who stall out as you try to get them to go behind you. They also include tips for eliminating treats from the routines.

Fancy Finish to the Left

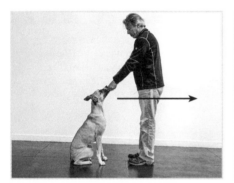

With your dog in a sit in front of you, get her attention with a treat.

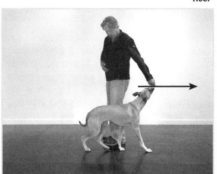

"Heel"

Keeping the treat close to her nose, say, "Heel," and lure her in a straight line behind you. Pull the treat ahead of her slowly or you might lose her connection to the treat. DO NOT be in a hurry. Form, not speed, is the most important element.

Lure your dog back until her rear end is behind your knee. Sometimes, especially with larger dogs, you may have to lure your dog all the way behind your rear end in order to get her rear end behind your knee, but this is essential. Then pull the treat to the inside and forward.

Keep her focused as you turn her inward toward you.

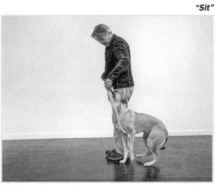

"Sit"

"Good sit"

As she turns forward, continue to keep your treat very close to her nose until her shoulder blades are more or less in alignment with your knee. At this point, bring your treat back over her head and lure her back into a sit.

Troubleshooting: The Step Back to the Left

In the beginning, some dogs will stall halfway through this fancy finish and simply return to a sit as they follow the treat. If you're having this problem, try this step-back technique. However, this is just a transition. Once your dog can complete the exercise this way, eliminate the step backward and practice the fancy finish to the left as shown above.

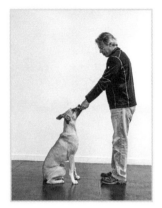

With your dog in a sit in front of you, get her attention with a treat.

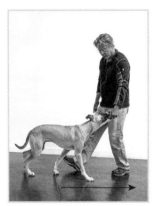

As before, lure your dog straight back behind you, while also taking a step backward with your left leg — or the leg on the same side as your dog. Keep your right (or front) foot firmly planted in place.

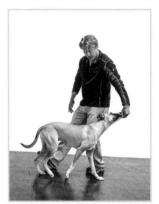

Be sure not to move too quickly. Keep your dog tightly focused on the treat in your hand. If you let too much space come between your treat and your dog's nose, you are likely to lose her attention.

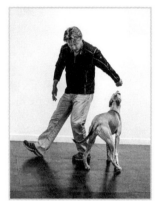

Also, DO NOT take more than one step backward. Instead, as your dog's rear end moves behind your left knee, guide the treat inside and forward...

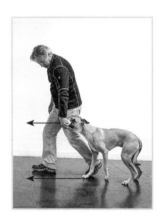

...and step forward with your left leg, luring your dog forward at the same time.

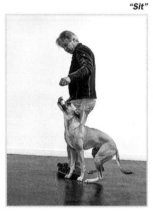

"Sit"

Once your feet are together, pull the treat over your dog's head and say, "Sit."

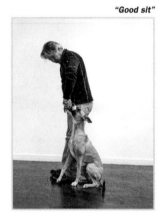

"Good sit"

Fancy Finish to the Right

The fancy finish to the right is possibly even cooler than the first. Your dog circles you, swinging around the *opposite* side from where she ends up. If you're heeling on the left, that means she'll swing around your right side, go behind you, and slide into a sit in the heel position on your left side. If you heel to the right, simply reverse this.

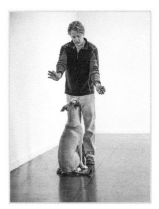

Place a single treat in your right hand, which you'll use to initially lure your dog, and place a few treats in your left hand, which you'll use to finish luring her into a heel on the left-hand side.

"Heel"

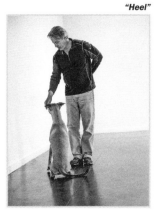

Hide your left hand behind your back, have your dog target the right hand, and say, "Heel."

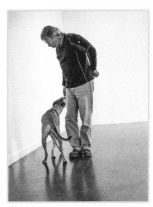

Keep the treat close to her nose to maintain your dog's attention, and lure her behind you.

Reverse angle

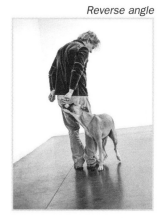

Here's the tricky part: As your dog's head reaches about midway behind you, switch her attention from the right hand to the left hand.

Reverse angle

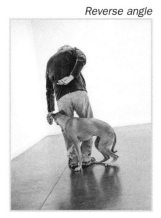

Then keep luring her around to the left with the left hand in order to complete the exercise.

"Sit"

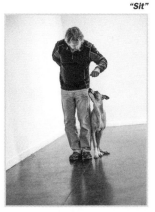

Once your dog reaches the left side, pull the treat above her head and say, "Sit."

"Good sit"

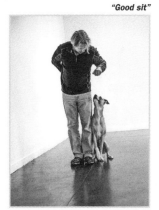

Troubleshooting: The Step Back to the Right

If you have the same problem with the fancy finish to the right — your dog stalls and sits halfway through — you can fix it using the same step-back technique.

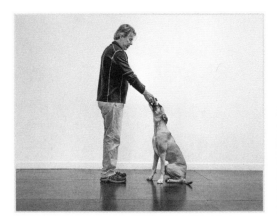

As before, start by having your dog target your right hand.

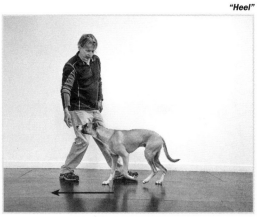

"Heel"

Say, "Heel," and as you lure her behind, take one step back with your right foot.

Behind your back, switch her attention from your right hand to your left hand.

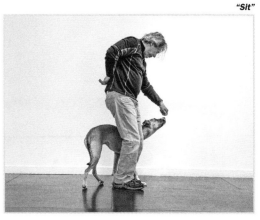

"Sit"

As you lure her forward on your left side, step forward with your right foot, and say, "Sit."

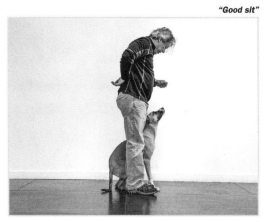

"Good sit"

Pull the treat above her head, and as she sits, say, "Good sit," and give her the reward.

When it's time to teach recalls in my level-one puppy classes, I get everyone's attention and say: "Now I'm going to tell you three fantastic ways of teaching your pup …" — insert pregnant pause — "… never to come to you."

Of course, everyone laughs and looks puzzled. But without meaning to, new owners screw up recalls for their dogs all the time.

The most common mistake is to call your dog to come to you to do something that your dog doesn't like — clipping their nails, giving them a bath, putting them in their crate, taking a favorite toy away, and so on. Do this and your dog will figure out in no time that coming to you is no fun for her.

Of course, we all need to do things to our dogs that they may not like. When those times come, don't call your dog; go and get your dog. The most common objection to this recommendation usually comes from young puppy owners, who complain that their pup runs off when they try to get them. If this happens to you, I suggest keeping your puppy on a leash in the house until you no longer have this issue. This simple solution is incredibly effective, and it has enormous additional positive impacts on your relationship with your dog. Not only does it keep your dog from getting into trouble, but it teaches her early on that she must primarily orient to you rather than to her own impulses when deciding what to do. Imprinting this early in your relationship is one of the most positive things you can do to help build a deep relationship.

The second way of screwing up recalls for your dog is calling her in order to reprimand her "over here" for something she did "over there." Again, your dog is not stupid. If you call and she comes and gets yelled at — then she won't do that again.

The third fantastic way to make sure that your dog won't come when called is to repeat the word "come" over and over and over despite the fact that she isn't responding. Keep repeating words to which you're trying to attach meaning — like "sit," "down," and "come" — and your dog will quickly throw those words in with all the rest of the irrelevant noise she hears coming out of your mouth all day long. People do this all the time.

So DON'T DO THIS!

As with every new exercise, when introducing recalls, start with simple baby steps. Most of all, in the beginning, make coming to you an awesome experience for your dog. As she comes toward you, go wild with enthusiasm (see sidebar on page 53) and give her killer treats she can't resist (see sidebar below). In addition, reinforce the command watch (which you first introduce when teaching sit in exercise 1), and in the middle of all the fun, briefly grab her collar (see sidebar on page 53), so she gets used to this as a natural gesture.

What shouldn't you do when introducing and practicing recalls? Don't run your dog through a series of sits, downs, stands, or other drills after she arrives. Just ask her to sit and to watch, and then let her go right back to what she was doing.

Of course, this can and will change down the road (such as when later exercises bulletproof recalls), but not yet.

"Teddy, come"

"Yay, good girl, yay!"

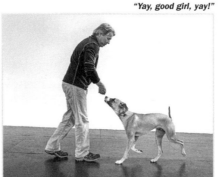

"Sit"

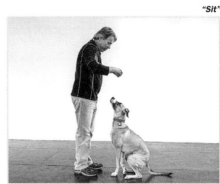

At a random moment, when your dog is simply wandering, get her attention with a treat; say her name and "come." Stick the treat right on her nose to get her attention; be obvious and make it easy to succeed. Once you've got her attention, back up and have her come to you.

While your dog is coming to you, be sure to voice lots of *enthusiastic* praise (but don't repeat the word "come").

Once she's in front of you, bring the treat over her head and say, "Sit."

⭐ Use Killer Treats

When introducing recalls, use the most delicious treats possible. Don't be afraid to use grilled chicken, roast beef, steak, cheese, or whatever your dog finds irresistible (that is, if regular high-value dog treats such as freeze-dried liver don't do the trick). Why? Because you want to set your dog up to succeed by making it impossible for her to fail.

Stick these treats right on your dog's nose in order to get her attention and bring her to you. If she's not interested in your treat, get a better treat. If that still doesn't do the trick, don't feed her breakfast and then try it. Hungry dogs always work better.

DO NOT try to make the exercise difficult by adding distance and distractions, at least not yet. Make recalls very easy at first. Reliable recalls take a relatively long time and multiple levels of training to develop (which we'll cover in the pages ahead). Do not be in a hurry! At this point you want to do everything you can to teach your dog that recalls are a massive plus for them with zero downside.

Remember, you won't always have to shower your dog with treats, but in the beginning, it's the best way to quickly generate your dog's enthusiasm and understanding of this extremely important behavior.

"Watch"

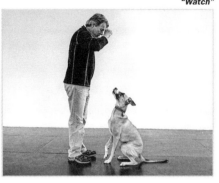

Grab the collar

Give the treat

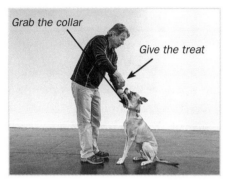

"Go play"

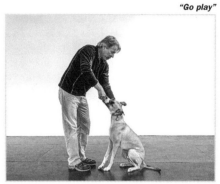

Once she sits, bring the treat up to your forehead and say, "Watch."

Once she's looked at the treat on your forehead, give it to her while simultaneously grabbing her collar (see sidebar below).

Once she's taken the treat, release the collar, tell her, "Go play," and let her go.

★ Be Enthusiastic WHILE Your Dog Is Coming to You

One of the most important elements of a good recall is to voice enthusiastic, high-pitched praise WHILE your dog is coming. Don't wait until after she's come. When she arrives, say, "Good come," as a positive marker and reward her with yummy treats. This is key, and many novice owners overlook this. Your enthusiasm energizes her and helps her stay focused on you in the midst of many other distractions.

★ Why Grab the Collar?

Many dogs learn that, when you try to grab their collar, it means you are going to put their leash back on and leave the park. Since leashing will end their fun, they dodge and weave to avoid your hand as it reaches for the collar.

However, you can avoid or undo this when practicing recalls. If every time your dog comes to you, you give her a special treat and also grab her collar for just a second or so, she'll quickly begin ignoring that move. Why? Because she'll come to associate it most of the time with getting a treat, which has no downside for her. And she'll learn to ignore it. Then, when you do occasionally grab her collar to leash her, that becomes an unexpected anomaly, rather than a gesture she's learned to anticipate and avoid.

It won't take long for your dog to learn that, when she hears "come" and runs over to you, she'll receive a treat. The next step is to practice come when she's playing with other dogs. Try this at your local dog park or with some dogs of friends and family. If you have trouble, practice in less-challenging environments, or among fewer other dogs, and see the sidebar "Recall Games with Friends and Family" (below) for fun ways to practice with others that will help improve recalls significantly.

"Teddy, come"

"Watch"

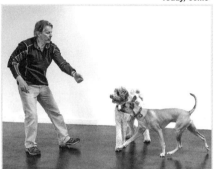

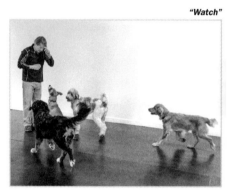

When your dog is among other dogs, get her attention on the treat and call her to you. Don't be shy. If you have to, stick the treat right on her nose until she targets it and follows you. Ignore the other dogs, even if they show interest in your treat. Stay focused on your dog to help her to stay focused on you.

As your dog follows, back away and see how long you can keep her attention. It's okay to repeat the word "come" to remind her of what you want. Repeating the word at this stage is fine because it's still an "exercise" rather than a "command."

Eventually, stop moving, lure her into a sit, and ask her to watch.

⭐ Recall Games with Friends and Family

Here are several fun ways to practice recalls with a little help from your friends and family.

One of these is "Back-and-Forth Recalls" (exercise 59): Stand in a circle with three or more people and take turns calling your dog round-robin style at random intervals so she can't tell who's going to call her next. For all of these games, each time your dog arrives at a person, they should give praise and a treat.

With only two people, call your dog back and forth. However, as she figures out the pattern, she might start running back and forth without actually responding to "come." In that case, when your dog turns without being called, the person she's running away from should call her back and keep encouraging her with enthusiastic praise until she returns. This helps to teach that "come" means turn away from what you're doing and return to the person who called you.

Also practice this whenever your dog is playing with other dogs. Stand on the edges of the play group and call your dog back and forth through the group of dogs. This helps develop the understanding that "come" means ignore everything else and return to me.

You can also vary the circular, round robin–style recall game in several ways. First, after the game is established, start spreading out. After each person calls your dog, they should move backward or to a new spot after your dog is called to someone else. Pretty soon, the small circle that you started with will become a pretty big one. From there, people can start hiding behind things or around corners, and this will quickly become a fun game of hide-and-seek.

Give these exercises a try and invent your own. They are fun, easy ways to practice recalls.

When she does, give the treat while grabbing her collar, and then release her to go play.

Note

If lots of other dogs trail along with your dog and are also interested in your treat, your dog might get jostled and have a tough time sitting and watching. In that case, dispense with the sit-watch combo and simply give her the treat. The come is the main event. Don't miss your opportunity to reward her for it because you couldn't get the sit-watch.

Another fun way to work with recalls is to run them together with fancy finishes (see exercise 25). As with fancy finishes themselves, this exercise isn't necessary, but the "cool" factor makes it worthwhile practicing.

That said, only practice this exercise once your dog has a decent command of stay (see part 5); otherwise, this might undermine the solidity of your stay command. For more on the suggested order for introducing these exercises, see "Session Plan" at the end of the book.

Fancy Finish to the Left

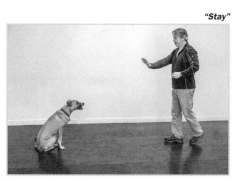

"Stay" — Begin with your dog in a stay.

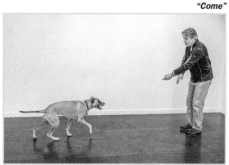

"Come" — Call her by saying, "Come."

Bring her around into the fancy finish…

…and reward with a treat.

Fancy Finish to the Right

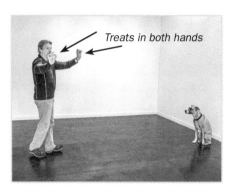

Treats in both hands

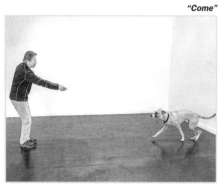

"Come"

Begin with your dog in a stay and treats in both hands.

Call her by saying, "Come," so she targets the right hand.

Bring her around into the fancy finish…

Keep her focused as you turn her inward toward you.

…and reward with a treat.

Throughout this book, I've noted the difference between "exercises" and "commands" as well as between transactional and relational training. The stay command forms a bridge between both of these.

It's the first place where you introduce a little bit of compulsion to physically demand the behavior and to introduce the notion — albeit gently — that "you must."

Learning the stay command is tricky at first, so expect your dog to blow it, and bear in mind that making mistakes is a hugely important part of learning. In fact, before blowing the stay and being "corrected," your dog is not really learning stay. She is just lying there getting fed. Only by correcting her mistakes do you teach her what you're looking for. In other words, correction is part of the process, so DO NOT get frustrated. Practice using a "negative marker" (see "On Using Negative Markers," page 59) to indicate your disapproval and improve communication.

Remember to set your dog up for success by making each step as easy as possible. Celebrate every little victory and build on it. Trust me, they'll add up, and they'll do so way faster if you take your time building your routines in little increments and slowly extending them rather than going too far too fast and always blowing it. This undermines both your dog's and your own confidence.

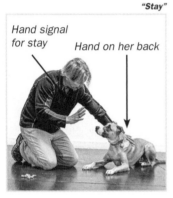

With your dog in down, kneel next to her with a nice pile of treats within easy reach. Rest one hand on her back, show her the hand signal for stay, and say, "Stay."

DO NOT apply downward pressure with the hand on her back. The main point is to prevent her from rising, not pressing her down. Next, reach for a treat...

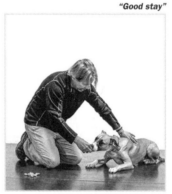

...and deliver the treat while saying, "Good stay."

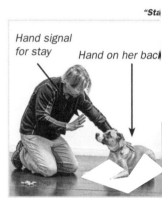

After delivering the treat, show her the stay hand signal and repeat, "Stay."

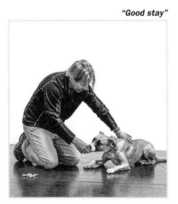

Without waiting very long, deliver another treat, and repeat this procedure a number of times. Slowly spread out the increments of time between treats so she must hold the stay position a bit longer.

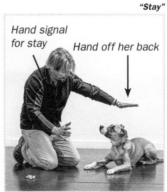

Eventually, your dog will "stabilize" and settle into a relaxed position. At this point, remove the hand on her back.

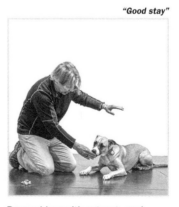

Reward her with a treat, and repeat the same procedure, but while keeping your hand off her back. Again, slowly stretch out the time between treats.

Correcting Mistakes

The "mistake" your dog will make is getting up out of down, which provides the opportunity to teach the real lesson: When told to "stay," your dog must learn to hold her position. As you progress, and your dog gets better at holding her stay, you might try distracting your dog by tossing a few treats onto the floor in order to tempt her to get up. Remember, she's not learning to stay until she's blown it and is corrected for it.

"Ah-ah"

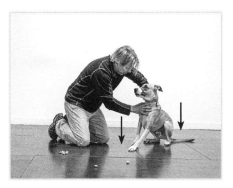

"Good stay"

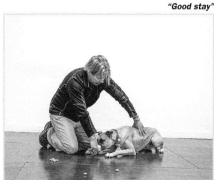

When your dog begins to get up, immediately respond by saying, "Ah-ah," as a negative marker. Speak with emphasis and urgency, but not anger.

Simultaneously, physically grab her and *quickly* place her back into her down-stay position.

Once she's settled, continue practicing stay as before.

✪ On Using Negative Markers

You use positive markers to help your dog understand when she's done something right, and this also signals that some kind of reward is on the way.

In the same vein, a negative marker helps your dog understand when she's made a mistake. When done at the precise moment that the unwanted behavior occurs, it gives her an opportunity, not only to understand what the mistake is, but to quickly adjust herself accordingly.

The most common negative marker is voicing "ah-ah" in a tone of urgency, but not anger. Choose one sound or word that you use consistently each time. The goal is simply to break the flow of your dog's attention away from whatever has distracted her and led her to blow it. This gives her the chance to refocus on you and hopefully correct herself on her own.

Of course, if she doesn't, you have to correct her. Please note that correction *does not imply painful physical punishment!* It simply means quickly resetting your dog so she can start over with whatever behavior you're working on.

Moving Away from a Down-Stay

Eventually, after being corrected a few times, your dog will understand what "stay" means. Then you're ready to take the next step — standing up and moving away from her.

As you do, it's very important NOT to have a treat in your signal hand. This is true for stays in all positions: down, sit, or stand. Holding a treat in your signal hand is very confusing for your dog since she will think you're luring her toward you. After all, that is how you use a treat in just about every other exercise. Instead, as you move away, keep the treat behind your back in your opposite hand, and when you want to reward her, bring it out and give it quickly.

Repeat this "moving away" exercise several times, and when you're ready to be finished, give your dog a release command (like "take a break") that lets her know the exercise is over, or else transition into another routine. However, in the beginning, DO NOT practice recalls out of stay (see sidebar below).

"Stay"

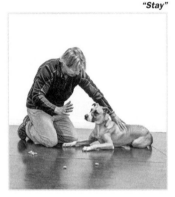

Settle your dog into the stay and get up on your knees.

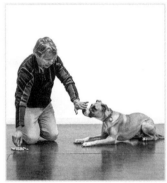

As you keep working with her, begin getting up.

"Good stay"

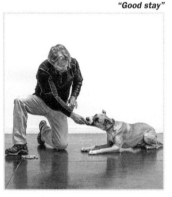

Then, as you hand her a treat, raise one knee. Do both moves simultaneously. If your dog is busy taking her treat, she will be less distracted by your leg moving.

✪ Don't Recall Your Dog from Stay — Yet

One of the most common mistakes when teaching stay is calling your dog to come when you're finished. DON'T DO THAT.

Think about it. If you recall your dog out of a stay, and she comes to you and receives a reward, what's she being rewarded for? Coming or staying? Coming, of course. So what happened to the stay? It becomes a mere waypoint to the recall and is no longer your dog's primary focus.

Also, dogs are master pattern recognizers. Repeat a pattern five or six times, and your dog will expect it. Soon, when you put her in a stay and walk away, she'll get ready to sprint to you in anticipation of the recall. But you want your dog to focus on remaining settled in her stay no matter what else happens.

Only much later, when stays are really solid, should you begin calling your dog out of her stays, and even then, keep it random and occasional.

"Stay"

Treat behind your back

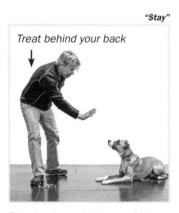

Then begin getting up, making sure to place a few treats in the non-hand-signal hand and hiding them behind your back. Keep the stay hand signal in front of her face while doing this.

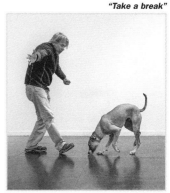

"Good stay"

ce up, reward with a treat
m your opposite hand behind
ur back.

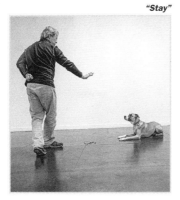

"Stay"

Rinse and repeat: Practice
several times by slowly backing
farther away from your dog and
changing your angles…

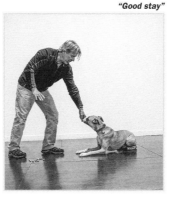

"Good stay"

…while periodically stepping
forward to reward her from your
opposite hand.

When you're through with the
exercise, give your dog a release
command so she knows the
exercise is over.

"Take a break"

Approaching the sit-stay in many ways mirrors the down-stay. You begin by placing your dog in the position you want, reinforcing with treats and introducing mild corrections to demand the behavior and help your dog understand what you're looking for. In this case, I suggest starting the exercise using a leash, so you can intervene when your dog blows it and quickly reset her (see "Correcting Mistakes: Using the Leash," which follows). Remember, expect your dog to blow it at first, but this is part of the learning process.

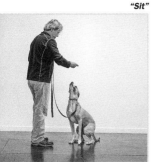

"Sit"

sk your dog to sit.

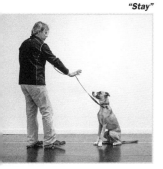

"Stay"

nse and repeat numerous times,
hile adding distance and changing
gles as you do with down-stay.

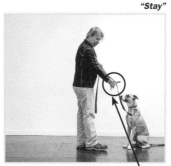

"Stay"

Then run your leash
between your thumb and
forefinger on your signal hand
and ask for stay. This gives
you a fulcrum point that you
can use to stop your dog if she
blows it and needs correction.

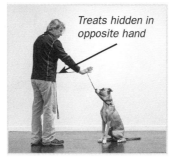

Treats hidden in
opposite hand

Keep some treats in the opposite
hand, which holds the end of the
leash, and back away a bit.

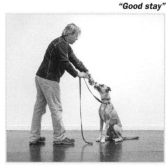

"Good stay"

As your dog stabilizes in the
stay, deliver the treats from your
opposite hand. Dropping the end
of the leash makes this easier.

Correcting Mistakes: Using the Leash

"Ah-ah"

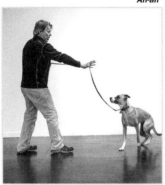

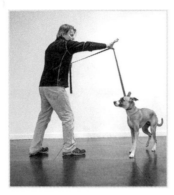

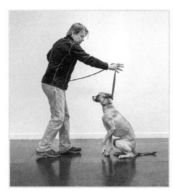

"Take a brea

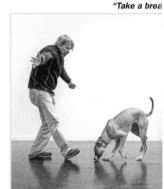

| As your dog breaks her stay, issue a negative marker: "Ah-ah." | Pull up on the leash with your signal hand as a fulcrum point. DO NOT YANK! Simply cinch up quickly… | …and return your dog to her sit-stay. | Then resume practicing, and when you're done, release your dog. |

✪ Can You Reprimand Your Dog for Thinking about Blowing It?

Yes! That's the whole point of negative markers.

These corrections use negative markers in conjunction with some physical response, such as pulling up on the leash or body blocking to reset your dog and help her understand when she's made a mistake. For more on these techniques, see "Do Not Yank!" (page 85) and "On Body Blocking" (page 63).

It won't take your dog long to associate the negative marker with the interruption and the need to reset or correct a mistake. As this happens, you can simply issue a negative marker without any physical response, *even if you're not right next to your dog*, and she will understand she's made a mistake. Then, she will often fix it herself with no further action on your part. This is why negative markers are so important and helpful. They accelerate both understanding *and the elimination of any physical responses to mistakes.*

Correcting Mistakes: Starting in a Corner

If you're having trouble getting your dog to sit-stay, an old trick is to start her in a corner. That way her escape routes are limited, and the only way she can break her stay is straight toward you. This uses a body block (see sidebar), which you'll use more in later exercises.

"Stay"

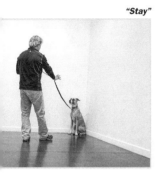

"Ah-ah"

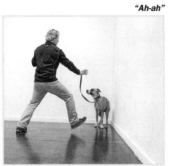

"Sit"

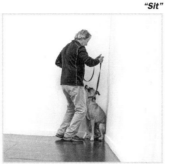

"Stay"

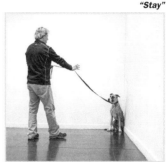

...ve your dog sit in a corner, ...y, "Stay," and back away a bit.

As she breaks her sit-stay, say, "Ah-ah," as a negative marker, simultaneously stepping toward her.

Hustle her back into the corner and reset her sit. Notice that there is little to no physical contact.

Then start over practicing the sit-stay...

"Good stay"

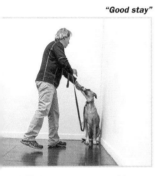

...and if she stays, reward her ...ickly with treats from your ...posite hand.

⊛ On Body Blocking

Body blocking is a way to interrupt your dog without using force and return her to whatever position she was in before blowing an exercise. You simply interpose your body abruptly between your dog and wherever she's decided to go. This startles her and refocuses her on you, at which point you reset her into whatever it is that you were working on. Ideally, this involves no or very little physical contact.

Body blocks are a form of "aversive control," and you want to align the intensity of your response to the sensitivity of your dog. Remember, the goal is to startle, interrupt, and refocus your dog, not scare the daylights out of her.

Once your dog has a solid grasp of the basic concept that "stay" means "don't move," you can begin adding complexity. One challenge is teaching your dog to hold her stay and not turn her body to follow you as you move in a circle around her. Another issue is teaching your dog not to pop up as you step over her. Here are exercises for both sit-stay and down-stay.

Circling in Sit-Stay

At this point, your dog should have enough experience with stay that you shouldn't have to keep chanting the word "stay." Your hand signal should become a visual reference point to your command, and as you circle, minimize your verbal instructions. This is also part of the transition from exercises to commands.

"Stay"

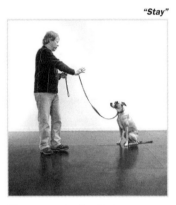

Place your dog in sit-stay.

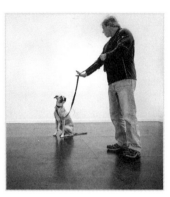

Begin circling around her, being sure to keep your hand signal up, so it is firmly and easily recognizable to your dog, and avoid chanting "stay."

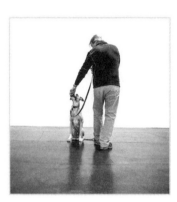

Deliver your first treat from an angle off to her side. Be sure to keep a few extra treats tucked into your palm.

"Good st..

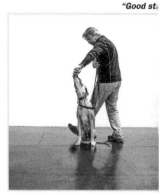

After delivering the treat for the stay, slide another forward and put it on her nose, *keeping it there without delivering it as yo.. move around her.*

"Stay"

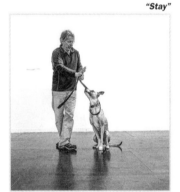

Deliver the treat as you come around her back and slide to the other side, then remind her that she's still in stay by saying, "Stay," and showing the hand signal.

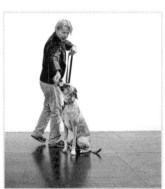

Then repeat the procedure in reverse.

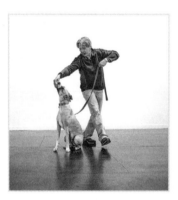

Keep the treat on her nose as you circle around her in the opposite direction.

"Sta..

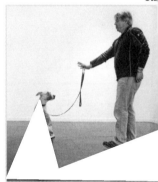

As before, when you return to the front, deliver the treat and remind her to remain in stay.

Circling in Down-Stay

This exercise is similar to circling in sit-stay, but it adds another layer of difficulty by also stepping over your dog. If you have trouble with your dog popping up, see "Correcting Mistakes: Step on the Leash," below.

"Stay"

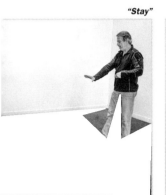

gin with your dog in a down-
ay.

"Good stay"

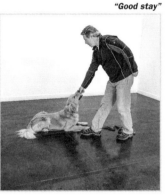

Deliver your treat and say, "Good stay." As when circling in sit-stay, immediately place another treat on your dog's nose to help keep her focus.

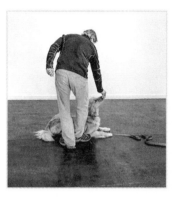

To keep her focused on the treat, let her bite little pieces off through the most difficult part of the exercise — as you step over her back.

"Good stay"

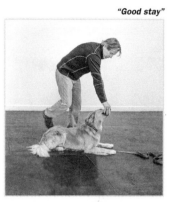

When you're fully on the other side of her, deliver the treat and say, "Good stay."

Hand signal only

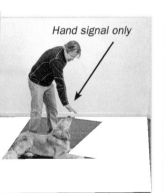

ter a few iterations of this,
move the treat from your hand
d simply put the hand signal
r stay in her face to remind her
at she's still on a stay. Repeat
is exercise multiple times until
ur dog has visibly relaxed and
ttled into it.

"Stay"

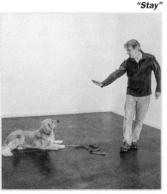

Then, instead of stepping over your dog's back, walk around her in ever-increasing circles.

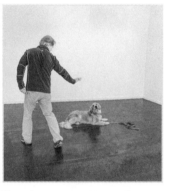

Note that you want to continue to thin out how often you say, "Stay," teaching her to increasingly rely on your hand signal for cues about what's expected.

"Good stay"

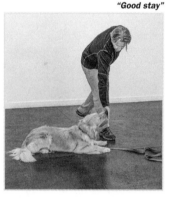

End every successful circle with more treats and a positive marker.

Correcting Mistakes: Step on the Leash

There are times when, even though you've practiced plenty, your dog will still pop up out of the down-stay when you try to step over her back. Here's a little trick to deal with that, which can also be used when stepping over in a sit-stay (next).

This is similar to the "foot on the leash" exercise to demand downs (see exercise 41), which you might practice first. Please bear in mind that this does NOT call for any kind of yanking or slamming your dog to the ground. Not only might this kick in your dog's "opposition reflex," but it might panic her, interrupting her ability to think. Both would set you back significantly.

"Stay"

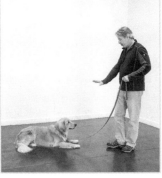

Begin with your dog in a down-stay.

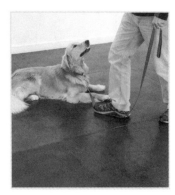

Set the leash off to one side of your dog and step on it. At the same time, focus her on the treat.

"Ah-ah"

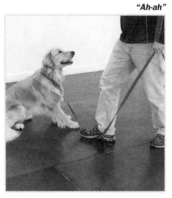

If she gets up, she'll immediately get caught by the leash, which will exert some downward pressure on her. Also issue your negative marker, "Ah-ah."

Ideally, both the leash and negative marker will cause her to quickly sink back into a down.

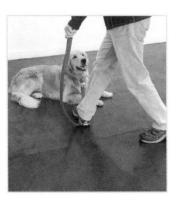

Once she's back down, with your foot still on the leash…

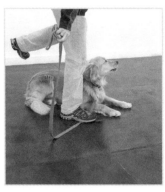

…continue stepping over and around her.

"Good stay"

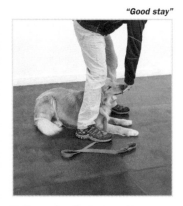

Deliver a treat when you're squarely above her.

"St…

As you finish stepping over, present the hand signal for stay. Repeat until your dog has caught on.

Stepping Over in Sit-Stay

Here is how to adapt the same exercise to a sit-stay. As with the down-stay, you can drop the leash and continue the exercise by going around your dog in ever-increasing circles.

"Stay"

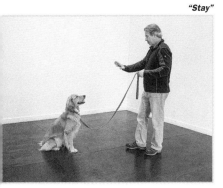

With your dog in stay…

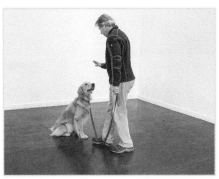

…step on the leash…

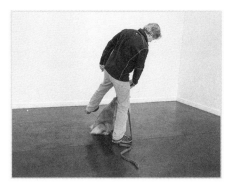

…and step over your dog.

"Good stay"

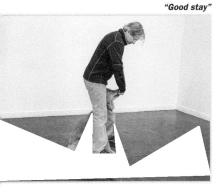

When you're squarely over your dog's back, deliver a treat.

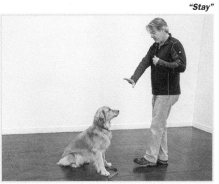

Then step over to the other side and remind her she's still on a stay.

"Stay"

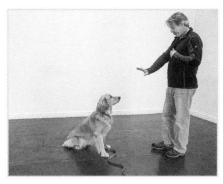

Keep up your hand signal but don't keep chanting "stay."

The first question one might reasonably ask is what's the point of teaching stand-stay? The main point is to teach your dog to hold still for various types of grooming and examination. Your vets and groomers will love you.

Before you work on stand-stay, make sure your dog has mastered exercise 6, "Down to Stand."

"Stand"

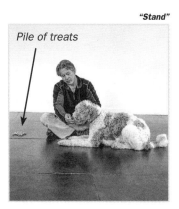

Keep a small pile of treats on the side for easy access. With your dog in down, sit by her side, get her attention with a treat, and lure her into a stand.

"Good stand"

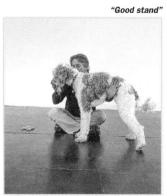

As she comes into a stand, give her the treat, say, "Good stand," and slip your arm and hand under her abdomen to help stabilize her in a stand and prevent her from sitting.

"Stay"

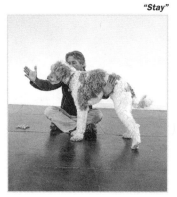

Then raise your signal hand in her face and say, "Stay."

"Stay"

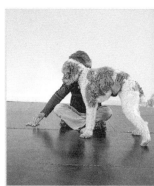

Quickly reach for a treat and rinse and repeat: Continue supporting her and rewarding with treats …

"Good stand"

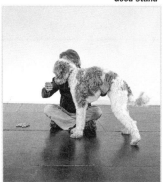

… deliver it as you say, "Good stand." Then after you deliver the treat …

"Stay"

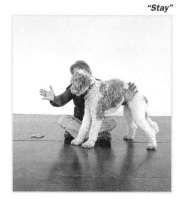

… raise that same hand to signal stay, while also saying, "Stay." This way your dog will hear the phrase "stand-stay" in relation to this position and begin to understand it.

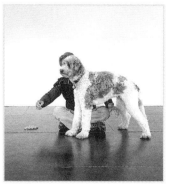

When you feel your dog has relaxed and stabilized in a stand-stay position, test your dog's stability by lowering the supporting hand under her belly. Keep rewarding with treats at intervals, while spreading them out bit by bit.

Pile of treats

Correcting Mistakes: Lift and Reset

Of course, at some point, your dog will inevitably blow it by wanting to sit.

"Ah-ah"

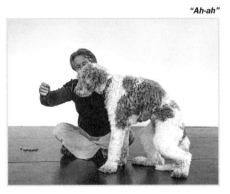

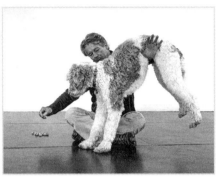

"Stand" *"Stay"*

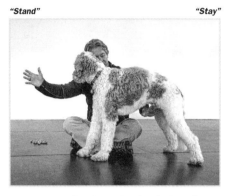

As your dog starts to sit, issue your negative marker, "Ah-ah," and with the supporting hand under her belly...

...briefly lift her rear end off the ground...

...and immediately set her back down in a stand. Repeat the stand-stay command along with the hand signal. This lifting and setting tends to cause your dog to adopt a more braced, stabilized position that makes holding the stand easier.

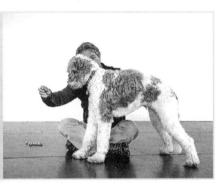

"Good stand" *"Stay"*

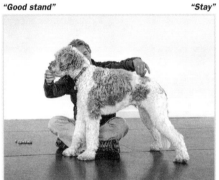

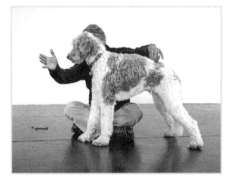

Resume practicing stand-stays until your dog understands it without constant interventions.

In addition: To help stabilize her stand-stay further, take two fingers and lightly press down on your dog's rear end, while saying, "Good stand" and "Stay."

If you do this right, and don't exert too much pressure (which would cause her to sit), you'll find this engages her "opposition reflex." This causes her to push up against your fingers slightly, thus stiffening her stand.

Remove the Support Hand and Stand

Once your dog demonstrates understanding and stability, try having her hold the stand-stay without your ongoing physical support. This can be tricky, so use the "troubleshooting" exercises that follow — the "Hand Signal Body Block" and "Inner Thigh Reset" — if necessary. Once she can do that, repeat the exercise and add distance and distractions, increase the time between rewards, and so on, as you do with down-stays and sit-stays.

"Good stand"

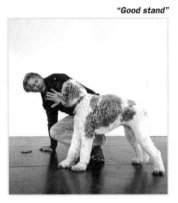

After delivering a treat, put your stay hand signal in front of her face and get up on one knee. The hand signal is a kind of body block that tends to prevent her from moving forward as you move.

"Stay"

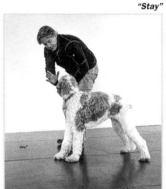

Maintain your hand signal in front of her face as you rise and pivot in front of her.

"Stay"

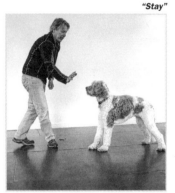

Keep shifting around until you're standing in front of her, being sure to maintain your hand signal in front of her face.

"Good sta

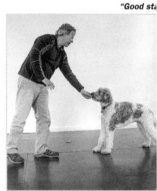

If she remains stable, say, "Goo stay," reward her with a treat, and practice variations, such as moving farther back. When finished, release your dog by saying, "Take a break."

Correcting Mistakes: The Hand Signal Body Block

Stabilizing stand-stay once you're up on your feet presents some challenges. For a dog, standing without moving is just a weird thing. That's why sometimes they need a little extra help to better understand the concept, which the following exercises provide.

"Good stand"

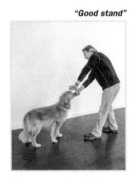

Once your dog is in a stand-stay and you are standing as well, deliver your treat and your positive marker.

"Stay"

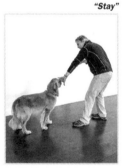

Then, as your dog is taking the treat and you're about to pull your hand away, put your signal hand in front of her face and say, "Stay." In effect, the signal hand blocks her from the temptation to follow your retreating hand.

"Good stand"

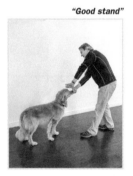

Give another treat with your opposite hand, without removing your signal hand from her face, and say, "Good stand."

"Stay"

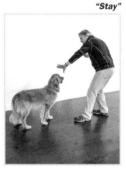

Then, as you pull your treat hand away, say, "Stay." Do this a number of times, until your dog is no longer tempted to move forward toward you or your hand.

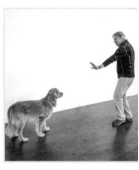

Then, slowly increase the distance between you and your dog, all while repeating the "good stand/treat/stay" routine. As with sit-stay and down-stay, practice circling your dog in stand-stay before releasing.

Correcting Mistakes: The Inner Thigh Reset

Another common trouble spot when trying to stabilize stand-stays is that your dog will want to sit as you move farther away. If that happens, do this.

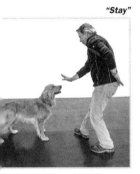
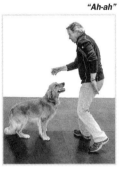
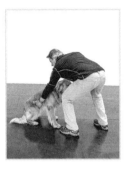
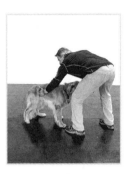
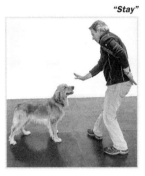

ith your dog in a stand, d with you standing in ont of her, ask her to stay.

If she begins to sit, issue your negative marker, "Ah-ah," ...

...and slip your hand inside her inner thigh in order to lift...

...and reset her.

Then return to your stay routine, per the other instructions.

Another trick that helps stabilize the stand-stay involves using a leash wrapped under your dog's belly. This is a helpful, temporary step if you're having trouble managing your dog using the other methods shown so far, and it won't take long before you can drop the leash completely. That said, the primary purpose of stand-stay is for use during any kind of examination — where the main distractions are human proximity and lots of physical contact — so this three-step exercise ends by simulating the kind of touching that occurs during an exam.

Step 1: Using a Leash When Needed

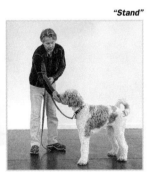
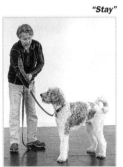
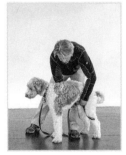
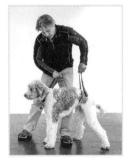
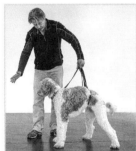

While holding the leash, lure your dog into a stand using a treat.

Issue your stay command with your hand signal.

Swing the leash under your dog's abdomen...

...move it into one hand...

...and use your hand signal to remind her she's still on a stay.

Step 2: Stabilizing with a Leash

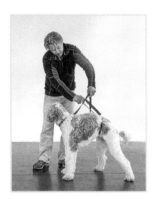

With the leash wrapped under your dog's belly, run the handle end of the leash under the part that's running over your dog's back.

Pull the leash slightly taut...

...and begin rewarding your dog with treats and positive markers.

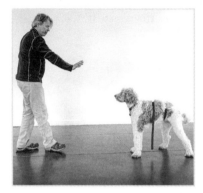

Gradually loosen the leash around your dog's waist until you can let it go altogether and step away, while giving the hand signal for stay. Remember, at this point, let your hand signal do most of the work and avoid chanting commands.

Step 3: Examination

Initially, let the leash hang over your dog's back, as a small reminder of your control, and begin a vigorous body exam. Of course, if she starts moving around, you can quickly grab the leash and go back to the previous step. If she doesn't, then take the leash off midway through and continue.

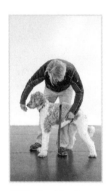

With the leash draped over your dog's back, begin examining her body, perhaps starting with her abdomen.

Run your hands down her legs, both inside and outside.

Examine her mouth. See if you can hold it open for five or so seconds.

"Good stand"

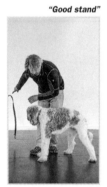

If it's going well, dispense with the leash, and don't forget periodic rewards and praise.

Lift each leg and examine her paws. Work from different angles, stepping from one side to the other.

"What a good girl"

Feel free to improvise and vary the order of what you do. However, when you're done, be sure to praise your dog for being so good and tolerant.

Once your dog has learned multiple training elements from parts 1 through 5, it's time to put them together into longer and more varied routines. This sequence strings together come, sit, both fancy finishes, heel, down, and down out of motion. But this is only one possible training sequence out of dozens that you can creatively string together. Feel free to experiment, and please see the examples and further instruction of this on my website at www.doggonegood.org/book-bonus. Most of all, keep it fun and interesting both for you and your dog. Make it complicated, but don't go on too long, since that can get boring, and boredom does nothing to facilitate learning.

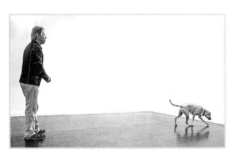
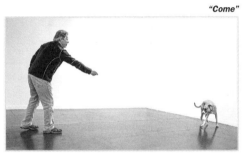
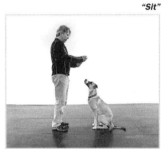

"Come"

"Sit"

With your dog at some distance…

… ask her to come, shamelessly luring her with a treat.

Ask her to sit in front of you.

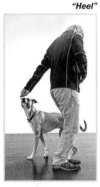
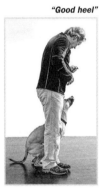
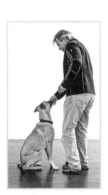
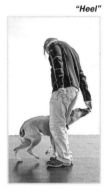
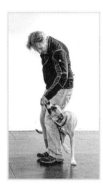
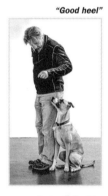

"Heel" **"Good heel"** **"Heel"** **"Good heel"**

Then bring her into a fancy finish to your left…

… and reward her with just a positive marker.

Swing around in front of her.

Then bring her behind your left…

… into a fancy finish on your left…

… and reward with a positive marker.

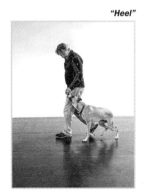
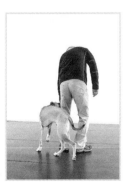
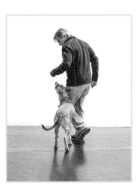
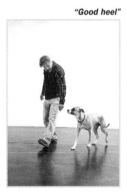
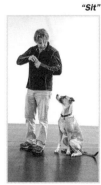

"Heel" **"Good heel"** **"Sit"**

Start walking and heel with your dog.

Include a right turn…

… and a left turn.

Praise your dog with positive markers…

… and finish in a sit.

"Stay"

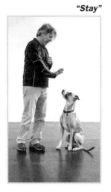 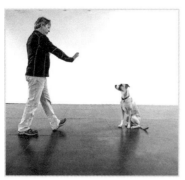 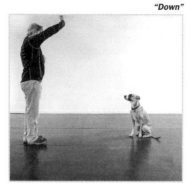 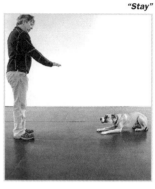

"Down" **"Stay"**

Add sit-stay… …back off a few feet… …and ask for down… …and then stay.

"Come" **"Sit"**

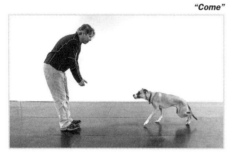 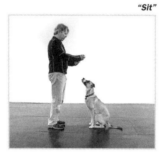

Recall your dog out of the down-stay… …and ask for a sit.

"Heel" **"Good heel"** **"Down"**

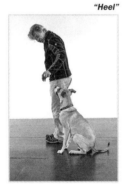 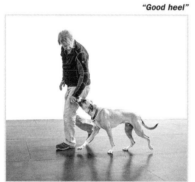 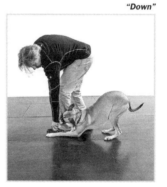 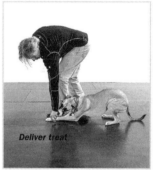

Deliver treat

Resume heeling… …and while walking… …move into a down out of motion. When you're done, finally deliver the rewards.

⭐ On the Use of Treats in Longer Routines

Throughout routines such as this one, continue using treats to lure and reinforce your dog. But start thinning out your treats. Get your dog to work harder and harder for less and less. In this case, the only treat that's delivered is at the very end.

What is best depends on you and your dog and the level of training you're at. In general, feel free to lure your dog with a treat as much as you need to keep exercises running smoothly. Then reinforce your dog by actually delivering treats in areas where she's struggling and may need a bit more help.

There are multiple ways to positively motivate your dog. The easiest and most widely applicable is to use treats, which we've been doing so far.

But treats aren't the only way to go. For some dogs, balls and other toys are just as potent as treats, and in some cases significantly more so. Also, an excessive focus on treats can favor transactional training over deeper relational training. Introducing balls as motivators, and using games as rewards, can address this imbalance and add a very robust relational dimension to an otherwise transactional training program.

Part 6 shows how to use balls as motivators in some of the exercises from parts 1 through 5. Meanwhile, additional exercises shown on my website at www.doggonegood.org/book-bonus extend these techniques and show how to use balls in more challenging environments and for more challenging commands.

If your dog is responsive to balls, toys, and games, feel free to experiment with how best to use them as you work toward your training goals.

✪ On Playing Tug-of-War and Dominance

One misconception still bandied about by some trainers is that playing tug-of-war encourages dominant and even potentially aggressive behavior in dogs. Or they may advise that you should always win tug-of-war, otherwise your dog won't view you as "alpha."

This is nonsense! In fact, at least one study has looked for a relationship between playing tug-of-war and problematic, dominant behaviors and found precisely none.

The truth is that tug-of-war is one of the best games you could possibly play with your dog as long as you follow a few simple rules: Initiate the game, control the game, and end the game. Simple as that.

What does this mean? "Initiate the game" means that you bring the toy out when you're ready to go for it. Don't let your dog bring the ratty rope toy, shove it into your crotch, and demand a game. "Control the game" means that every thirty seconds or so, command off (see part 10), ask your dog for any command, and then resume the game and repeat the cycle. "End the game" means giving your dog some cue, such as saying, "That's enough," and putting the toy away.

Lastly, it's perfectly fine to let your dog win a few rounds. After all, what fun is playing a game that you always lose? No, this won't make your dog more dominant. In fact, dominant dogs routinely allow lower-ranking pack members access to high-value resources because they know they can get them back simply by walking over and going "woof." In the same way, if you want the toy back, you can simply walk over to your dog and command off, and your dog should easily relinquish the toy. If you've properly trained your dog, she'll listen, take her cues from you, and eagerly await the next iteration of the game. All of this supports the relational dimension of training.

Using the ball as a motivator instead of a treat is very simple. Here is an example of how to use it in the sit-down-stand routine in exercise 7. This presumes that your dog has already learned this routine and it's not new. While you can use the ball to introduce these early exercises instead of using treats, it's usually easier to use treats first and then use the ball later. In addition, using a ball that squeaks, or using a squeaky toy, helps get your dog's attention.

Squeak

Get your dog's attention with the ball. Using one that squeaks can be very helpful.

"Sit"

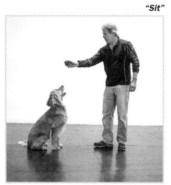

Ask her for a sit.

"Down"

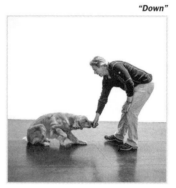

Then a down.

"Good do

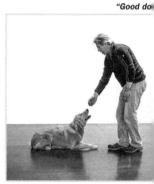

Hold the ball close to her nose just like a treat. Use your posit marker when she hits it.

"Sit"

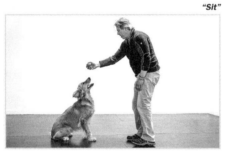

Then go back to a sit...

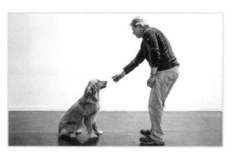

...and from the sit...

"Stand"

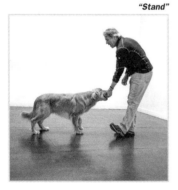

...move to a stand.

"Down"

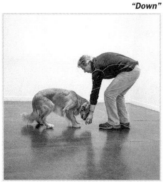

Then go to a down by driving the toy between your dog's feet.

"Good down"

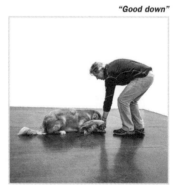

Don't let go of the ball. Again, use your positive marker when she hits it.

"Go p

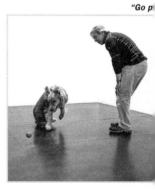

From here, you can continue th routine in any way you like. Wh you're done, reward your dog b throwing the ball and instructir "Go play!" Then, of course, pla with your dog before initiating new exercise.

You can use a ball to inspire tight, enthusiastic heeling, and your dog won't even realize she's working.

Heeling in a Straight Line

"Heel"

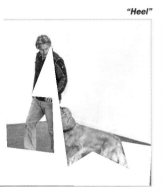

"Good heel"

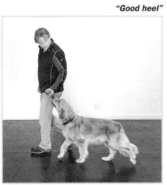

"Sit"

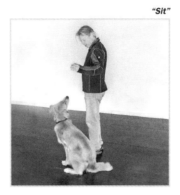

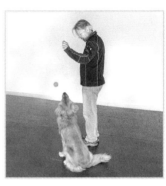

et your dog's attention on e ball, say, "Heel," and start alking.

Keep teasing your dog with the ball to keep her attention on it. Throw in a few "good heels."

When you feel like it, move the ball back over her head, and ask for a sit.

When she complies, reward her with a toss of the ball.

The Right Turn

Please review exercise 16, "Right Turns and Left Turns," to be sure you understand the mechanics of turns and how to keep your dog in the proper heel position as she moves.

"Good heel"

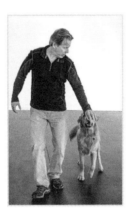

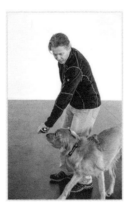

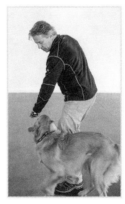

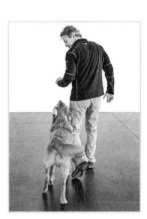

With your dog targeting the ball...

...bring the ball very close to her nose and keep it there.

Then lure her through a tight right turn.

Keep your dog focused and speed into the turn, which will allow her to stay in the proper heel position.

As you straighten out, bring the ball up higher and have your dog continue to target it.

The Left Turn

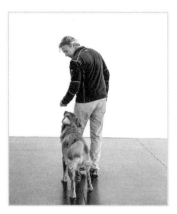

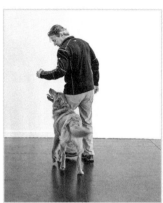

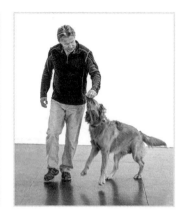

With your dog targeting the ball, bring the ball very close to her nose and keep it there.

Then as you move into the turn, bring the ball slightly up and back over your dog's head in order to slow her down a bit.

Slowing down helps her stay in the proper heel position, and it helps you avoid running into her side.

As you straighten, give your dog a little bite on the ball, keep her focused, and continue walking.

If your dog is ball crazy, heeling with a ball will go quickly, but just like when using treats, you soon want to switch the ball to the side opposite from her; see exercise 18, "Moving the Treat to the Opposite Side," and exercise 19, "Moving the Treat to the Opposite Side Through Turns." This is designed to maintain the ball-crazed intensity of your dog's heeling without having to constantly show her the ball.

Heeling in a Straight Line

"Good heel"

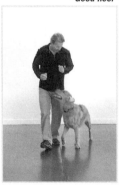

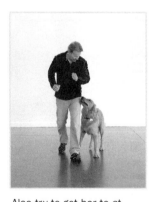

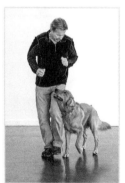

"Ah-ah"

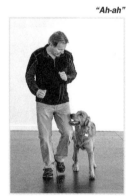

"Good"

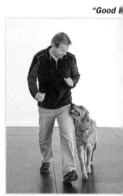

While heeling, keep her focused on the ball, which is now in your right hand, while using your positive marker, "Good heel."

Also try to get her to at least intermittently target the left hand, or whichever hand is on the same side she is. Keep it in a fist as if it holds a treat.

If she tries to cross over to grab the ball from your right hand...

...give her a little bump with your leg and say, "Ah-ah."

Then refocus her on the target hand, or your left fist.

The Right Turn

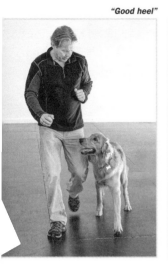

"Good heel"

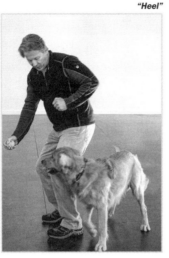

"Heel"

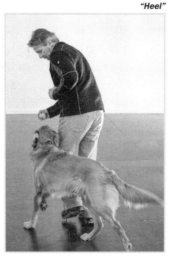

"Heel"

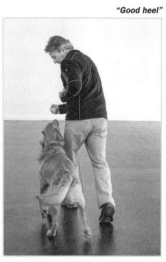

"Good heel"

As you prepare for your right turn, get her attention on the ball in your right hand and say, "Good heel."

As you turn right, say, "Heel," and if the ball has a squeaker, use it to encourage her throughout the process.

Keep her tightly focused on the ball as you move, bearing in mind that she should remain in the heel position throughout, without storming ahead or dragging behind.

When you straighten, praise her by saying, "Good heel."

The Left Turn

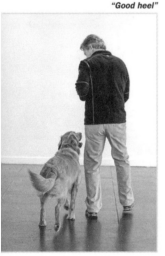

"Good heel"

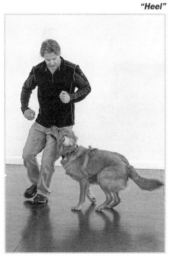

"Heel"

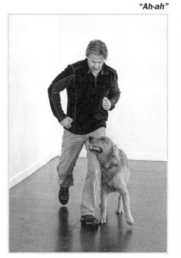

"Ah-ah"

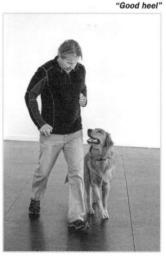

"Good heel"

As you heel, try to alternate your dog's focus between the ball in your right hand and the left or target fist on the same side as your dog.

Keep her focused on the ball through the turn.

Again, if she cuts across too far, issue your negative marker and give her a little leg bump.

Once you straighten, praise her by saying, "Good heel." Once done with these exercises, reward her with a game of fetch.

When using a ball as a motivator, you might find that your dog is reluctant to give up the ball upon her return. Instead, she might try to get a game of "keep-away" going by goading you into grabbing for the ball. Don't do it, and don't demand she give up the ball by commanding "off." That will interrupt her totally positive enthusiasm and possibly dampen her drive for the ball itself, reducing its power as a motivator.

Here's a simple work-around. Take two *identical* balls and get your dog's attention with the first one. Throw it. Once she returns and refuses to give it up, show her the other ball and tease her with it. But don't throw it!

At least, not until she gets so fixated on the one you're holding that she gets bored with the ball in her mouth and drops it. Then *immediately* throw the ball in your hand across her line of sight. As she sprints after the thrown ball, pick up the one she dropped, and repeat the procedure when she returns again. After ten to twenty iterations of this game, your dog will quickly spit out the ball in her mouth to get you to launch the one in your hand. Problem solved.

Another potential solution is to offer her a treat when she brings the ball back rather than use a second ball. However, this is less effective and smooth. Some dogs will ignore the treat and still want to play keep-away. And injecting a treat can break the rhythm and change your dog's focus, and it undermines the *other* training goal of minimizing treats. At any rate, try this and see what approach works best for your dog.

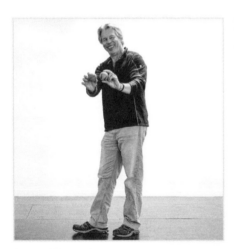

Start with two identical balls.

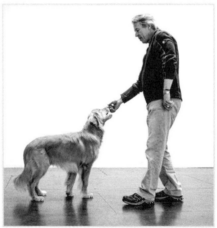

Get your dog's attention with one…

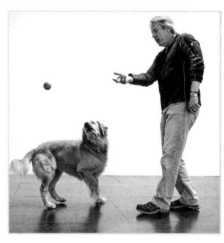

…and toss the ball and have her go for it.

s she returns, show her the second ball.

Tease her with it until, at some point, she drops the one in her mouth.

Immediately toss the second one…

…and as she chases it, pick up the first one. Rinse and repeat.

⭐ On Resolving Conflicting Drives

The reason that some dogs have a tough time releasing the ball once they get it is that they're caught at a tension point between two drives: prey drive and play drive.

Here's the issue: A central directive of prey drive is that, once you grab your prey object, you *never* let it go. Why? Because prey is related to food and to survival, and survival is both primal and primary. So never giving up the prey object once you've got it runs deep in a dog.

Play drive, on the other hand, has as its central directive the desire to keep the game going. Nothing more than that. Though dogs are not stupid and recognize that the tennis ball is not a prey object, prey drive still tells them "never let go." The way dogs generally resolve the tension between these two drives is by turning the fetch game into a game of keep-away. That way dogs get to keep the prey object and keep the game going.

Using the two-ball routine circumvents this by giving your dog another prey object to focus on, and you keep the game going that way.

Once your dog is completely familiar with all or most of the concepts and exercises in parts 1 through 6, it's time to introduce the concept "you must" and to transition from "exercises" to "commands." This is also the point where you should increase your focus on relational training, rather than using almost entirely transactional training.

This transition can be challenging, but it is critical for attaining reliability in commands. So far, all the exercises have been taught in controlled, distraction-free environments using an abundance of positive motivators. But that doesn't always work in real-life situations, so as training continues, it focuses on increasingly challenging circumstances while reducing the reliance on positive motivators.

In essence, this means shifting from "asking" your dog to do something and then rewarding her when she complies to teaching your dog to understand when she must obey or comply with a command even if she doesn't want to. How to teach "you must" is where the training world gets divided. Almost no one today supports the old-school,

punitive, "show 'em who's boss" methods. But when your dog is more interested in something other than your command or any reward for compliance, you have to impose your will in some fashion or to some degree. At times, the safety of others and of your dog requires it.

So as you transition to commands, it's *very* important that your dog already understand what she's being asked to do. Take the time to fully teach your dog every significant exercise to this point. Imposing demands when dogs don't fully understand what's requested is both inherently unfair and counterproductive.

Without being heavy-handed, the exercises in part 7 are designed to help your dog understand that she *must* comply while simultaneously raising the performance bar. This primarily involves teaching your dog that certain types of leash pressure are demands for certain types of behavior. Once your dog understands this, you can use this leash pressure to demand behaviors without being harsh. This is how exercises become commands.

Before you can effectively use a leash to demand behaviors from your dog, you must teach her what that leash pressure means. Initially, you do this by using treats. However, once you've practiced these techniques enough times, and your dog understands what they mean, there's no need to continue to use treats in conjunction with leash pressure. Then, you can use these maneuvers whenever your dog decides she doesn't want to do something that you've asked her to do *and that she already knows how to do.*

Also, using a leash to demand sit is a leverage move, not a force move. In other words, per the title of the sidebar on the next page: DO NOT YANK! If you find yourself using a lot of force, please stop and reevaluate what you're doing. The point is to teach your dog, and to use the leash as another form of communication, not to punish or hurt her.

From Standing or Walking to Sit

The trick to this exercise is to make sure that your leash is on your dog's flat collar with the leash clip underneath her neck. This exercise WILL NOT WORK if you don't have the leash clip under her neck. Otherwise, the leash pressure will simply choke your dog, which is definitely NOT the point. With the leash clip under her neck, slowly pull the leash upward and toward you at a 45-degree angle, which puts upward and forward pressure on your dog's neck. Doing this with slow, steady pressure will trigger your dog's "opposition reflex," which will make her resist backward at precisely that same 45-degree angle, which will automatically put her into a sit. The second her rear end hits the ground, simultaneously release the leash pressure, say, "Sit," and reward her with a treat.

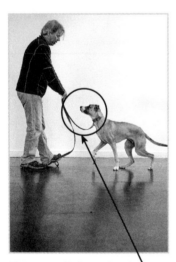

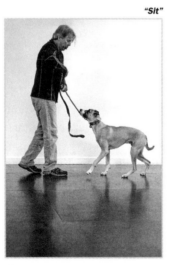
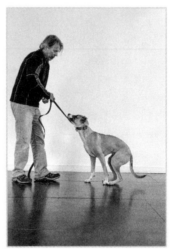
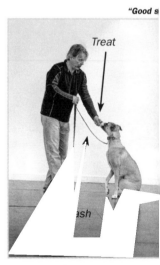

"Sit"

"Good s[it]"

Treat

[le]ash

Make sure that your leash clip is UNDER your dog's neck on a flat collar. Then get your dog's attention.	Slowly and *without yanking*, pull the leash from under her neck upward at a 45-degree angle toward yourself and say, "Sit."	When this is done properly, your dog will resist precisely in the opposite direction, quickly pulling back into a sit.	As soon as her rear end hits the ground, release the leash pressure and reward with a treat.

✪ Do Not Yank!

Up to now, the foregoing exercises haven't used or mentioned leashes very much. When a leash is used in these exercises, it is meant to help your dog understand what she is meant to do, perhaps by interrupting an impulse, refocusing attention, or encouraging her into a certain position. The leash is not used as punishment for some kind of failure, nor should using it ever cause pain. In fact, one good approach is to see how gently you can use the leash while still being effective. Please read the sidebar "Evaluate the Level of Correction" (page 106).

Further, yanking or exerting too much pressure can be counterproductive. It can trigger your dog's opposition reflex or a negative recoil reaction that defeats the purpose of some exercises, such as when using the leash to demand down (exercise 41). Then again, other exercises, like demanding sit, are designed to trigger your dog's opposition reflex by applying steady, gentle leash pressure that encourages your dog to move on her own into the correct position.

Throughout training, using the leash without yanking is *extremely* important!

From Down to Sit

Conveniently, the same exercise works to get your dog from a down into a sit.

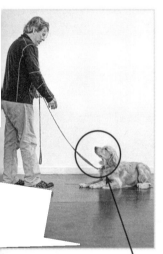
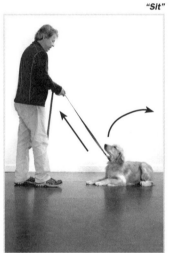
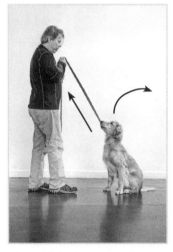
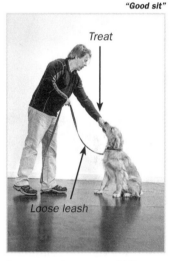

"Sit"

"Good sit"

Treat

Loose leash

ake sure that your leash
ip is UNDER your dog's
eck on a flat collar, then
et her attention.

Slowly and *without yanking*, pull the leash from under her neck upward at a 45-degree angle toward yourself and say, "Sit."

When this is done correctly, your dog will back up and away from the pressure, causing her to sit.

As soon as her rear end hits the ground, release the leash pressure and reward with a treat.

Using the Leash with a Hand Signal

Once your dog understands this maneuver, add your hand signal for sit.

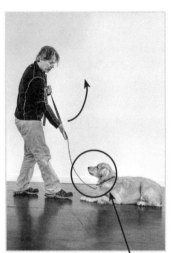

"Sit"

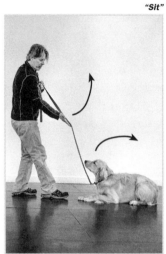

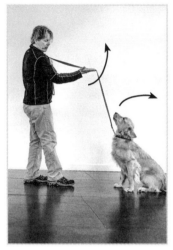

"Good s

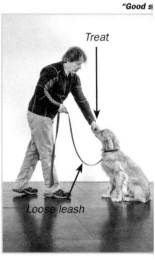

Treat

Loose leash

Once again, make sure that your leash clip is UNDER your dog's neck on a flat collar, then get her attention.

Slowly and *without yanking*, pull the leash at the same angle, but hold your palm up in the hand signal for sit. At the same time, say, "Sit."

When this is done properly, your dog will back up and away from the pressure, causing her to sit.

Once she's in sit, release the leash pressure and reward with a treat.

If your dog has a collar that continually slips around, using a leash to demand sit can be difficult. Here's an alternative technique, which is also effective if you have to demand sit when your dog is not wearing a leash.

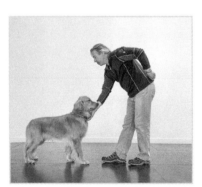

"Sit"

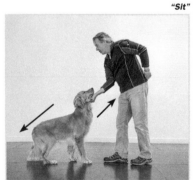

"Good sit"

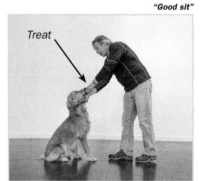

Treat

When your dog is standing, grab her collar UNDER her neck.

With slow, steady pressure, pull upward and toward yourself at a 45-degree angle, the same as if using a leash, and say, "Sit."

When this is done correctly, your dog will tilt back into a sit. Once she does, reward her with a treat.

Using the leash to demand down involves an entirely different set of dynamics than for sit. For down, your dog's opposition reflex works against you and will cause her to pull away. Therefore, you use a treat to teach her that moving toward the leash pressure will release it.

If your dog has a strong negative reaction to the downward leash pressure, and she starts bucking and pulling, it means you've put too much pressure on the leash too quickly. Lighten up and use just a tad of pressure on the collar. Remember, *don't force your dog down*. And certainly don't do anything that causes a strong negative reaction in your dog.

In this situation, you may need to use a better treat, and focus her attention on it more quickly, to help her get over any initial resistance. The point is to teach your dog that downward pressure on the leash is released by moving toward the pressure, and if she does, she gets a great treat.

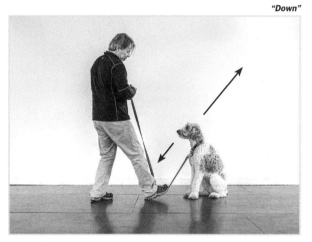

With your dog in sit, put your foot on the leash and exert some *mild* pressure downward while saying, "Down."

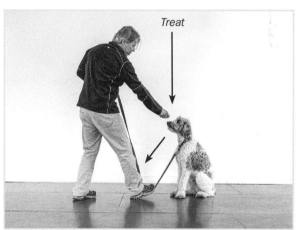

The leash pressure will make her opposition reflex kick in, and if she pulls back and away from the pressure, get her attention on a killer treat.

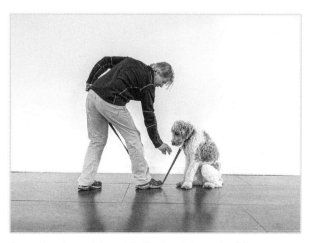

Once she shows interest in the treat, lower it while maintaining downward leash pressure.

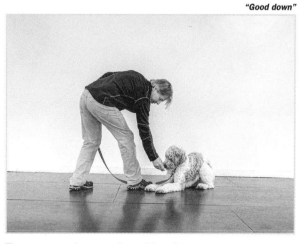

The moment she commits to lying down, reward her with the treat.

Teaching your dog to understand what leash pressure for stand means involves the same approach as for down. You use killer treats to teach your dog to overcome her opposition reflex and move toward the pressure rather than away from it.

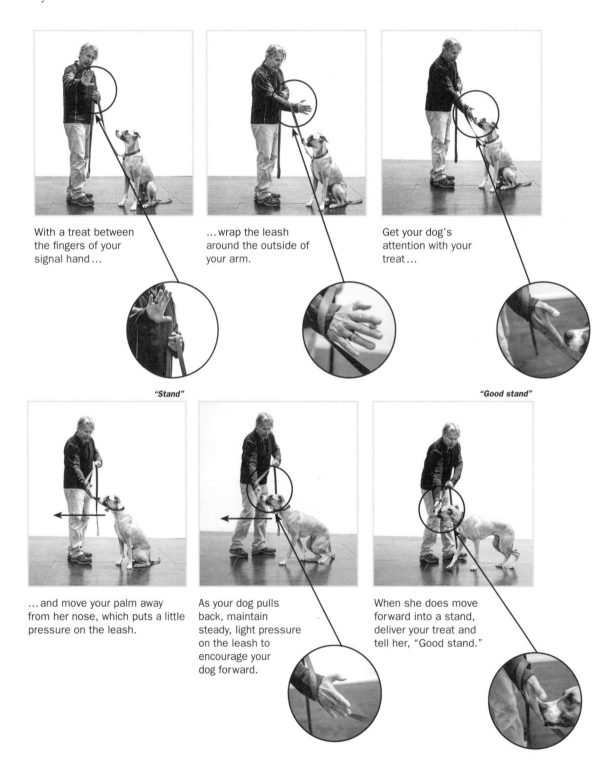

With a treat between the fingers of your signal hand...

...wrap the leash around the outside of your arm.

Get your dog's attention with your treat...

"Stand"

"Good stand"

...and move your palm away from her nose, which puts a little pressure on the leash.

As your dog pulls back, maintain steady, light pressure on the leash to encourage your dog forward.

When she does move forward into a stand, deliver your treat and tell her, "Good stand."

Dogs have a natural walking pace that is much faster than ours. And being hunters, they're hardwired to be interested in and to explore everything. That means that in order for dogs to walk nicely alongside us and not pull on a leash, they have to make a big effort both to slow down and to put a lot of attention on us — rather than focus on the thousands of other interesting things in the environment. Of course, this is challenging for dogs, and it takes lots of training and practice, and sometimes special equipment, to achieve this. Part 8 provides a simple exercise for training dogs to walk on a leash without pulling (the "Pay Attention Exercise"), and it describes how to use it with three types of collars — the flat collar, head collar, and prong collar — as well as with the chest-leading harness.

All collars, leashes, and other training equipment are designed to impose some form of physical constraint on a dog. This is unavoidable. The real question is which methods and equipment are best for teaching dogs how to walk on a leash with humans in the most-efficient and least-stressful way. This is another area where many dog trainers and dog owners disagree. Personally, I don't think it's very helpful to label some pieces of equipment as "positive" and some as not. Integrated Dog Training recognizes that every dog/owner combination is unique and that what may work well for one such combination can differ dramatically from what may work for another. In addition, each piece of training equipment has inherent limitations. My goal in part 8 is to introduce you to the most commonly available collars and harnesses, and then you must decide for yourself which works best for you and your dog.

People who are committed to a "purely positive" approach won't consider using a prong collar, and that's fine. Some may even object to the Pay Attention Exercise itself, which uses a slight bit of aversive control. Again, it isn't required. You can work to keep your dog's attention on you with a lavish supply of treats or an exciting squeaky toy, but many find that's not enough to keep their dog from pulling on a leash. Also, it requires relying on a relentless stream of treats in order to keep your dog's attention, and it doesn't address the question of what happens when your dog becomes much more interested in something besides the treat. So while these approaches can work, a lot depends on the dog, and I encourage you to reevaluate any approach if it is not working for you.

One thing to bear in mind is that an avalanche of research has consistently shown that dogs that *understand their choices* in the face of potential aversive control *experience little to no stress as a consequence*. When they understand that different choices have different consequences, they can act on that understanding. This *increases their sense of agency* and, as a result, their sense of self-confidence. And if you are the vehicle through which they gain this understanding, then the relational component of training is significantly enhanced.

In these exercises, I discuss how to acclimate

your dog to each type of equipment and how to adapt them to the same essential exercise. What you're looking for is equipment that quickly helps your dog understand the basic concept of "pay attention to me regardless of how fast I walk or what direction I move in." This understanding should start to occur within three to five iterations of an exercise. If that's not happening, or your dog reacts very negatively, I suggest trying a different collar or type of equipment. However, if you prefer to stick with the equipment that you're using despite a relatively lower level of effectiveness, you may have to compensate by increasing your usage of treats and practicing for a considerable period of time.

The primary purpose of this exercise is to convince your dog that it behooves her to pay attention to you. Quickly eliminating leash pulling, important as it is, is merely a secondary effect of this exercise.

Attention is foundational. After all, if you don't have your dog's attention, it doesn't really matter what you've taught her or what she knows. She won't do it. Why? Because you don't have her attention! On the other hand, once you've got her attention, everything she knows comes right to the surface and is much more readily available to you. Why? Because you've got her attention and she's ready to work.

This exercise doesn't use treats to get your dog's attention, but rather yourself and your movement, so this represents an important bridge between transactional and relational training. This exercise is "relational" because it teaches your dog that being near you is the safe place, where the leash is always loose, and that direction and authority flow from you.

There are two stages to the Pay Attention Exercise: First, practice while standing still to master the basic mechanics of leash handling, and only then practice while walking or in motion. Handling the leash smoothly is key to making this exercise work, and it's key to avoiding unintentionally turning this into nothing more than a meaningless series of yanks and jerks.

Finally, I demonstrate this exercise using a flat collar and a six-foot leash. A six-foot leash is the best length for all versions of this exercise, but once your dog is an expert at not pulling, any style of leash is fine. Meanwhile, a flat collar is the standard collar nearly all people use, and it's often the one that's most agreeable to dogs. While it tends to be least effective in teaching your dog not to pull, it's a good collar to start with to see how responsive your dog is. Next I'll explore other options and how to adjust this exercise when using them.

Step 1: Pay Attention Exercise Leash Mechanics

With your dog in sit in the heel position, put the thumb of your right hand through the handle of your six-foot leash.	Then take up two feet of slack in your hand. This gives you two feet, while leaving four feet to your dog.	In step 2, this is how you will walk. For now, simply wait a moment, then drop the slack in your leash.	Grasp the leash end firmly with both hands like a baseball bat and tuck your hands to your belly button.	Then turn in place to the right and face the opposite direction.	Note that the leash is slack. While standing still, there is no yanking or pulling.

Step 2: Pay Attention while Moving

Before attempting this exercise while walking, please be sure to practice the mechanics of proper hand positioning on the leash. As I note in the captions, the point isn't to yank the leash. Simply change direction while walking and give your dog a few feet of leash to notice that you're turning before the leash goes taut. In this way, your dog quickly learns that she is in control of the level of "correction." If she pays attention to you, and turns with you, then the leash will remain loose and she won't be pulled.

Hold the leash as instructed in step 1, and walk with your dog in heel position on your left side.

As your dog moves ahead of you, and while still walking, drop the slack in the leash.

"Yay, good girl!"

Continuing to walk, grab the leash with both hands like a baseball bat and tuck your hands into your belly button.

Only once you've done that, and *without warning your dog*, turn to your right and change direction. She's got four feet of time and space to notice that you've done this.

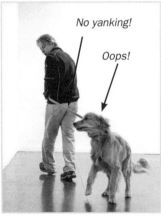
No yanking!
Oops!

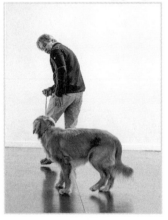

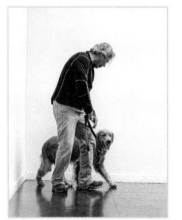

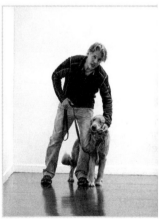

If not, she'll hit the end of the leash, *giving herself a correction*. This is important: DO NOT yank the leash. Simply change direction while holding the leash end to your abdomen. Whether your dog hits the end of the leash or not, and with what level of force, is up to her.

After the correction, your dog will turn to see what happened. The second she turns, start praising her and encouraging her wildly to come to you. Enthusiastically pat your hip. It's important to express lots of enthusiasm!

As she realigns herself with you, continue to praise her both physically and verbally. This kind of praise means a lot to a dog after she's just been corrected. It contributes enormously to working together in a way that fosters bonding.

From here, keep walking normally, and at random intervals, repeat the exercise.

When the Pay Attention Exercise Goes Right

It should only take three to five turns for your dog to figure out the Pay Attention Exercise and avoid being pulled by the leash. If you don't notice any significant improvement or a dramatic shift in your dog's attention, consider using a different collar or piece of equipment. Here's what success looks like.

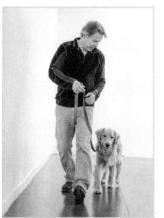

alk with your dog, holding the ash as instructed.

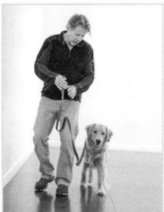

Without warning her, but while still walking, drop the slack in the leash.

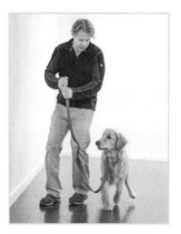

Notice that she's figured this out. The moment the leash drops out of my hand, her head and attention come up toward me.

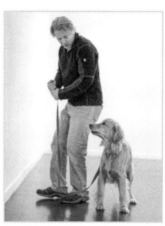

Watch your dog as you turn to see whether she maintains her attention.

"Yay, good girl!"

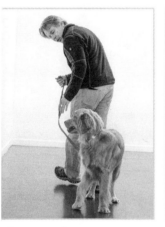

this case, she easily moves rough the turn and follows efore the leash goes taut.

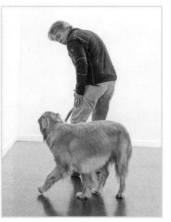

When this works, your dog won't experience the slightest bit of pressure on her neck. And that outcome is *based on her attention and choice* independent of any food or toy lure.

Of course, respond with lavish physical and verbal praise.

✪ Note

Unlike with heeling, in the Pay Attention Exercise you are not so concerned with whether your dog is in the perfect heel position. In fact, it doesn't matter whether your dog is a little bit ahead, to the side, or behind you so long as when you turn or change pace, your dog stays with you without pulling. That said, this exercise is easier if your dog already has experience with heeling (see part 3).

Head collars are an innovation based largely on the horse bridle. Unlike collars that put tension on a dog's neck and throat directly, head halters are designed to steer your dog's head. This is built on the understanding that where the head goes the body follows.

The primary difficulty with head collars is that dogs tend to HATE them. Often they'll buck and kick like wild ponies the moment they feel the constraint on their muzzle and the torque on their neck. Introducing head collars can take time and patience using a process called "systematic desensitizing." Systematic desensitizing simply means that you condition your dog to accept something she may not like very much by coupling small amounts of it with large amounts of something she really does like — a piece of steak, for instance.

Here's how it works.

Introducing the Head Collar

As with heeling, I think that string cheese makes a very effective treat when introducing a head collar, since your dog can remain focused on nibbling off pieces as, step by step, you place and secure the equipment. That said, you may have to repeat parts of this sequence, or even the whole sequence, multiple times — putting it on, giving her a string of treats for tolerating it, then removing it and starting over — before you can move on to the Pay Attention Exercise while using it. See also "Struggling with the Head Collar" next.

Here is a head collar.

Begin by holding the loop that goes around your dog's snout in front of your dog while getting her attention on a killer treat (in this case, string cheese).

As your dog reaches for the treat, slowly slip the loop across her muzzle...

...and let it hang there while you both give her the treat and stroke her head affectionately. You may have to do this multiple times to simply get her used to the whole experience.

When you feel that your dog is okay with this, reach under her neck...

...and grab the strap that goes around her neck.

Then grab the other strap...

...and clip them together behind her neck. If your dog struggles at this point, remove the head collar and repeat this sequence until she's calm before moving on.

With the head collar on, keep her focused on the killer treats, and as she nibbles...

...slowly pull the small ring under her chin, which is where the leash will be attached. For a while, just do this before eventually attaching the leash.

Once the leash is on, lure her forward by pulling *slightly* on the leash while keeping her attention on the treat. If she resists, loosen up a bit *without* letting go of the tension altogether. You want her to learn that moving forward and toward you releases the leash pressure.

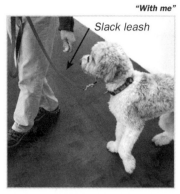

"With me"

Slack leash

The moment she moves forward, let the leash go somewhat slack and fall into a slight curve. Also say, "With me," or "Let's go," to cue her to move with you. Then walk for a while and ask for a few simple behaviors, like sit, while providing abundant positive reinforcement.

Struggling with the Head Collar

Unfortunately, what the previous sequence shows often doesn't represent what actually happens the first time you attempt to use a head collar on your dog. In many cases, dogs will struggle, sometimes violently and for weeks, before ultimately and grudgingly accepting it.

If this happens with your dog, the most important thing is to practice patience. DO NOT yank your dog around if she struggles and bucks. Once the head collar is on, try to get her moving and maintain a positive, upbeat energy, or else return to the desensitizing routines in the previous exercise.

That said, if trying to use the head collar is causing high stress and lots of conflict that doesn't diminish, consider using different equipment such as a chest-leading harness or a prong collar. To me, it's ironic that some folks who advocate a "purely positive" approach will stress out a dog for weeks to get them to accept a head collar, but they refuse to even consider a prong collar, despite the fact that most dogs learn to walk on a prong collar within less than five minutes and with minimal stress.

As always, evaluate your dog, and if something doesn't work within a reasonable amount of time, change tactics.

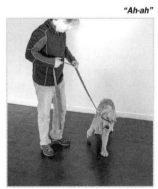

"Ah-ah"

The second you put on the head collar, many dogs will struggle and work like crazy to get it off their face.

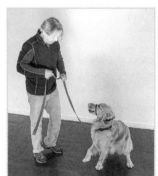

The first thing to do is to be patient. Merely hold the leash somewhat taut, issue a negative marker, and try to direct your dog's head back toward you with a treat.

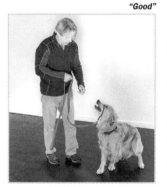

"Good"

The moment she faces you, praise her and release the leash pressure. This teaches that focusing on and moving with you releases pressure.

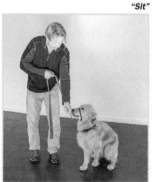

"Sit"

Focus her on a treat, and then ask her for something simple and familiar, such as a sit.

"Heel"

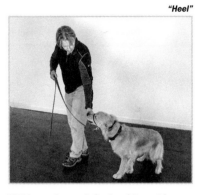

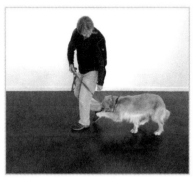

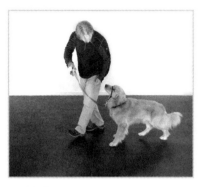

If this works, ask for heel to get her moving.

In all likelihood, your dog will continue to struggle with the collar for a while.

As this happens, refocus her on a treat and try to keep moving rather than allowing your dog to dig in and hunker down.

The Pay Attention Exercise Using the Head Collar

Once your dog accepts the head collar, develop the quality of her attention by practicing the Pay Attention Exercise. The main difference with the head collar is to verbally alert your dog as you turn, and then to hold the end of the leash out, rather than into your abdomen. Why? Because the head collar can torque and hurt your dog's neck if it goes taut too suddenly. As always, DO NOT YANK. Instead, use gentle, steady pressure, adequate warning, and food lures to help your dog through the turn.

"With me"

"Ah-ah"

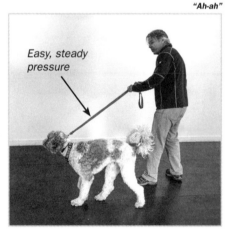

Easy, steady pressure

As you walk with your dog…

…drop the slack in the leash, provide a verbal cue like, "With me," and slowly move into a turn, giving your dog ample time to notice what you're doing.

If your dog does not turn with you, issue your negative marker, "Ah-ah," and put *a little steady pressure* on the leash to guide her back into position. DO NOT YANK!

"With me" *"Good with me"*

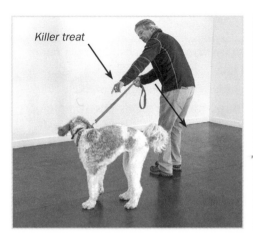

Killer treat

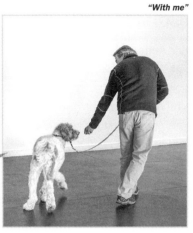

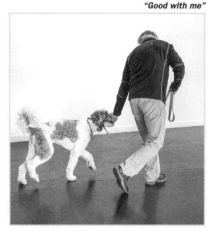

As soon as she turns her head in your direction, get her attention with a killer treat…

…so she refocuses on you.

Then complete the turn and continue walking.

Chest-leading harnesses are a nice alternative to head collars as well as to flat and prong collars, and they work quite well to manage pulling with many types of dogs.

The chest-leading harness is also an enormous improvement over regular back-leading harnesses, which actually encourage pulling. A harness is fitted around the strongest part of the dog's body, and if the leash clip is positioned on the back, it produces perfect body mechanics for pulling. That's why they're used for sled dogs!

However, attaching the clip to the front of the chest undermines these body mechanics, since as dogs pull on the leash, they get awkwardly tugged to one side. Generally, dogs find this annoying and will slow down in order to relieve any unbalanced, one-sided pressure on their chest. This makes dogs significantly easier to manage than when wearing a back-leading harness, and it puts zero pressure on their necks.

A further thing to consider is that pulling on a leash with a back-leading harness can contribute significantly to on-leash reactivity against other dogs.

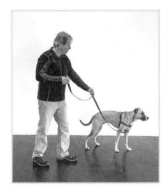

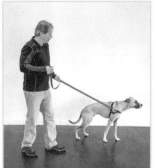

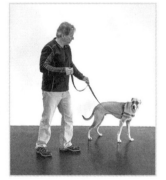

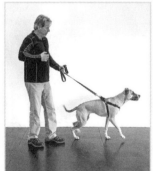

As you walk along…

…if your dog begins to pull, the chest-leading harness exerts awkward sideways pressure on your dog's chest.

That will usually get her to slow down and reorient to you.

Compare that to a back-leading harness, where the body mechanics are perfect for pulling.

The Red Light, Green Light Exercise

While it's possible to practice the Pay Attention Exercise with a chest-leading harness in almost the exact same way as with a flat collar (see exercise 43), here is a variation called "Red Light, Green Light." This is a less-abrupt way to introduce your dog to the notion of staying with you and paying attention. While this is unlikely to be very effective with high-drive, powerful dogs, it can be quite helpful in introducing this set of concepts to more sensitive ones. It can also be an interim point as you experiment with the various approaches to determine the best fit of equipment and exercises for you and your dog.

This version of the Pay Attention Exercise can be performed both with and without the use of treats. I suggest first trying it without treats, and then adding them if your dog seems to need the extra motivation. Remember, if after five or so repetitions, your dog doesn't seem to be getting the point, help her out by either changing training equipment or, in this case, adding treats. That said, the more you use treats, the more "transactional" the exercise becomes and the less "relational." These two attributes are always interwoven, but as training progresses your goal is to emphasize the relational in order to produce reliability in all situations.

Finally, with the chest-leading harness, there is one thing to watch out for, both with this exercise and in general. The leash connects to the harness on your dog's chest at a low center of gravity. This means that, if your dog dashes forward and hits the end of the leash abruptly and with force, she may flip over. Thus, be sure to allow some "give" in the leash as she's about to hit the end. This softens the stop and should prevent her from accidentally flipping.

"Ah-ah"

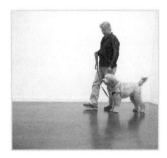

Hold your leash as described in exercise 43, and walk with your dog.

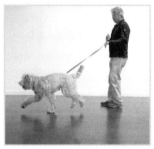

As she forges ahead, drop the slack in the leash and simply stay put. Do not warn your dog or turn in the other direction.

As she hits the end of the leash, stand firm while issuing your negative marker, "Ah-ah."

Once your dog comes to a stop, use your leash to redirect her toward you.

"Good with me"

If you need or want, present a treat at this point to reorient her focus on you. In these photos, I'm not holding a treat, though the dog is looking for them.

Then use a combination of your leash and/or treat, and work her back into the proper heel position next to you.

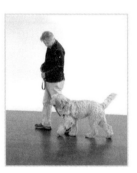

Then resume walking and repeat the routine until …

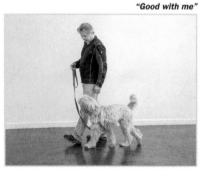

… your dog has figured out that walking alongside you is the way to go. Feel free to experiment with the use of treats, always looking to thin them out and raise the bar for what's expected. As your dog walks nicely near you, use positive markers, like "Good with me," to help her understand what you're looking for.

Adding an Accomplice

Repeat this exercise until your dog stops with you without a prompt or cue other than that you've stopped walking. Once you've gotten to this point, use an accomplice to help you take it to another level.

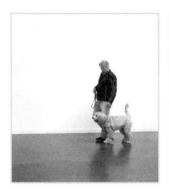

As you walk with your dog…

"With me"

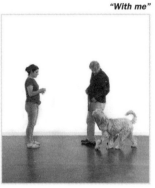

…approach your accomplice, who has some delicious treats in her hand. Remind your dog to stay by saying, "With me." If she pulls, practice the above.

"Sit"

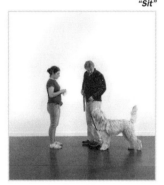

As you reach your accomplice, try to keep your dog's focus on you. Talk to her. As you stop, ask your dog to sit.

"Good sit"

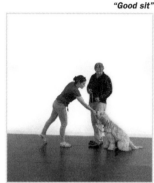

When your dog sits, have your accomplice give her a treat.

The prong collar is one of the most misrepresented and maligned pieces of equipment in the trainer's toolbox. It's also one of the most powerful. It *reduces* the level of force that's used by about 95 percent over anything else that's out there. That's not an exaggeration. Unfortunately, due to its draconian appearance, it's often difficult to convince people of this. In fact, when teaching your dog not to pull on a leash, it usually takes no more than two or three turns, some *mild* tugs on the prong collar, and all of one or two minutes.

It's precisely because the prong collar is so powerful that you need to use it properly and introduce it gently. Always start with the "gentle version" of the Pay Attention Exercise below.

A properly fitted prong collar should fit snugly around your dog's neck without actually compressing it. The chain part of the collar should generally ride at the back of your dog's neck, though it often slips a bit to one side or the other. However, if it slips *under* your dog's neck, it should be readjusted.

The Gentle Version of the Pay Attention Exercise

This is essentially a very gentle version of exercise 43, the "Pay Attention Exercise." When using a prong collar, always start with this. In many cases, this is all you'll need to dramatically transform your dog's leash behavior, and not out of fear, but out of connection. Remember, this exercise makes you the safe place for your dog and strengthens the relational dimension of training. Only continue with the full version if you have a very powerful, high-spirited dog who doesn't respond quickly to this one.

Note that at the time of this photo shoot, I'd never worked with this dog before. I didn't use treats, toys, or other motivators of any kind. Yet, after only one turn, we formed the connection and level of attention you see. Also note the dog's attitude. She's happy and upbeat and intensely focused on *us* and our teamwork together. While prong collars aren't for everyone, when used correctly they can enhance your bond very quickly.

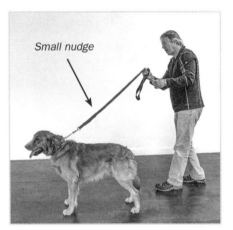

Small nudge

While walking, with your dog slightly ahead, give a gentle tug on the collar, just enough to get your dog's attention. Every dog is different, so experiment and build gradually. The whole point is to see how *little* you can do to get your dog's attention. DO NOT YANK!

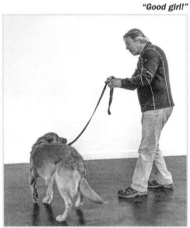

"Good girl!"

The moment your dog turns her head toward you, clap your hands, praise wildly…

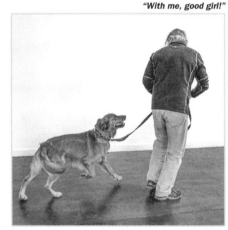

"With me, good girl!"

… and begin moving in the opposite direction, all the while continuing with enthusiastic praise.

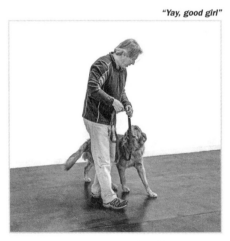

"Yay, good girl"

As you move through your turn, keep her attention, *not with treats*, but with ongoing, high-spirited verbal praise.

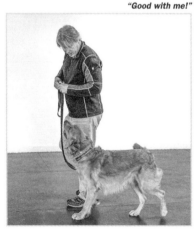

"Good with me!"

Continue walking forward again as you keep engaging with her. If she starts forging ahead again, repeat the sequence.

Switching between the Prong Collar and the Flat Collar

Often, once people see just how effective and *low force* prong collars are, they're happy to jump on board. However, despite this, they'll often ask the same question: "Will I always have to use the prong collar in order to get my dog to pay attention to me and walk nicely?" The answer is no. Once your dog has learned how to walk nicely on the leash and continued to demonstrate that knowledge *for some months*, you can transition to a flat collar. However, make sure that you've got several months of consistent performance in order to be sure that your dog has really internalized what proper walking is and shed the habit of pulling altogether.

Further, it's *very important* that you switch collars as instructed here, by doing so multiple times *during the same session*, and then repeat this exercise until your dog demonstrates no difference in how they walk when wearing a flat collar. DO NOT simply use the prong collar one day, and then one day stop entirely.

Switching back and forth from one day to the next will almost immediately lead to "equipment orientation," in which your dog will learn to adjust her behavior according to the equipment she's wearing. Even one iteration of this can set you back and mean that you'll have to spend a long, compensatory amount of time working to override this knowledge. Instead, by switching collars back and forth during the same walk, after some months of your dog wearing it regularly, you can make on-the-spot adjustments depending on your dog's behavior, so she doesn't learn to start pulling again with impunity.

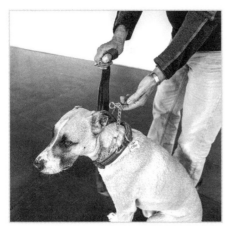

Make sure your dog is already wearing a flat collar, with the leash attached to the prong collar. Then, at some point while walking, ask your dog to sit.

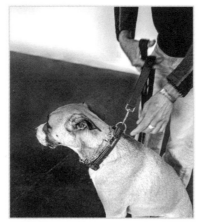

While she's sitting, in as sneaky a way as possible, quickly switch the leash from the prong collar to the flat collar. Do this so that your dog doesn't really notice.

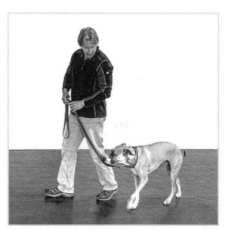

Then continue walking, with the leash now attached to the flat collar.

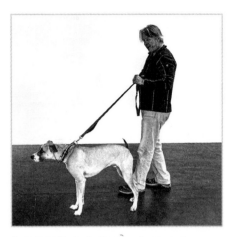

As you walk, include a few turns and changes of pace to test whether she's really paying attention and staying with you.

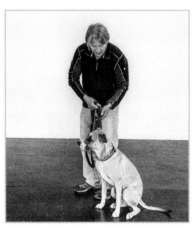

If at some point she begins to pull, ask her for another sit.

Then switch the leash back to the prong collar and practice a few more turns.

✪ Note

Make sure to switch the collars back and forth on your dog multiple times during the same walk. However, if you find that your dog starts to pull soon after switching to the flat collar, or you have to switch to the prong collar often, it suggests that maybe you haven't worked long enough with the Pay Attention Exercise to sufficiently establish the habit of good walking without the help of the prong collar. In that case, practice a few more weeks before trying this again.

One of the key things I want all dogs to learn is an emergency stop coupled with a distance down. I want my dog to be able to stop and drop into a down-stay out of a full run at distance. When might this be useful? When you want your dog to stop moving forward or in any direction but not come to you. For instance, say your dog has run across the street after something, and you don't want her to keep going but you don't want her to return across the street to you. You want her to stop, drop, and stay until you can retrieve her. This sequence of exercises will achieve that.

In order to teach this exercise, it's important for your dog to have already learned down at a distance (exercise 14) and down out of motion (exercise 23). Knowing these will help your dog understand more easily what you're looking for. Also, it's helpful if dogs are already familiar with *body blocking*, which I first introduce in sit-stays (exercise 30). However, if your dog hasn't already learned about body blocks at this point, that's fine; she'll learn now.

A key part of teaching the emergency stop is to help your dog understand that in fact there is an emergency and she MUST stop immediately! Remember, the difference between stopping immediately and taking a few more steps before dropping can be the difference between being in the street and not being in the street. That's why, when introducing this exercise, I tend to be abrupt and even sharp, if needed.

"STOP!"

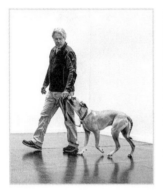

Begin walking with your dog.

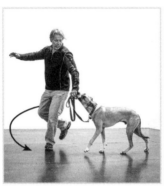

Suddenly, step around in front of your dog. Plant your left foot in front and pivot on it to face her.

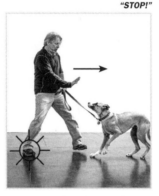

Stomp loudly with your right foot to startle and interrupt your dog and abruptly move toward her. Put up your stay hand signal and sharply say, "STOP!"

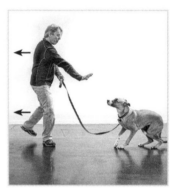

The second she puts on the brakes, stop moving forward with your body block and step back to create a little distance. This is important! Any dog will stop if you block her path, but you want your dog to learn to stop at a distance from you. Build this in from the beginning.

"Good stop"

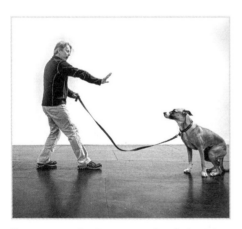

Be sure to maintain your stay hand signal in order to help her understand that you want her to stay right there.

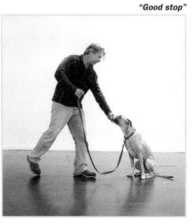

So long as she stops — regardless of what position she's in — and does not continue forward, giver her a treat accompanied by your positive marker.

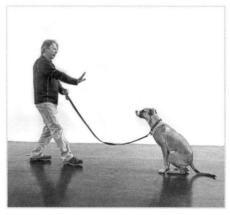

Then immediately back away a few steps while keeping your stay hand signal up…

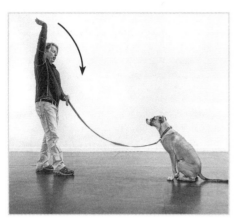

"Down"

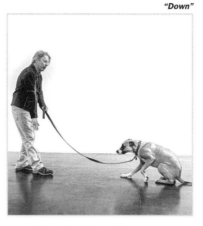

"Good down"

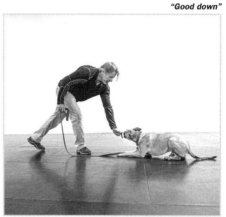

...then raise your hand...

...and drop her into a down.

Again, immediately come forward to give her a treat.

The Finished Product

Emergency stops usually don't take long to teach, though you may need to add some compulsion with a leash at first (see exercise 48). However, eventually, your dog should immediately go into down when stopped; here is what you're aiming for.

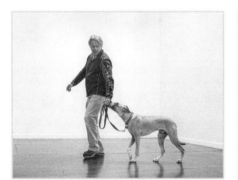

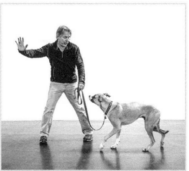

"Stop"

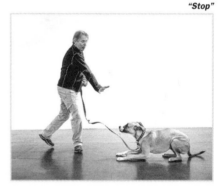

As you're walking...

...suddenly step ahead, stomping your right foot in front of your dog.

Throw out the stay hand signal, issue the sharp command, "Stop!" and simultaneously step back.

"Stay"

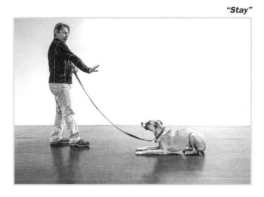

"Good stay"

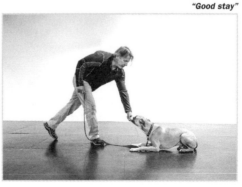

As soon as she's down, command, "Stay." The moment she settles...

...quickly reward her with a treat.

Most dogs will learn an emergency stop using only a body block, but some are not so easy and require physical compulsion using a leash. Not everyone wants to use physical compulsion, and if you don't, then simply keep practicing exercise 47 until your dog puts it together. However, this is a potentially life-saving command, and I want dogs to understand from day one that this is not a game. Further, some dogs are simply tough, driven, and willful, or they may try to turn the emergency stop exercise into some kind of evasion game. As with using a leash to demand behaviors in part 7, I have no issue with using some compulsion to demand certain behaviors, but see the sidebar below, "Evaluate the Level of Correction," for more on how to judge what is appropriate and what isn't.

"Stop" *"Stay"*

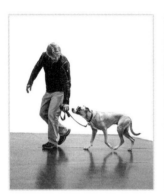 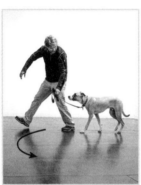 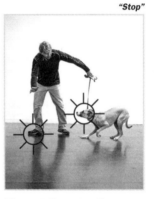 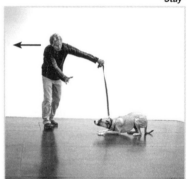

Begin walking with your dog.

As before, step in front of your dog as a body block.

Then, at the same time, stomp your right foot, say, "STOP!" and add a quick upward snap on the leash.

Immediately, step back and say, "Stay." Often, dogs are so startled they not only stop but drop into a down as a submissive gesture. If that happens, immediately reward with a nice treat.

⭐ **Evaluate the Level of Correction**

Physical correction should be avoided when training dogs as much as possible. However, despite strident claims to the contrary, I find it is necessary *in some cases* in order to get the reliability and compliance you need.

This raises the question of how forceful to be when giving a correction. In my view, both over- and undercorrecting are problematic. If someone continually undercorrects in order to be nice, they will generally end up giving meaningless corrections repeatedly, which, in my view, is a form of abuse. Overcorrecting is also abusive for the obvious reason — it's too harsh and can cause dogs to experience excessive anxiety and to shut down.

What you want to find is the level of force that teaches the desired behavior with no more than one to three corrections. That level of force will vary from dog to dog, so it's up to the owner to evaluate what's appropriate for their dog, which is a balance of effectiveness and compassion.

When you're not sure, start by being less intense and see how it goes. But don't repeat that level of intensity for too long or if you don't see improvement; this risks your dog becoming immune to your corrections or toughening up against increasing levels.

The point of corrections, of course, is not to keep giving them. They are temporary teaching aids and should be used only a handful of times in a context of massive positive reinforcement in order to highlight or compel a behavior that you know your dog already knows how to do. Of course, if your dog doesn't understand what you're asking for, no amount of force will help. So please be sure that you've properly taught behaviors before enforcing them with compulsion.

Again, corrections are a very temporary training aid *in some cases* that you want to put behind you as soon as possible.

It's important to work emergency stops without a leash, at a distance, and from different angles because you never know when in real life you're going to need them. Dogs can learn emergency stops in a specific training context and perform quite well, but that doesn't automatically translate into unexpected situations in everyday life. Here I present several variations, but experiment with your own and practice in different contexts, such as outside (see exercise 63).

Emergency Stops without a Leash

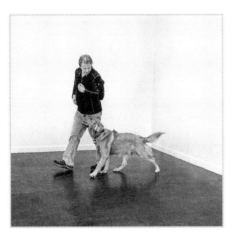

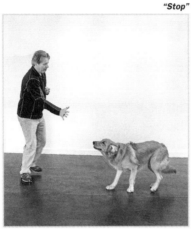
"Stop"

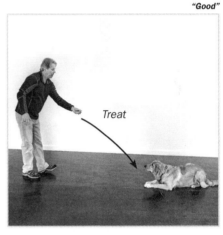
"Good"

Treat

Begin by heeling with your dog.	Suddenly, step around and in front of her using a body block, raise the stay hand signal, and command, "Stop."	Simultaneously back off, and as she settles into down, toss a treat into the area between her feet.

Emergency Stops at a Distance

Do this when you're already standing at a bit of a distance. In fact, try this after the previous emergency stop: A moment or two after you've released her, ask for another emergency stop.

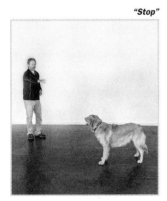
"Stop"

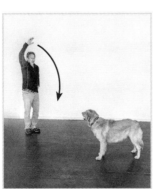

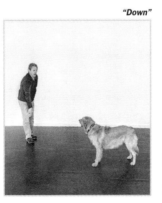
"Down"

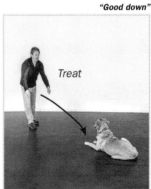
"Good down"

Treat

After the previous emergency stop, and after your dog has taken a step or two, turn to her, say, "Stop," and put up the stay hand signal.	Because she's now at some distance, use the field hand signal for down. Raise your signal hand in the air…	…and lower it while saying, "Down."	The moment she drops, toss her a treat accompanied by your positive marker.

At Different Angles

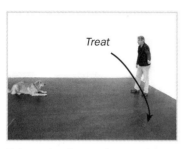

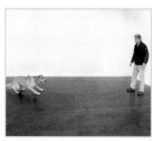

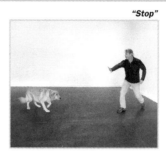

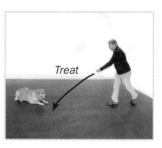

"Stop"

Treat

Treat

Release her from a down and encourage her to run in a direction at an angle away from you. One strategy is to toss a treat to the side.

Let her take a step or two in the direction of the treat…

…and suddenly raise your stay hand signal, take one step toward her, and strongly command, "Stop."

When she does, immediately reward with a tossed treat.

As Your Dog Moves Away

This is the same technique as practicing at an angle, but make sure your dog is turned away from you. Toss a ball, a treat, or anything your dog finds exciting.

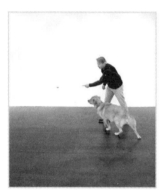

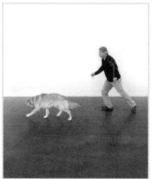

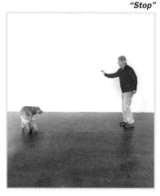

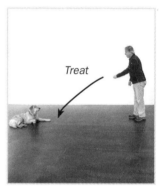

"Stop"

Treat

Toss a treat (or anything) and encourage your dog to go for it.

Let her take several steps…

…and then command, "Stop," in an urgent tone while raising the stay hand signal.

If you've practiced enough, your dog will look at you, stop, and drop into a down-stay. If so, toss a treat; if not, keep practicing the previous techniques.

⭐ Don't Do Too Many Emergency Stops in a Row

After teaching emergency stops, it's very tempting to practice it many times in a row to reinforce it. Don't do that!

Once your dog has learned emergency stops, don't do more than two or three in a row. Otherwise, you can seriously set back the progress you've made on heeling and recalls. Why? Because once your dog learns to anticipate that an emergency stop is coming, she'll respond to that anticipation by slowing down and getting ready to hit the stop. And slowing down in anticipation of an emergency stop kills the focused forward momentum you want in both heeling and recalls.

In other words, once your dog has learned emergency stops, sprinkle them in here and there when your dog isn't expecting them. This will keep your dog honest by making sure she remains alert to the sudden appearance of an emergency stop without being slowed down by anticipation. For more on this exercise, please go to my website at www.doggonegood.org/book-bonus.

There are many reasons to teach the command off, meaning "leave that alone!"

Off is key in helping your dog understand what's off-limits as well as returning her attention to you when faced with distractions. That makes off very helpful for improving other obedience commands, especially stay, heel, and come. In fact, a solid off command improves each of these between 50 and 70 percent.

Part 10 introduces multiple ways of teaching off. While some people use other phrases, like "leave it," any word is fine; it's the same thing.

Exercises 50 through 54 follow a progression, going from nonaversive to using increasing degrees of aversive control. These methods include mild physical contact, using a squirt bottle, and if needed, some leash correction. In *most* cases, some form of aversive control is necessary to produce reliability with the off command. That's because you're generally using it to get your dog to leave something alone that she's *very* interested in.

As I've noted, some people object in principle to any form of aversion, and one alternative some trainers suggest is giving dogs "time-outs" for failure to comply with off. Personally, I find that time-outs generally don't have much impact on dogs, except for the most sensitive or responsive dogs. In real-life situations that call for off, all dogs care about is getting to whatever they're interested in, consequences be damned. That is, unless the consequences are noteworthy. A well-taught off command warns the dog of noteworthy consequences.

Remember, aversive control doesn't have to involve causing pain or terror. It simply means doing something sufficiently annoying — like giving a squirt of water in the face — that your dog prefers that it not happen again, and so she chooses to obey certain commands to avoid that annoyance.

So, I suggest working your way through the part 10 exercises one at a time and in order. Slowly introduce the concept of off to your dog and discover which methods are most effective. Remember, as with all aversive control, the right level gets the message across in just a few iterations (see "Evaluate the Level of Correction," page 106). If that's not happening, move on to the next exercise in the progression.

This very basic exercise is designed to teach your dog the basic notion that when she hears "off" and backs away from what she was interested in, she gets a reward. This does not teach her that there are consequences for failure to comply. It simply introduces the notion that "off" (some people use "leave it" — same thing) means back away from something. But it's a great place to start, especially for sensitive dogs and very young pups.

"Off"

"Good"

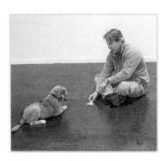 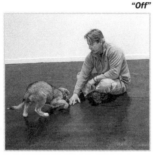 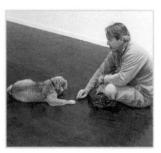 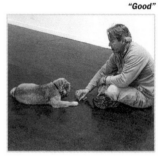

Get your dog's attention on a yummy pile of treats in front of you.

As she moves toward the treats, say, "Off," and cover the pile of treats with your hand so your dog can't get to them.

After some sniffing around, your dog will most likely lie back down wondering what to do. Mark the right choice with your positive marker, "good" and…

…immediately grab one of the treats and offer it to her.

⭐ Generalizing the Off Command

Introducing the off command with this simple, treat-focused exercise is an excellent way to teach the notion "leave that alone," but by itself it will almost never translate into a reliable off command in real life.

For that, most dogs require some degree of "aversive control" rather than the promise of a treat reward. That's because, no matter how good a treat is, there will be many instances when your dog is simply *more* interested in whatever she wants to do, grab, or investigate.

Which brings up another issue. While most of these exercises end by giving a treat as a reward for compliance, if that were all that was involved, this approach would soon become counterproductive. That's because dogs are excellent pattern recognizers, and they will quickly figure out that if they do something we don't like — say, pick up a dirty sock — get our attention, and then comply with our predictable off command, they will get a treat. And guess what? The unwanted behavior will increase. It shouldn't take a degree in psychology or animal behavior to figure that out. But many advocates of the "purely positive" approach simply deny or avoid this fact. Don't do that!

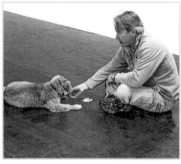

Repeat this sequence until your dog backs off without you having to cover the treats. This should take five to eight iterations. If not, then consider moving on to the next exercise.

Here's a slightly more assertive version for teaching off. It involves giving your dog a quick shove on the chest while issuing the off command in a forceful voice, but *without yelling or being angry*. The point is to interrupt your dog in order to get her attention back toward you, wondering what the deal is. It's a mild shove, not a punch or a slap! You are *not* hitting or hurting your dog in any way.

At the same time, the shove has to be abrupt. Very gently pushing your dog backward won't do the trick. This is difficult to demonstrate in pictures. You want your dog to be startled, but you don't want her so scared she runs away.

In short, start easy and work your way up as both you and your dog feel your way through this exercise.

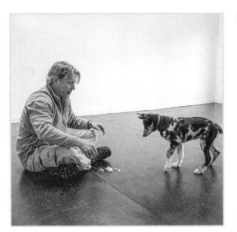

Place a pile of treats in front of yourself.

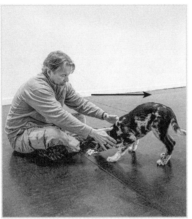

When your dog goes for it, give her a quick, somewhat abrupt shove back …

"OFF"

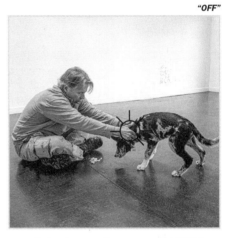

… and simultaneously command, "Off," in a strong, assertive tone (without yelling).

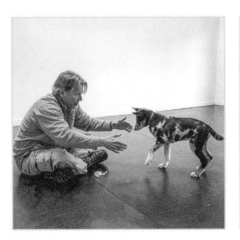

Wait a moment to see how your dog reacts. If she goes for the treats again, repeat the shove and command.

"Good"

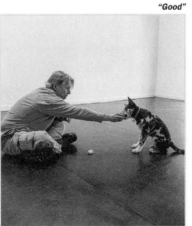

If she hangs back, even for a moment, reward her with a treat for her impulse control. Say, "Good," as your positive marker.

"OFF"

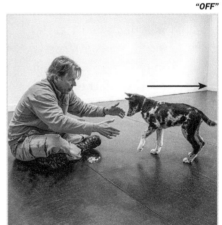

After three or four iterations, it should look like this: As she goes for the treats and you say, "Off," …

"*Good*"

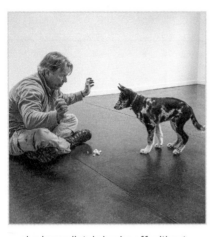

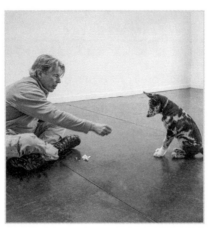

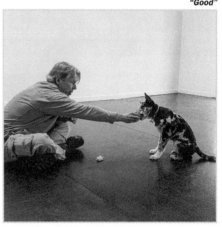

…she immediately backs off *without having to be touched…*

…and may settle into a sit.

If so, immediately reward with a treat and your positive marker.

Before using a squirt bottle, make sure to do both of the previous exercises, so that you know your dog understands what the word "off" means, even if she doesn't comply every time.

Using a squirt bottle is a step up in terms of aversive control, even though it is still mild and innocuous. Being squirted with water is annoying, which is the point, but no dog will be physically harmed by it, nor will this method be likely to cause a dog to become terrified or fearful.

To summarize: Begin by presenting your dog with a treat and telling her to take it multiple times in a row while letting her have it. Then, at *random* intervals, present the treat and instead say, "Off," and *give her a second to comply*. This is extremely important! If she withdraws, and follows your command, then you give her the treat. *Only if she doesn't comply* do you respond with a quick squirt from the bottle, which is otherwise hidden behind your back.

Note that *timing is critical*. For more on this, see the sidebar "The Importance of Timing with Corrections" (page 114). You must give your dog a one-second delay to hear what you've said, process it, and choose whether to comply. The point is to teach her that the second she hears the word "off" (or "leave it"), she must back away in order to avoid getting squirted. The idea is to empower your dog with conscious choice and increase her control over outcomes in her life.

As with the other mildly aversive methods in this book, your dog should start to comply with the off command after about three or so iterations of this exercise. If she doesn't, you need to change tactics.

First Practice "Take It"

Repeat this sequence five or six times before moving on to the next step.

"Take it"

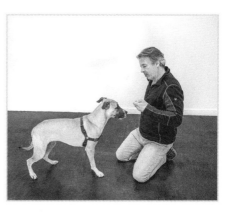

Show your dog a treat and tell her, "Take it." Give her the treat. Pause for a moment.

Then repeat this sequence half a dozen times: Show a treat; say, "Take it"; let her have it; and then pause before doing it again.

Adding "Off" and the Squirt Bottle

Please begin by reading the sidebar "On the Proper Use of the Squirt Bottle" (page 115) for tips on using the squirt bottle. Make sure the bottle is hidden behind your back, unseen by your dog; don't threaten her with it ahead of time. Then, only use the squirt bottle once, and only if you need to, and once you use it, immediately return to the "take it" exercise above. Repeat "take it" another five to six times before returning to the off command at random, unexpected intervals.

"OFF"

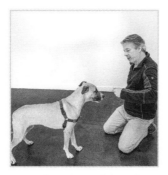

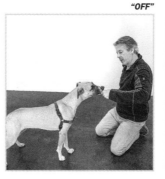

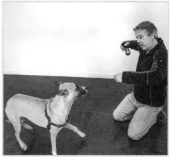

...le the squirt bottle behind ...ur back, and make sure your ...g doesn't know it's there.

As you have been doing, show your dog the treat.

But this time, as your dog reaches for the treat, say, "Off," in an assertive tone (but not yelling or angry).

After saying "off," wait one second for her to comply, and if she doesn't, give her a quick spritz with the water bottle on the nose and mouth, but NOT in the eyes. At first, after being told multiple times to "take it," most dogs won't respond to the off command, even though they understand the concept, so this part of the sequence will need repeating.

The Finished Product

Here is what this sequence should look like once your dog understands the rules and chooses to comply. Once this successful, move on to exercise 53, "Using a Squirt Bottle — Variations."

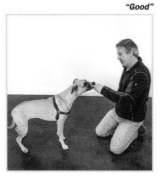
"Take it"

Offer the treat and tell her, "Take it."

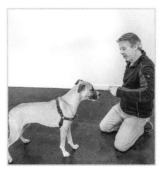
"Good"

Deliver the treat accompanied by your positive marker, "Good."

After a brief pause, again show a treat…

"OFF
…but this time say, "Off."

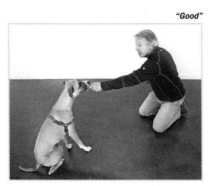

If your dog quickly backs off…

"Good"

…tell her, "Good," and reward her with the treat.

⭐ The Importance of Timing with Corrections

When teaching off using a squirt bottle (or when using leash corrections), proper timing is essential. Many owners make the mistake of giving their dog a correction at the same moment they say "off," and this makes the exercise unfair to your dog.

After all, your dog needs a moment to process your request and respond. That only takes a second, but that second is everything. If she hears "off," and in the following second immediately backs off from whatever she's focused on or reaching for, she's done what you've asked, avoided the correction, and should be rewarded and praised. This delayed response gives your dog a moment to process your request and comply with it and empowers her to make conscious choices and increase her control over outcomes in her life.

If your dog feels in control of whether she gets corrected, it empowers her sense of agency and builds her trust in you. An avalanche of research has consistently affirmed that when dogs understand the consequences of their choices in the face of a possible aversive, they don't experience elevated levels of stress. In fact, they usually experience lower stress than control groups in these studies. Why? Because they understand the rules and *are therefore able to avoid the negative consequence through their own informed choice.*

When dogs understand their world, they become increasingly confident, not more fearful, thanks to an increased sense of agency, and this develops the relational side of training, since you're the vehicle through which the world becomes more intelligible to your dog.

✪ On the Proper Use of the Squirt Bottle

When working with a squirt bottle, it's important NOT to be obvious with it. Keep it behind your back, and only reveal it if your dog doesn't comply, at which point you should whip it out to give a quick squirt. Then just as quickly hide it back behind you. It's important to deemphasize the bottle itself. You want your dog focused on you and the off command, not on whether or not you have a squirt bottle.

Warning your dog by waving the bottle will cause her to become "equipment oriented" (see exercise 46). She'll pay attention to your equipment and determine her behavior by that instead of listening to you. If that were the goal, it would mean you'd always have to show your dog the bottle before she'd decide to comply.

So when practicing this, hide the bottle and keep your dog from knowing whether you've got it or not. This way, the need for the squirt bottle quickly disappears, and your dog will comply promptly, with little to no further correction after the first few times.

After successfully introducing the squirt bottle, vary your use of it to help generalize the concept of off beyond the narrow training context. You want to teach your dog that whenever she hears "off" in any context she needs to stop and bring her attention to you immediately. You can also combine the commands off and come, which anticipates exercises 55 through 57, which combine off with other commands.

This sequence is very similar to the first squirt bottle exercise. Start by tossing treats to the ground and saying, "Take it." Then once every five to eight times, instead say, "Off," and use the squirt bottle if your dog doesn't comply. Then repeat the sequence. Remember, the goal isn't to teach your dog that treats are off-limits. The point is to teach her to instantly back off *anything* when she hears "off." And she should be ready to respond to this at random, unpredictable moments because that's what real life produces — random, unpredictable moments when you need your dog to leave something alone, *now*.

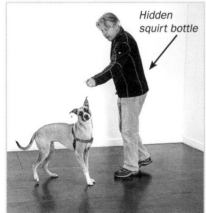
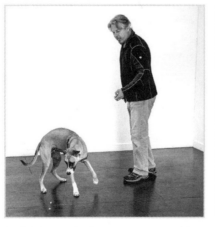
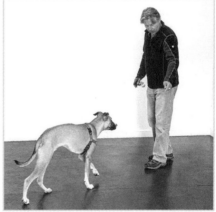

Outside or in a new location, toss a treat to the ground near your dog and say, "Take it," or say nothing at all.

Let her scoop the treat, and repeat this a number of times, until your dog is very comfortable.

Then, at a random interval, toss a treat yet again …

"Off" *"Good dog"*

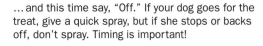 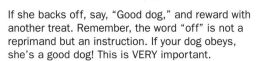

…and this time say, "Off." If your dog goes for the treat, give a quick spray, but if she stops or backs off, don't spray. Timing is important!	If she backs off, say, "Good dog," and reward with another treat. Remember, the word "off" is not a reprimand but an instruction. If your dog obeys, she's a good dog! This is VERY important.

★ Alternatives to Squirt Bottles

A squirt bottle is the simplest and most harmless way to teach the concept of off. But it's not the only available tool. This is a good thing because some dogs actually like the water squirt.

A "Pet Corrector" is a good alternative. It's a canister of compressed air that makes a sharp hissing sound and blows air out in a thick stream. It's *completely* harmless, but many dogs find it incredibly off-putting. Please don't use a Pet Corrector if you have multiple pets in the household as they might feel corrected as well though having done nothing wrong.

Or try a couple of "old-school" alternatives. One is a shake can, which is a soda can with five or six pennies in it that makes a loud rattling sound. Use it like the squirt bottle and rattle the can quickly if, after a moment to consider, your dog doesn't comply with off. Again, if there's another pet in the household you should avoid this approach. Another method is to toss a jangly set of keys, either on the ground near your dog or on top of the "off" object. Like the others, these are harmless ways to startle and interrupt your dog if she doesn't comply and return her attention to you.

Combining Off and Come

Developing a solid off command helps significantly improve other commands like come, heel, and stay. Why? Because you're pulling your dog's attention away from distractions and refocusing it back on you. While still working with a water bottle, introduce come as part of the sequence.

Once your dog learns this sequence, she's learned how to avoid ever getting corrected. Upon hearing "off," she should immediately come in order to receive a treat. Now, not only can she avoid correction through her own informed choice, she can receive a reward to boot. The need for further corrections should quickly diminish and disappear altogether, and the opportunity for positive reinforcement is further developed. Again, aversive control, especially in the context of heavy positive reinforcement, is quickly "self-extinguishing."

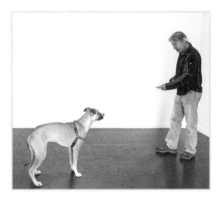

While practicing the previous sequence above, toss a treat to the ground.

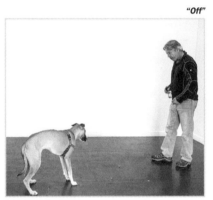

"Off"

As your dog eyeballs it, command, "Off."

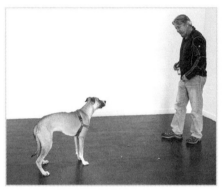

As she shifts her attention from the treat to you...

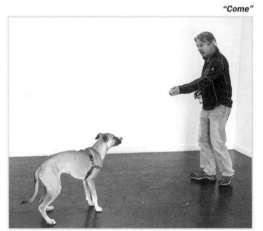

"Come"

...ask her to come...

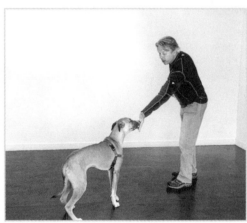

...and if she does, while ignoring the treat on the ground, reward her with a treat from your hand. As for the treat on the ground, either pick it up or simply leave it behind, but don't let your dog go back to grab it thirty seconds later. Anything designated as "off" should be permanently "off."

For some dogs, the previous sequences may prove sufficient to produce a solid off command and to generalize it to novel situations. If you find that your dog won't comply in more challenging situations even with a squirt bottle, using a leash correction may be an unavoidable step for developing reliability. However, it shouldn't be the first step.

Review parts 7 and 8 for more information on correcting with a leash and types of collars; this exercise can be used with any collar. However, please read the sidebar on page 119, "Correcting with a Head Collar," since head collars require a much gentler approach.

This exercise follows the same sequence. Begin by throwing one treat after another on the ground and letting your dog take it. After repeating this six or seven times, on the next toss suddenly command, "Off." Wait a second to allow your dog to comply, and if she doesn't back away, give a quick snap on the leash. The motion is like flicking a towel. *Don't drag your dog toward you or hold the leash taut!* The moment she backs off, whether you had to correct her or not, call her to come and then reward her with a treat (as in the previous sequence).

After tossing a series of treats on the ground and letting your dog take them, as in previous exercises, toss one…

"Off"

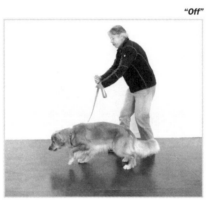

…and immediately command, "Off." Wait one second for your dog to process your command and decide whether to comply.

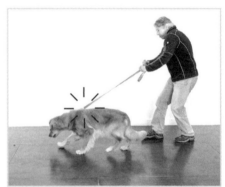

If your dog moves forward after having an opportunity to comply, give a quick, short snap on the leash, like a quick towel snap. Do not drag your dog back!

"Come"

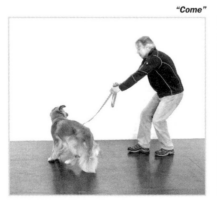

The moment your dog turns back to look at you, say, "Come."

"Good"

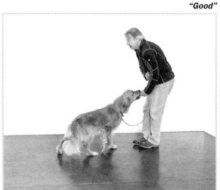

When she comes, reward her with a treat. As in previous exercises, repeat the entire sequence at this point: Let her take thrown treats multiple times before commanding "off" and leash correcting if necessary.

The Finished Product

After a few iterations of this, your dog will have put it together. As when you use a squirt bottle, your dog will learn how to avoid getting corrected and to immediately come after hearing "off" in order to receive a treat. Here's what the sequence should look like.

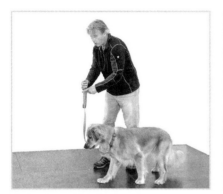

Toss the treat.

"Off"

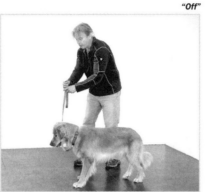

Command, "Off."

The second she complies…

…ask her to come…

…and reward with a treat. Then repeat this cycle, but issue the off command at random times, so that your dog doesn't anticipate this but has to listen.

✪ Correcting with a Head Collar

If you're doing this exercise using a head collar, such as a Halti or Gentle Leader, you have to be careful when giving the correction. In this case, you should NOT give a sharp snap on the lead because it could torque your dog's neck. That's not what you want.

Be much more gentle and use the halter to quickly steer your dog's head away from the treat and toward you. When her attention shifts to you, command, "Come," and reward her with another treat.

Once your dog has learned a solid off command, use it to help "proof" the stay command, which just means making stay more reliable. That said, first practice the exercises in part 5 until they are as reliable as you can make them.

For this exercise, use a ball, not treats, and once your dog is reliable with the initial exercise, add an accomplice. However, know that there will be times when the distraction of a toy overwhelms the strength of your off command. If this happens regularly, first review how well you've practiced both off and stay, and perhaps return to the basic techniques in parts 5 and 10.

"Stay"

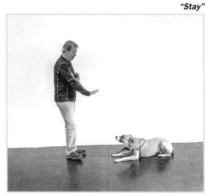

Place your dog in down-stay, using a commanding tone of voice and clear hand signal.

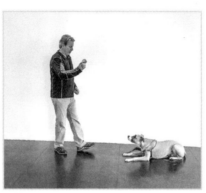

Show her a ball and tease her with it until it rivets her attention.

"Off"

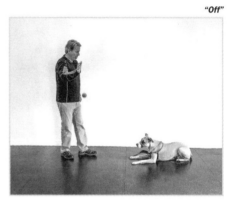

Drop it and simultaneously say, "Off."

"Stay"

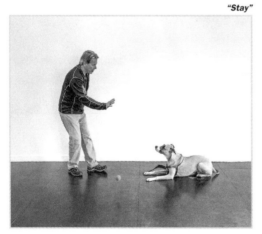

The second she takes her attention off the ball, tell her, "Stay."

"Good stay"

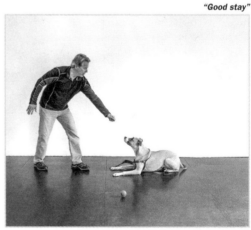

If she stays, immediately reward her with a treat and praise her with a positive marker.

If She Blows It, Use a Negative Marker

If correcting her with a negative marker, as shown here, does not work, then go back to more basic exercises before attempting this again.

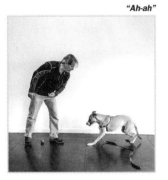
"Ah-ah"

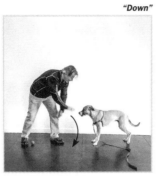
"Down"

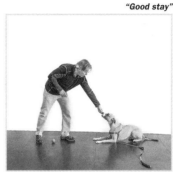
"Stay"

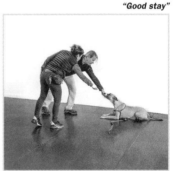
"Good stay"

If your dog rises out of her stay to get the ball, despite the off command, the second she blows it, issue a sharp, "Ah-ah."

Then quickly use the hand signal for down and say, "Down," …

…and when she settles into down, reissue the stay command.

If she complies, reward with a killer treat and praise with the positive marker, "Good stay."

Using an Accomplice for Off-Stay

In this exercise, enlist an accomplice to attempt to distract your dog with a really good treat. This shows one complete, successful sequence. When you get to the point where your dog will ignore a treat from a stranger in response to your off-stay command, you're ready to practice outside (see part II).

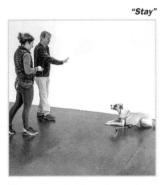
"Stay"

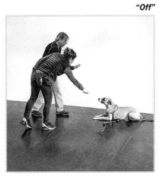
"Off"

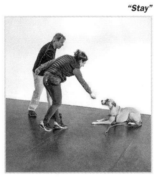
"Stay"

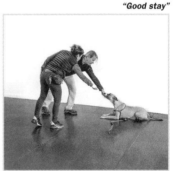
"Good stay"

Place your dog in a down-stay and back away.

Have your accomplice approach with a treat and attempt to lure your dog into blowing her down-stay. The minute your dog fixes her attention on the treat, command, "Off."

The second she shifts her attention from the treat to you, command, "Stay."

If she does, immediately reward with praise and a treat and end the exercise.

"Ah-ah"

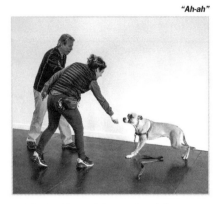

But if she blows it instead and rises, say, "Ah-ah," …

"Down"

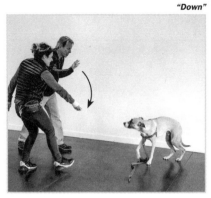

…and quickly command, "Down," along with the hand signal.

"Stay"

Once she's back down, remind her to remain in stay.

"Good stay"

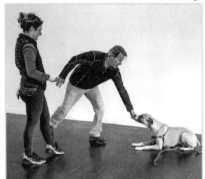

When she settles into it, reward her with a treat accompanied by your positive marker.

"Take a break"

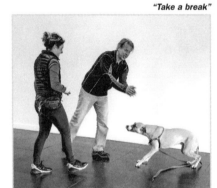

After this, release her with a clap of your hands and a phrase like, "Take a break."

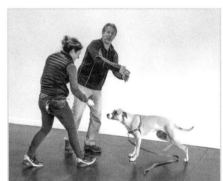

If you want, have your accomplice reward her with an additional treat. Remember, it's not about not having the treat. It's about exercising impulse control and checking in with you. After a break, you can practice again.

Using Leash Corrections with Off-Stay

Some dogs find temptation too hard to resist, despite lots of practice, hearing a negative marker, your authority, and the promise of a treat.

If so, consider using a leash correction with an accomplice to improve your dog's off-stay. If you get to this point, review exercise 54 and part 8, as well as the sidebar on p. 106, "Evaluate the Level of Correction," and remember: All effective corrections depend on correct timing, and if they don't get results in a few iterations, you need to stop and change tactics.

This sequence shows a chest-leading harness, but any type of collar can be used. Also, this uses a treat as a distraction, but a ball works just as well.

"Stay"

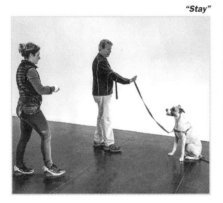

Place your dog in a sit-stay with your accomplice off to one side and slightly farther away. Run the leash between your thumb and forefinger to provide a fulcrum point.

"Off"

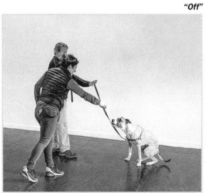

As your accomplice approaches with the treat, command, "Off."

"Ah-ah"

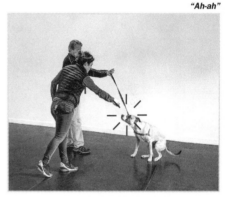

When your dog blows it and goes for the treat, issue your negative marker, "Ah-ah," and briefly pull up on the leash and quickly release.

"Ah-ah"

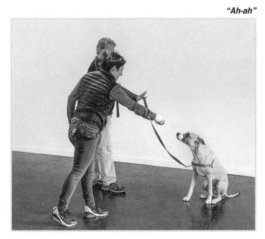

Your accomplice should NOT back away with the treat. You want your dog to leave the treat alone even when it's right in her face. If your dog goes for it again, repeat the correction, while your accomplice continues to hold out the treat.

"Good dog"

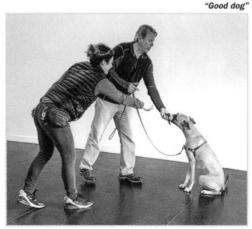

The minute your dog backs off from your accomplice's treat, immediately reward her with your own treat — preferably a better one — accompanied by a positive marker. Then release your dog, take a break, and repeat the exercise until your dog holds her off-stay without correction at all.

A solid off command can improve heeling in the same way it increases the effectiveness of stay. Remember, while heeling, your dog isn't supposed to leave your side regardless of what distractions exist in the environment. But it's inevitable, once you're outside in the real world, that you'll encounter all sorts of things your dog will find more interesting than heeling. That's when off can really help to quickly refocus your dog's attention on you.

Before trying this, review heeling (part 3) and make sure to have practiced your off command a lot. Also, this sequence uses a leash correction (the same one as with off-stay, page 123), but you might find that you won't need it if your off command is strong. That would be fantastic! If you do use a leash correction, review exercise 54 and part 8, as well as the sidebar on p. 106, "Evaluate the Level of Correction."

"Heel"

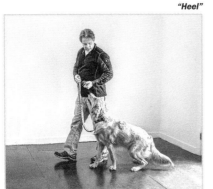

Begin by heeling with your dog.

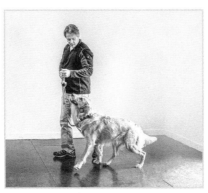

At some point, toss a ball, or some other major distractor, out to the side.

"Off"

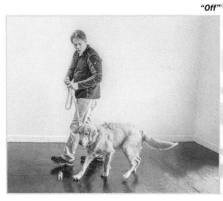

If the ball catches her attention and causes her to break out of her heel, strongly command, "Off."

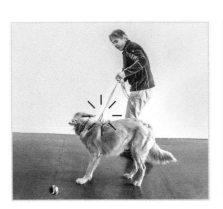

Wait a second to give your dog time to hear the command and evaluate. ONLY if she doesn't turn back toward you, give her a quick leash correction.

"Heel"

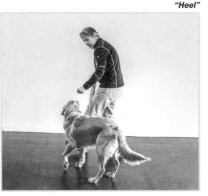

The second she turns back toward you, say, "Heel," and refocus her on another motivator, such as a toy or treat.

"Good heel"

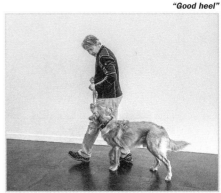

As she resumes heeling, provide a positive marker. This will serve as a sharp contrast to the correction, put her back in a positive frame of mind, and reconnect her with you.

Using an accomplice is also a good way to strengthen the off-come combination, which you first introduce while working with the squirt bottle (see "Combining Off and Come," page 117). Improving this puts you in the perfect position to recall your dog when you need to, no matter what is happening, and reward her before letting her go back to whatever she was doing.

In essence, the accomplice's job is to get your dog's attention with some yummy treat like chicken or string cheese. Let your dog lick and nibble at the treat for a few moments, until she's really into it. Then, at a random point, command "off." If she doesn't leave it and immediately back off — which she probably won't at first — give her a quick leash correction and immediately call her to come. This is the exact same sequence as when combining off with stay and heel (exercises 55 and 56), and it uses the same, towel-snap leash correction. However, DO NOT snap the leash if you're using a head collar. Remember, the mechanics of the head collar can torque your dog's neck, so steer your dog's head more gently (see "Correcting with a Head Collar," page 119).

As before, the timing of the correction is VERY important. Give your dog one second to comply with the off command; only give a correction once she's had a moment to process your request and comply and fails to do so. This is key to the exercise being fair and making aversive control self-extinguishing (see sidebar on page 126).

Finally, after working with an accomplice, adapt this exercise to any real-life context. When you're out walking and your dog gets her nose into something really interesting, once in a while command "off," have her come, reward her with a treat (or a toy), and release her. You'll quickly find that off-come serves you well in increasingly challenging contexts.

"Off"

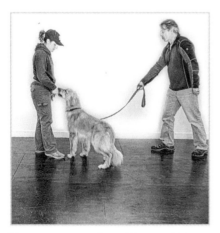

Have your accomplice offer your dog a treat and let her take it. Do this multiple times or let it happen for a while, without saying anything to your dog.

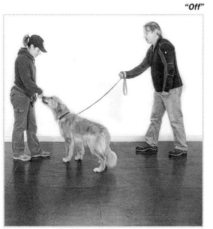

Then, at some point, as your dog reaches for another treat, command, "Off," in a strong tone without yelling.

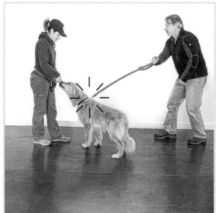

Wait a second to see if your dog complies. If she does not, give a quick leash correction.

"Come" *"Good"*

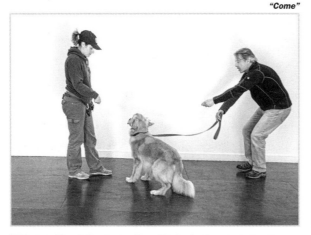 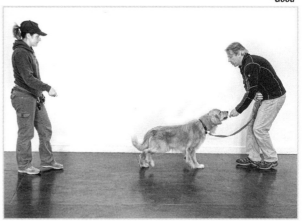

With or without the correction, the instant your dog pulls away from the treat and turns to you, *immediately* show her another treat and say, "Come."

When she does, reward her with a delicious treat. Then release her, take a break, and repeat this sequence again. It should only take about three iterations for your dog to leave the treat alone upon hearing off, without any correction.

✪ Aversive Control Is Self-Extinguishing

While most of the exercises in part 10 use some degree of aversive control to teach off, all of it is meant to be as mild as possible and short-lived. The goal is to influence your dog's decision-making process: These techniques let her know that there's a negative consequence for failure to comply *as well as positive consequences for compliance*.

It bears repeating that extensive research confirms that when dogs understand the consequences of their choices, this empowers them, provides a sense of control, and reduces stress in the face of the aversive to insignificant levels. Most of all, when executed properly, aversive methods are rapidly self-extinguishing. And most importantly, when used in the context of massive positive reinforcement for opposite behaviors, *aversive control quickly extinguishes the need for more of itself*. That's why evolution produced it as part of the behavioral repertoire of most living things — it works, and it does so quickly!

So far all the work we've done, extensive as it is, has been indoors in a controlled environment. That's as it should be. People also start their educations in controlled classrooms, so that we learn in a focused environment without unnecessary distractions. But at a certain point, we must take our knowledge and test and develop it against the challenges of the real world. It's the same in dog training. In the next two parts, you will go outdoors to improve and strengthen the techniques that you and your dog have learned so far, and then in the book's final part, you will take what you've learned to the streets and see how well it works in the hurly-burly of real life.

Perhaps the single most important command when out in public is come. However, producing absolute reliability with recalls is also the most difficult thing to achieve. After all, at the most basic level, dogs are hunters, which means they're deeply wired to seek and explore. They do it as if their life depends on it because once upon a time it did. So it is asking a lot to require your dog to set aside that impulse and return simply because you said so.

Nonetheless, that's what you're asking, and improving recalls outside should be your primary focus in training once you've successfully taught your dog all of the essential commands, like sit, down, heel, come, stay, and off. This is what part 11 does, but please note: Even though you are outside, you still use a leash for all of these exercises. In the last one, I show you how to get rid of the leash without subverting all your training.

Obviously, these exercises build upon the foundation you've already created with your dog in the preceding pages. In particular, reread part 4 for my general advice on recalls, and please pay special attention to the way so many people screw them up for their dogs without meaning to: They only call their dogs to come when they are doing something wrong or it's time to leave. This only teaches your dog that hearing "come" means fun time is over. Don't do that! Instead, set your dog up to succeed by training her that the opposite is true: Coming to you is the best choice of all.

When going outside, the first mistake people often make is immediately taking off the leash and letting their dog run freely. That seems like a nice gesture, since it gives your dog some uninterrupted playtime, but it also teaches her that, once the leash is removed, she's got the option to take off, and there's little you can do about it. Instead, until you've developed a decent outdoor recall, keep your dog on a long leash. If you motivate her to come without ever giving her the chance to run away and blow you off, it might never occur to her to do that.

Another mistake is calling your dog to come when she is in the initial phase of greeting another dog. Initial greetings are short but socially charged moments for dogs, and interrupting them puts unnecessary pressure on the dogs. Instead, wait a few moments until the peak of the interaction dissipates, and then try calling your dog.

Finally, in all these exercises, apply the

principles that I've discussed so far: When giving treats, incorporate and maintain random schedules of reinforcement (see "Random Schedules of Reinforcement," page 23), along with using multiple motivators to reward your dog, not just treats (see "Using Multiple Motivators," page 42). Then, pay close attention to the level of distractions in any given outdoor environment, and when distractions are high, close the distance between you and your dog (see "Difficulty versus Distance," page 137).

To start improving outdoor recalls, first revisit the Pay Attention Exercise (exercise 43), which I've tweaked for this new context. However, don't jump right into this. Begin this and every outdoor session with your dog with a brief recall warm-up.

Short-Leash Recall Warm-Up

Whenever you go on an outing with your dog — whether to the beach, a park, or wherever — spend the first few minutes running her through a string of super easy, highly rewarded recalls using a six-foot leash. Keep this simple, high energy, *and impossible to fail* (see "Outdoor Training Requires High-Value Treats" on page 130). Remember, when you call your dog to come, praise her *as she is returning* and be extremely enthusiastic. Squeal like a twelve-year-old cheerleader! Praise is like a beacon or homing device that helps your dog stay focused on you and energizes her to come. Enthusiastic praise is easily half of your success.

With your dog on a short leash, let her know that you've got some killer treats on you as you walk.

"Luna, come"

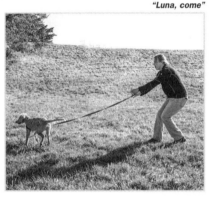

At some point, your dog will wander off a bit. Let her do this for a while, but then in a happy, upbeat tone, call her by name and say, "Come."

"Yay, good girl"

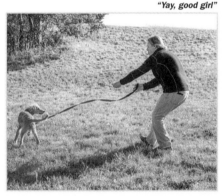

As she turns toward you, make the treat in your hand obvious and *begin praising immediately!* DO NOT wait to praise until she arrives.

"Yay, good girl"

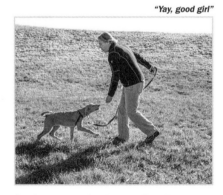

As she comes, back away from her, almost making her chase you, while extending a treat and almost letting her have it. Backing away triggers a follow response in your dog that's super helpful when trying to teach recalls.

"Sit, watch"

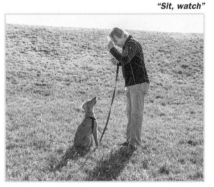

Then ask her to sit and bring the treat up to your forehead and say, "Watch."

"Good"

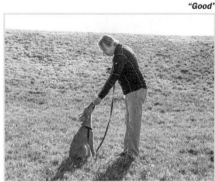

Finally, deliver your treat, and repeat this exercise, rapid fire, for five to eight minutes.

Pay Attention Using a Long Leash

Once your dog is warmed up, switch from a six-foot leash to a thirty-foot leash. Here, I'm using a "BioThane" leash. I love this material because it's lightweight, tough, has no give, and doesn't soak in dirt or water. That means even if your dog is dragging it through the surf and sand, it's not going to pick any of that up and add weight to the leash.

The purpose of this exercise is the same as the first Pay Attention Exercise (exercise 43), and the technique is almost identical. You're teaching your dog to pay attention and stay connected with you, even in public places, and you do that by changing directions unannounced until your dog learns it's in her best interest to keep an eye on you.

Use a thirty-foot leash of any kind. Have some in your hand while leaving most of it loose on the ground, so your dog has plenty of slack. Then start walking.

At some point while walking, your dog will wander away from you. If she appears to lose her focus on you, turn around and walk in any other direction *without warning your dog*.

If she doesn't notice, eventually the leash will go taut, usually not very hard, and she will turn toward you and usually begin following. Even if she doesn't follow closely or return, she'll now be tracking you and moving in your direction.

However, if she comes to you, either right away before feeling the leash tighten or afterward, reach down and pet her lavishly. Remember, you're the safe place. Repeat this sequence multiple times, until your dog is tracking you at a distance, regardless of whether there's a treat.

⭐ Outdoor Training Requires High-Value Treats

When you go outside in public to work on recalls, it's important to use the most high-value treats possible. I usually suggest steak, roast beef, grilled chicken, or cheese. It's important to have a motivator that can successfully compete for your dog's attention with all the powerful distractions impinging on her from every side.

If no treat is that powerful, then try skipping a meal prior to your outing. As I mentioned earlier (see "What If My Dog Isn't Interested in Treats?" page 2), strategically keeping your dog hungry is a tried-and-true method for increasing motivation. Plus, behaviors learned during a period of deprivation tend to stick better.

Adding Recalls

Once your dog is tracking you pretty well, and you've done the long-leash Pay Attention Exercise a number of times, add recalls with treats. This is no different than the recalls described in part 4.

"Maple, come"

"Yay, good girl, good girl"

As you're walking using the long leash, let your dog get ahead of you. At a certain point, call her by name and say, "Come." Make sure she sees your treat.

As she returns, praise her wildly, and continue this verbal praise to help keep her attention on you despite the many surrounding distractions.

When she arrives, guide her into a sit, using only a hand signal. This way, you build sit into the come command.

⭐ **Note**

If you recall your dog and she is followed by a bunch of other dogs who are interested in your treat, and who are jostling her around and making it hard for her to sit, forget the sit. Simply give your dog the treat and send her on her way. You don't want her to come to you and then not get her treat because she won't sit, which the other dogs are preventing her from doing.

Using Leash Corrections

Of course, it's inevitable that at some point your dog will blow you off and ignore your recall. She has more important things to do, like sticking her nose in a gopher hole and inquiring about the tenant. When that happens, use a quick leash correction to get her attention, then get her focused on the treat and both encourage and demand that she come to you. Make sure she understands that "come" is no longer optional.

"Maple, come"

"Ah-ah"

"Yay, good girl"

"Yay, good girl"

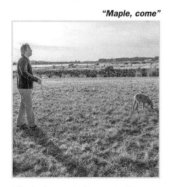
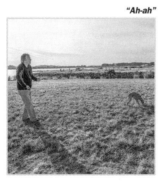
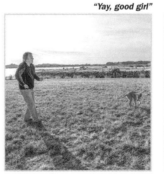
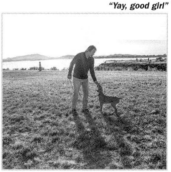

Maple is exploring a gopher hole. I call her to come but she doesn't respond.

When this happens, say, "Ah-ah," and tug briefly on the leash. How hard you correct depends on your dog; scale it to her disposition. The point is to interrupt her and get her attention. Find the level of correction that gets a response between one and no more than three times.

The second she even twitches an ear in your direction, show her your treat and start praising her like a twelve-year-old cheerleader.

When she arrives, reward her with the treat.

BACK-AND-FORTH RECALLS

In the sidebar "Recall Games with Friends and Family" (page 54), I introduced this simple exercise, which is a great way to improve outdoor recalls once you've practiced the long-leash Pay Attention Exercise.

You need an accomplice, but the exercise is simple: Stand some distance apart, and each person alternates calling the dog, so she runs all the way back and forth between you. Remember, each person should praise wildly the moment your dog even thinks about coming, continue this praise until she arrives, and then reward her with a treat.

Start the exercise relatively close together, and then move farther apart as it continues. Also, while you don't hold your dog's leash during this game, leaving a long leash attached acts like a security blanket, giving you a chance to stop your dog if she decides to go running off. When your recalls are solid, you can dispense with the leash.

Finally, this exercise works even better with three or more people standing in a wide circle. That way, the order of recalls can be randomized and your dog can't anticipate where the next recall will come from.

"Maple, come"

You and your accomplice should stand about thirty feet apart. One person calls the dog.

"Yay, good girl"

The moment the dog responds, that person should praise wildly and continue praising until she arrives.

"Good girl, go play"

Promptly reward with a treat and release her by saying, "Go play."

"Maple, come"

Then, a moment or two after the first person releases the dog, the second person calls her.

"Yay, good girl"

"Good girl, go play"

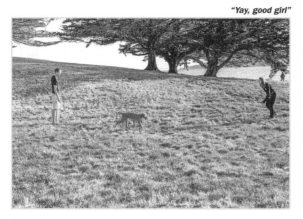

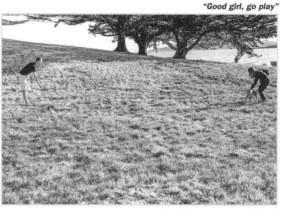

Remember, praise the whole time she's coming to you.

Then give her a treat and release her again. Rinse and repeat. Once the game is established, a good variation is to walk together while remaining apart and still calling your dog back and forth. This adds dynamism and the slight challenge of a changing environment as you walk. You can also attempt to call your dog back and forth through groups of playing dogs.

Vary the Pattern

Inevitably, if this is done with two people, your dog will begin to anticipate the routine by running toward the other person without being called, having learned that another treat is waiting there. When this starts to happen, the person she is with should immediately issue a negative marker, step on the lead if necessary, call her back, praise wildly as usual, and deliver another treat when she returns. You can avoid such anticipation by adding a third person to the routine and randomizing the pattern.

"Ah-ah"

"Come"

"Good girl"

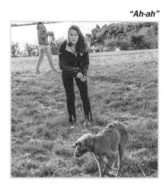

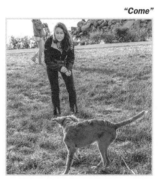

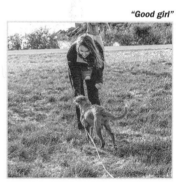

After reaching one person, your dog starts running toward the other person without being called.

Issue a negative marker, saying, "Ah-ah," to interrupt your dog…

…and call her back to you.

Praise her as she returns and reward her when she does.

Before doing this exercise, make sure to practice the off-come command in earlier exercises: "Combining Off and Come" (page 117) and exercise 57, "Combining Off and Come with an Accomplice" (page 125). Practicing this outside is significantly more challenging, but it's worth it. The better your off command, the better your come command — by about 70 percent! Why? Because "off," when it's well understood, gets your dog's attention off whatever she's doing and returns it to you. Once you've got her attention, everything gets much simpler, including recalls. Why? Because you've got her attention!

Remember, as before, the key to leash corrections is timing. (See "Evaluate the Level of Correction" on page 106 and "Importance of Timing with Corrections" on page 114.) In this case, give the command before your dog reaches whatever she wants in the environment (whether that's a thrown ball, another dog, or a gopher hole), and pause one second before giving the correction, to allow her time to process the request and comply. Of course, if she does comply, then there's no need for any correction.

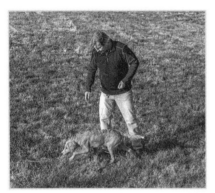

Here, Maple has spotted a loose treat in the grass.

"Maple, off"

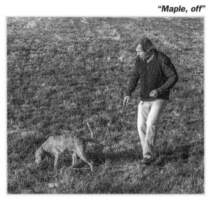

As your dog approaches what she wants, use her name and command, "Off." Using your dog's name helps ensure you get her attention.

Wait one second, and only if your dog disregards the command, give a leash correction. In this case, I've put my foot on the leash, which stops Maple short of the treat.

"Come"

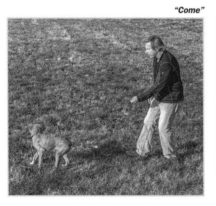

With or without a leash correction, the moment your dog turns to look at you, say, "Come," and present a killer treat.

"Yay, good girl"

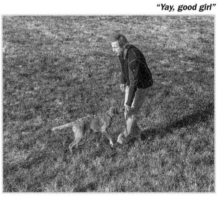

As she returns, praise her wildly and quickly reward her with the treat.

Once you've successfully completed all of this outdoor recall work, it's time to transition away from the leash altogether. This is one of my favorite tricks. Simply string together three, six-foot leashes, each of which can be removed as your dog hits increasing levels of reliability. Another approach is to use a thirty-foot leash, and then keep cutting it shorter until only a little tab is left on your dog's collar. But that wastes a perfectly good leash, and stringing three short leashes accomplishes the same result.

Using Three Leashes

Start with three, six-foot leashes strung together.

Toss a ball to get your dog running after it (as I've done here), or simply wait for something to attract your dog.

"Off, come"

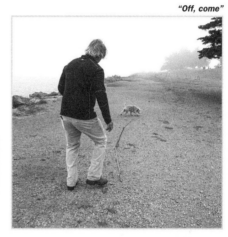

Well before your dog reaches the end of the leashes, issue the "off-come" command. Be sure to use a strong tone that she can hear through whatever other distractions might be nearby.

"Ah-ah"

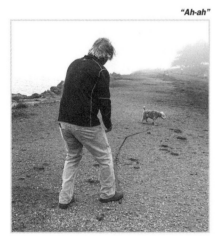

If your dog ignores the command, step on the leash as a mild correction and say, "Ah-ah," as a negative marker.

Ideally, after the correction, your dog will return. Praise her wildly and lure her with a treat. If she doesn't return after the quick leash correction, use the leash to pull her in.

"Yay, good girl"

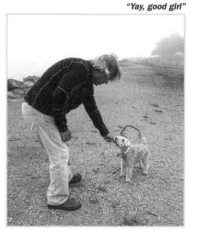

Once she arrives, reward her and release her. Rinse and repeat until your dog is reliable at this distance.

Removing the Leashes

Once your dog shows reliability, she earns the privilege of losing one leash, and after that, a second leash.

With two leashes on your dog, repeat the same exercise. Toss a ball to get your dog running ...

"Off, come"

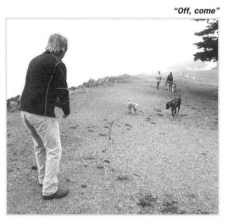

... practice the "off-come" command ...

"Yay, good girl"

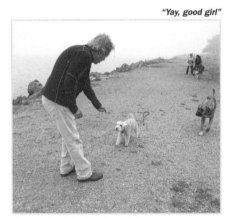

... and when she returns, reward her with praise and treats. Rinse and repeat as often as needed.

When your dog is reliable on two leashes, remove the second leash and repeat the sequence.

"Off, come"

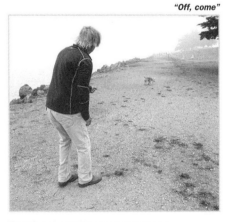

Practice the "off-come" command ...

"Yay, good girl"

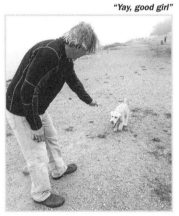

... and reward with praise and treats when she returns.

✪ Difficulty versus Distance

One of the basic principles of producing reliability in increasingly difficult circumstances is that, at least during the training process, as the distraction level increases the distance between you and your dog should decrease until you can produce reliability in the new context and begin adding distance again.

I always marvel at how often clients working on recalls will wait until their dog is in the most impossible situation before asking for a recall. They'll let their dog run free, do nothing to practice recalls, and then when she's eighty feet away playing with a group of other dogs or chasing birds, they decide it's a good time for a recall, even though they've done nothing to prepare their dog for that level of difficulty. Then they're shocked when the dog ignores them. *Don't do that!*

Remember to set your dog up for success even as you increase the level of difficulty. Trust me, your dog will make plenty of her own mistakes without you setting her up for them.

When I take a dog to my favorite beach to practice recalls, *I start in a very quiet area* with the dog on a leash, and I start practicing recalls from three or four feet away using killer treats — roast beef, grilled chicken, and so on. In the first few minutes, I'll practice fifteen or twenty very simple recalls, each ending with a juicy treat as a reward, and using the leash to redirect her toward me if she blows it. What I'm attempting to do is teach her that when she hears "come," if she appears in front of me quickly, she'll get an amazing treat she rarely sees at any other time and, most importantly, be immediately released to go back to whatever she was doing.

Once I've set the tone for our outing this way, I start calling the dog from farther and farther away. This tends to produce very good recalls pretty quickly *at this level of distraction*.

However, if I see a group of dogs playing and notice that the dog I'm with is very interested in joining the fun, I know that my recalls, which might have been great at fifty or eighty feet in an area with a lower level of distraction, are going to start falling apart. *So I close the gap.* When the dog is near the high level of distraction, I close the distance to maybe eight or ten feet, and then I work recalls again, being very obvious with the treat and also being sure to release the dog the moment she's come and taken her treat.

Also, I don't try to call a dog when she's right in the middle of a wrestling match with another dog. That's setting her up to fail because, if she's in the middle of wrestling, she actually can't come because another dog is all over her. In this scenario I wait until the dogs break up for a momentary breather, then I call the dog from a very close distance, reward her, and release.

If you keep working this way with your dog, she will slowly perform increasingly reliable recalls in this much higher level of distraction, so long as you are nearby. Only once this is the case should you start building in distance again. The same thing is true for stays.

Keep repeating this process until your dog's level of reliability is where you want it. Practice with low-level distractions in the beginning and add distance; then increase levels of difficulty and decrease distance; and when reliability is attained at the new level, add more distance again. And so on.

Off-Leash Recalls

Eventually, your dog will have had so many repetitions that the transition to off-leash recalls should go smoothly. If it doesn't, then go back to previous exercises and practice some more.

"Yay, good girl"

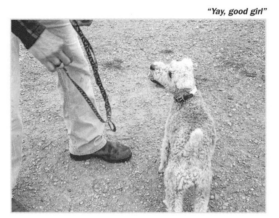

Take off the last leash.

Toss the ball as a distraction.

"Off, come"

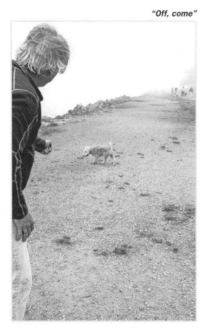

"Yay, good girl"

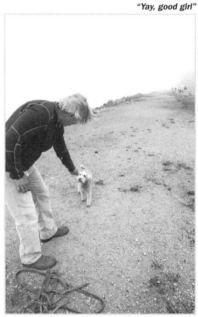

Use the "off-come" command.

Reward with a treat.

Before your dog is ready to be freely off-leash in outdoor places like beaches and public parks, you need to improve the reliability of commands when your dog isn't near you and all you have is your voice and your dog's motivation to listen. The outdoor recall exercises in part 11 are one step in this direction, but the outdoor exercises in this part, which use the ball as a motivator, might be the next step. Once you successfully complete these, you'll be ready for the ultimate test: real life.

Most dogs are motivated by balls to one degree or another, but these exercises work best when your dog is intensely motivated by them. If your dog needs some extra encouragement in this regard, see the sidebar "Increasing Your Dog's Ball Motivation" (page 140).

These exercises also presume that you and your dog understand and have practiced all the main commands to this point in the book. If you know you're weak in any area, or you discover a weakness while attempting these, please review those commands and practice them until they are solid before continuing. Also, make sure to review and practice all of the ball-focused exercises in part 6. These make excellent warm-ups to do right before trying the more challenging exercises here.

Before using the ball as a motivator for emergency stops and distance downs, warm up with some of the exercises in part 6. In particular, I suggest starting with exercise 38, "Using Two Balls to Get the First One Back." For your dog, this is simply fun, and you might need to work with two balls in some of the exercises that follow. Then, get more serious and practice the combined sit and down sequence here.

The dog in this part's sequences is Georgia, my photographer's eight-year-old Airedale. She's nuts for balls, but she had never done any of these exercises before. She was familiar with the basics covered earlier in the book, meaning she was precisely where your dog should be when you try this.

"Come"	"Sit"	"Down"		
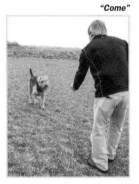	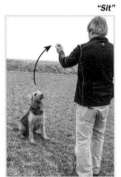	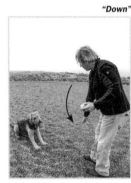	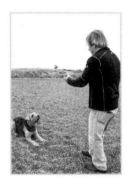	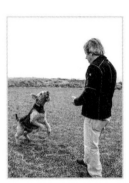
While your dog is off-leash, ask your dog to come, using the ball as a motivator.	As she approaches, keep her focused on the ball and use the ball hand as your signal hand. Provide the hand signal and say, "Sit."	Quickly follow by signaling and saying, "Down."	Then toss her the ball.	After a short break, rinse and repeat. Do this exercise several times.

⭐ Increasing Your Dog's Ball Motivation

Some dogs are born ball crazy. Some aren't. And some lie along a spectrum in the middle. On the whole it's best to figure out what your dog's primary motivator is and lean heavily on that when training. However, if you want to expand the types of motivators you work with, it's sometimes possible to dial up her ball motivation.

Years ago I worked with a Jack Russell terrier named Monty who had some interest in the ball but not to the degree that was helpful in training. So I spent two weeks trying to addict him to a tennis ball. Every day I'd have a few sessions where I'd show him a ball on a rope, swing it and bounce it around a bit to get some interest going, and then let him briefly grab it for a little tug-of-war or give him one or two tosses. Then I'd stop, put the ball somewhere he could see it but not reach it, wait a while, and repeat the sequence later. The trick is to get some interest going, and once it is, stop, tease your dog with the toy, and then put it away. This can slowly increase motivation.

I did this with Monty four to six times a day, and then basically ignored him the rest of the day. That meant that his only interactions with me came via either tug-of-war or fetch.

After a few days of this, I brought him outside, tethered him to a chain-link fence, and then dragged the toy around in front of him until he got worked up, let him take a few bites at it, and then put it and him away again.

As I repeated both of these processes, Monty's interest in both tug-of-war and fetch kept growing. And as it did, my engagement with him increased both in terms of time and intensity. But I'd always do my best to stop in the middle of the peak of his interest and leave him wanting more. At the end of two weeks, Monty was crazy for both tug-of-war and fetch, and it became easy to work these games into his training.

If you think your dog has some potential to increase their drive for toys and balls, give this a try and see what happens.

Once your dog is warmed up, practice adding distance to your down command. Do this in progressive stages at increasing distances, and at your farthest distance, work in an emergency stop.

Down from Stand: Close By

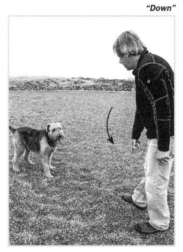
"Down"

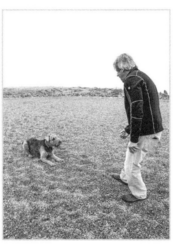

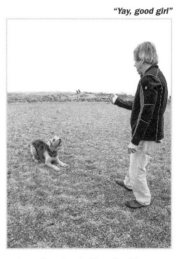
"Yay, good girl"

With your dog close to you and in a stand, show her the ball, signal for down, and say, "Down."

The second her elbows hit the ground...

...toss her the ball and add some wild praise.

From a Middle Distance

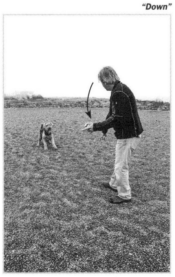
"Down"

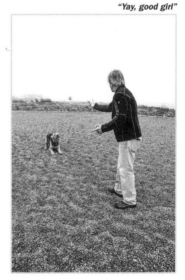
"Yay, good girl"

While your dog is about ten or fifteen feet away, show her the ball.

With the ball in your hand, give the hand signal and say, "Down."

The second her elbows hit the ground, toss the ball, accompanied by wild praise.

From Far Away

I recommend doing several rounds of throws from the middle distance before attempting it from far away. You want your dog primed for the throw and to jump the gun, running out ahead of your throw in anticipation.

Here I've faked my throw, and Georgia is barreling toward where she thinks the ball is going to land.

"Stop"

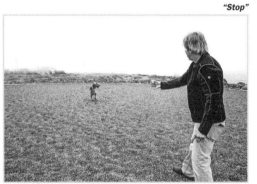

Let this continue for a moment, then get your dog's attention by loudly commanding, "Stop." Typically, this will startle your confused dog, who will turn and look at you. At this moment, clearly show her the ball.

"Down"

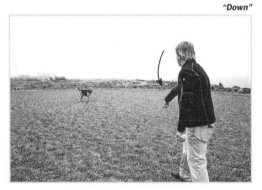

Then strongly command, "Down," while making the hand signal with the ball in your hand.

"Yay, good girl"

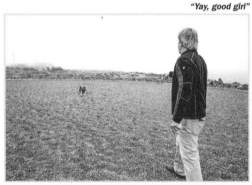

The moment she's down, toss the ball and praise wildly.

Emergency Stops on the Retrieve

In order to deepen your dog's understanding of the emergency stop, you have to add as much variability as possible and break up training patterns. For instance, your dog will quickly learn to anticipate that when you throw the ball, or fake a throw, you might toss in that emergency stop. So don't do it every time. Instead, throw the ball, let your dog retrieve it, and then on her return, ask for the emergency stop (for a refresher, review exercise 49).

"Stop"

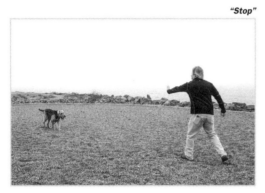

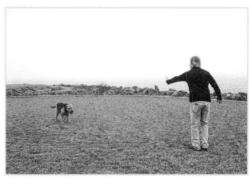

Here, Georgia has grabbed the ball and is heading back. As your dog returns, suddenly say, "Stop," and lunge toward her abruptly at the same time.

If you've practiced this enough, your dog will stop and drop pretty quickly.

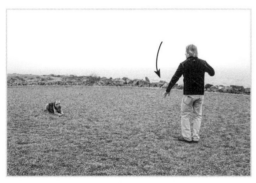

"Yay, good girl"

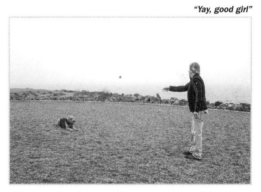

If she doesn't, add the down hand signal.

The moment she complies, reward her with a well-timed throw of the other ball and enthusiastic praise.

> ⭐ **Note**
>
> Once you've practiced this a few times, keep going, but mix in a few actual throws and pure play with fake throws and emergency stops and distance downs (as well as a few recalls, see exercise 66). If you don't vary what you do, your dog will stop falling for your fake throw. For a dog who's very driven by toys, teaching this in the context of a high-intensity game is very effective, and it will easily translate into situations when it isn't a game. Bear in mind that most high-level working dogs, especially protection and search-and-rescue dogs, are trained with toys as their primary motivator, not treats.

USING THE BALL TO

In addition to emergency stops and distance downs, balls come in very handy for improving stays, heeling, and recalls. If a ball-crazy dog can hold a stay when you throw the ball, she will be able to withstand all manner of other distractions as well.

When introducing this exercise, put a short leash on your dog. Teaching stay using a ball usually requires the leash at least a few times to interrupt your dog's attempt to take off after the ball. However, once your dog learns not to blow the stay, you can remove the leash for further practice.

"Stay"

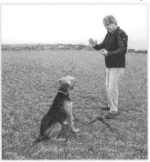

"Stay"

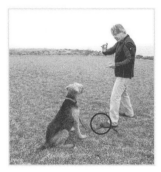

"Ah-ah"

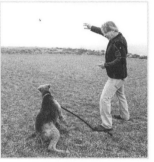

"Sta

Here, Georgia is wearing a leash. While simultaneously showing your dog the ball, display the hand signal for stay and command, "Stay."

Before you throw the ball, put your foot on the leash, especially the first time. Your dog is almost certain to blow it the first few rounds.

Throw the ball. If your dog breaks her stay to chase it, she will quickly hit the end of the leash. At that moment, issue the negative marker, "Ah-ah."

Remind her that she's on a stay, and if she holds her stay, you can opt to reward her with a treat or two.

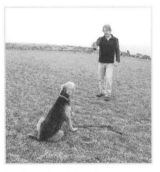

"Take a break"

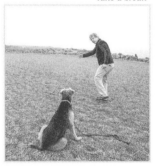

"Yay, good gir

While maintaining the stay hand signal, step back to add some distance.

Then release your dog by saying, "Take a break," …

…and encourage her to get the ball.

Praise her wildly as she returns. Rinse and repeat. (Please note that you can do this exercise from a down-stay as well and that you shouldn't remove the leash until your dog no longer blows it.)

Before using the ball to reinforce heeling, review part 3 and make sure heeling is solid indoors. Then, once outside, if your dog is wearing a leash, wrap it loosely around her neck (as shown in exercise 20), so if you wind up needing it, she's already wearing it.

"Heel"

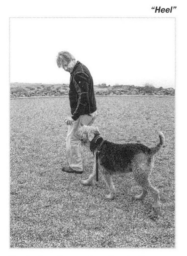

Begin heeling, using the ball as a motivator and point of focus.

"Good heel"

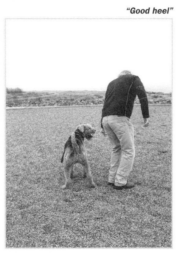

Remember to work turns into your routine.

"Heel"

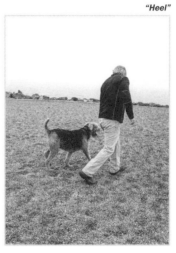

As you continue to heel…

"Sit"

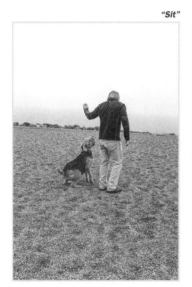

…ask for a sit.

"Heel"

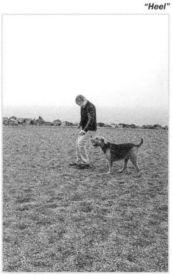

Then keep heeling and work more turns into your routine.

"Sit"

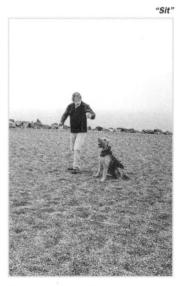

At some point, when you're ready to be done, ask for another sit, and then reward your dog with a ball toss and release her.

In this exercise, toss the ball, *and before your dog reaches it*, use the off-come combination (see exercises 54 and 57). If you can get your dog to come off the ball when she's halfway there, and from a full run turn on a dime and sprint back to you, you'll be able to get her to do the same thing in nearly any situation.

This is a good way to build variety into your distance down and emergency stop routines, but ultimately, your goal is to combine all of these ball-focused distance commands into improvised, random sequences that increase in length and complexity.

Get your dog's attention on the ball...

...and throw it.

"Off"

Wait until she builds up some real momentum, then in a strong tone command, "Off."

If you've been doing your homework, your dog should hit the brakes and turn toward you.

"Come"

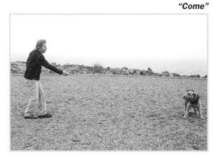

Command, "Come," and present a second ball as a motivator.

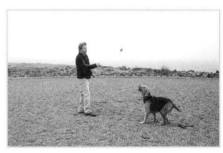

If she sprints back, reward her with an enthusiastic ball toss. Rinse and repeat.

Building Random Routines

Eventually, as you practice these ball-focused exercises on their own, start stringing them together into randomized, more complex routines. Get creative, mix it up, and raise the bar.

Remember, if you ask your dog to do something and she regularly blows it, step back and work on that technique separately. Otherwise, keep adding complexity to your sequences.

This is just one example.

"Stay"

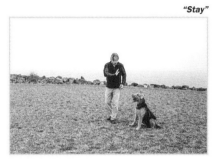

Start with your dog in a sit-stay…

"Down"

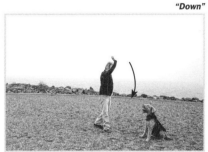

…and transition to a down.

"Stay"

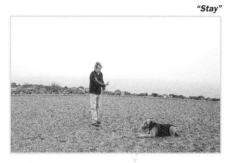

Back away while reminding your dog that she's in stay.

"Off"

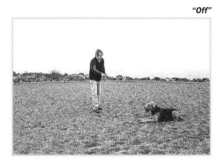

Toss the ball across her line of sight and command, "Off."

"Good stay"

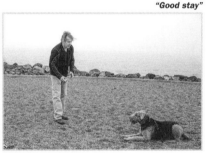

If she holds her stay, provide a positive marker only.

"Come"

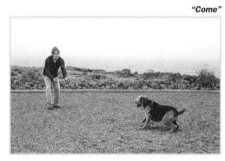

Then call her to come…

"Stop"

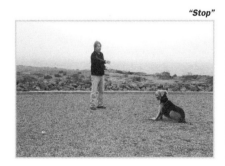

…and as she does, ask her to stop. Ideally, she will immediately stop and go down.

"Come"

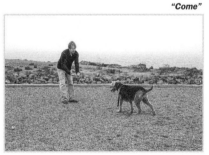

Then call her to come again…

"Stay"

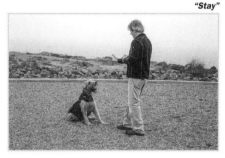

…and put her in another sit-stay…

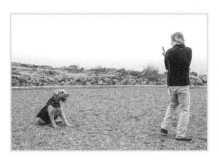

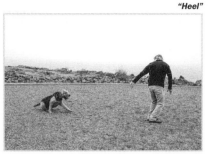
"Heel"

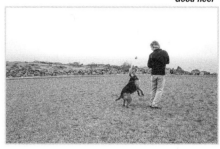
"Good heel"

... and walk away while maintaining the stay.

Call her into the heel while presenting her with the ball...

... and after she's walked in heel for a bit, reward her with a ball toss.

⭐ Using the Ball to Reinforce Recalls

Another area in which balls can be extremely useful training tools is in recalls.

When I get to the park or the beach, I pull out a ball and show it to the dog. The moment I have her attention, I throw the ball. When she retrieves it, I throw it again. If she wants to play keep-away, I use the two-ball trick (exercise 38). After several iterations of this, I make a big show of teasing the dog with the ball as if I am going to throw it again, and then I put it in my pocket and begin walking, ignoring the dog.

Usually the dog will bounce around me for a few minutes, barking wild-eyed, demanding, "Throw the ball, throw the ball, throw the ball." I continue to ignore the dog until she gives up and goes off after other adventures.

Then I repeat this pattern throughout my walk. It never takes long for the dog to be constantly dialed in to me in anticipation of the ball and immediately responsive whenever I call. When your dog can no longer tell the difference between playing and training, you're in the best position possible when it comes to responsiveness and reliability, never mind relationship building.

Now that you've worked your way through this book, you're ready to test your training against the distractions and surprises of the real world. In what follows I'll show you how to take the exercises you've learned and test them against the challenges of real life. This is something you can begin doing the moment your dog achieves a reliable level of performance in a more controlled environment.

And in the closing section I'll show some of my students at work with their dogs doing the exercises in this book. Each of these students came to my twelve-week training course knowing literally nothing, and they achieved the levels of performance you see here.

Not all of them are perfect, but that's just fine.

Training is a work in progress and there's always room for improvement, especially at the intermediate to advanced stages, which is what we're working our way through in this book.

But the exercises in this book, when practiced diligently, will not only produce a dog that will experience a high level of controlled freedom even amidst the challenges of a big city like San Francisco. They'll also produce a deep, lifelong bond of profound friendship that will enrich both of you. Getting you to that place has been a fundamental goal of this book and if you've worked your way through it to this point you should be starting to get a sense of what I'm talking about.

By this point in training, you shouldn't need treats for heeling at all, or if so, only occasionally. However, when you first start heeling in public, I suggest using treats again as lures and rewards. In the sidebar "Difficulty versus Distance" (page 137), I discuss how, when you're outside, distractions and difficulty levels increase, so at first you must decrease your distance with your dog. Then, as your dog becomes reliable with commands outside, you can increase your distance. With heeling in public, the same principle applies. While distance isn't an issue, since your dog will be right next to you, you may need to use treats temporarily to compensate for the high level of distractions in a public setting and to help remind your dog of what you're doing.

However, it won't take very long for your dog to get used to heeling in public, and as her reliability increases, fade out the treats again just like before.

Begin by showing your dog the treats in your hand...

...and then ball them up in your fist and have her target your fist to keep her focused.

Step 1: Blocking Distractions

Find a challenging situation — such as a busy city street with cafés and lots of people — and heel with your dog exactly as you did in part 3. However, initially, walk so that you are between your dog and the really high levels of distractions (like food and people). If she gets distracted, use off-heel (exercise 56), and throughout, continually talk to her and praise her, saying, "Good heel, good heel." Sometimes give her treats as you walk, and other times just keep her focused on your fist without delivering a treat.

"Good heel" *"Good heel"*

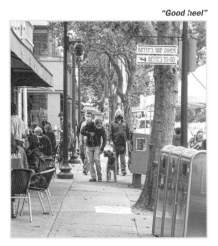
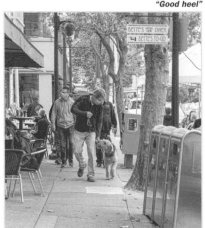
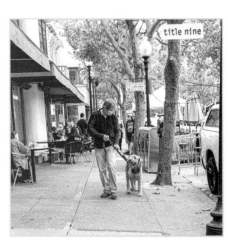

Step 2: Not Blocking Distractions

As reliability increases, switch positions, so that as you heel, nothing is between your dog and the highest distractions (in this case, tables full of food). Do this multiple times, using the same approach, and eventually fade treats away until you don't need them anymore.

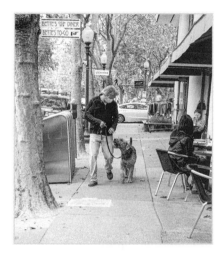

End in Sit-Stay or Down-Stay

In general, after passing through a high-distraction environment like this, it's always good to finish with a down-stay (or sit-stay). You'll likely do this thousands of times over the course of your dog's life. Out of the heel, guide her into a sit, then transition to a down and then a stay.

These photo sequences show an advanced outdoor class I taught at Crissy Field in San Francisco. The focus was on down-stays. The only goal was to ask the dogs to maintain their down-stays despite the increasing distractions and the increasing distance between them and their owners. We tackled this as a progression from easiest to hardest, exactly as I describe in the sidebar "Difficulty versus Distance" (page 137).

Step 1: Fewest Distractions, Closest Distance

We started in a less-busy part of the beach, away from pedestrians, in order to warm the dogs up. This was more challenging than our indoor work, but nothing compared to what lay just ahead.

"Stay"

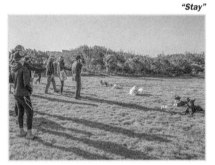

To begin, each owner is relatively close as they instruct their dogs to stay in down.

"Ah-ah"

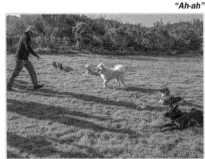

Of course, for one dog, the distractions are too much and he stands. I move forward and issue a negative marker.

"Down"

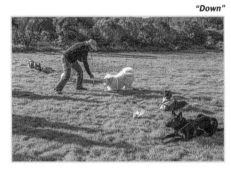

The dog quickly corrects himself without me having to touch him, which is the point of negative markers. Once all the dogs remain stabilized even after we add more distance, it is time for step 2.

Step 2: Increasing Distractions, Increasing Distance

Next in our progression, we raised the bar considerably. We moved to the Crissy Field bike and jogging trail that everyone uses, especially on a gorgeous Sunday like this one.

"Down"

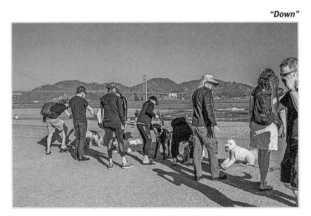

To begin, everyone settles their dogs in down-stays from a very close distance.

"Stay"

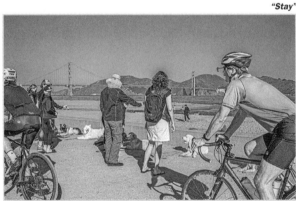

The owners initially stay close so that all the bikers, joggers, and other dogs pass *behind* them.

"Ah-ah, down"

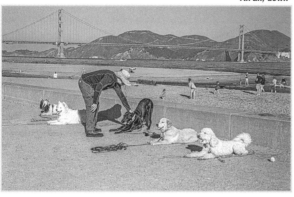

As we added distance, various dogs break their stays, and commands have to be reinforced multiple times in order to help steel the dogs against the new level of distraction.

"Ah-ah"

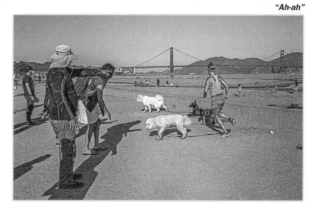

This is NOT easy! For two dogs here, the joggers are too much, and the owners move in to reset them.

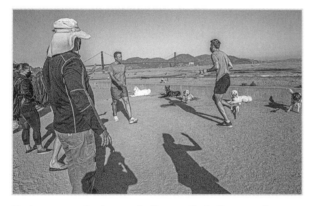

Next, we move back even farther, so that other people pass in between ourselves and the dogs.

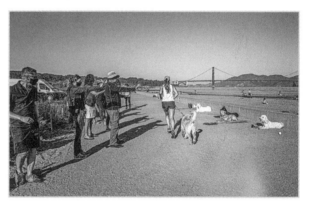

At this point, to help the dogs maintain their stays, we continuously hold up our hand signals. But we are not chanting the word "stay." The hand signal is now the visual reference point to communicate what we want.

Then we add even more distance. Notice how much farther away we are than in the first photo.

Periodically throughout, particularly after a few significant distractions, each owner moves forward to reward their dog with a treat, and then they step back and maintain the stay. These treats are a well-deserved reward for a job well done, not a way to cajole the dogs into doing the job in the first place. There's a big difference between a bribe and a bonus!

This sequence shows a client, Justin, working with his dog, Jackson, in real time. We were using a ball to work on emergency stops and distance downs (see parts 9 and 12), and while Jackson was doing great overall, he had trouble stopping at a distance without coming partway back to Justin before doing the down. That is an issue because, in a real emergency, those few steps could mean the difference between being in the street or not.

The Problem

"Stop, down"

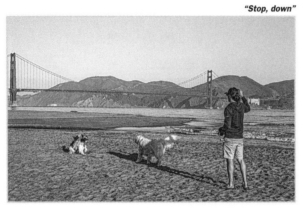
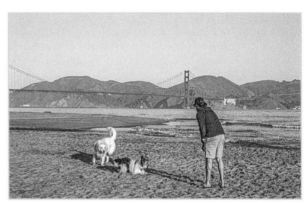

While Jackson explores at a distance, Justin commands down with an unknown white dog in between them.

Jackson successfully ignores the other dog and hits the down, but he takes several steps toward Justin before doing so. This needs to be fixed, but Justin appropriately rewards Jackson with a throw of the ball for the solid effort and enthusiasm.

Step 1: Stop When Moving Away

To fix this issue, we used two approaches: First, I had Justin fake a throw to practice an emergency stop while Jackson was moving away (see exercises 49 and 63).

"Get it" "Stop" "Down" "Good bo[y]"

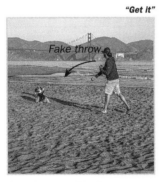
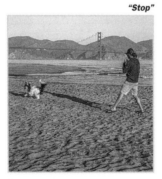
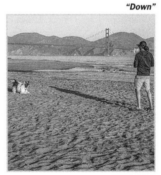

Fake throw

Justin fakes a big throw, and Jackson blasts off, anticipating the thrown ball landing behind him.

With Jackson's momentum moving *away* from Justin, Justin commands, "Stop," in a strong tone. Here, Jackson is turning to see what is going on.

Justin immediately says, "Down," before Jackson builds any momentum running *toward* him. This time, Jackson quickly drops into the down.

At which point, Justin promptly rewards with verbal praise and an immediate toss of the ball.

Step 2: Stop When Returning

Next, I had Justin do an emergency stop on the retrieve (see exercise 63), though in this case, it was a fake throw, so Jackson didn't have the ball. After this, I had Justin continue, while mixing these two sequences among some real ball throws to prevent Jackson from falling into "pattern training."

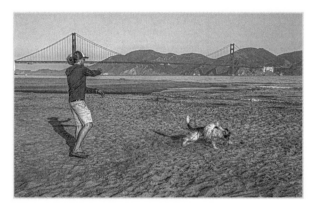

Once again, Justin fakes a throw, and Jackson blasts off in hot pursuit.

Once Jackson realizes there's no ball, he turns back to see Justin holding the ball in his hand. Jackson promptly jets back toward Justin.

"Ah-ah"

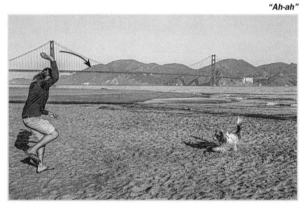

The moment he does, Justin issues a *sharp* "Ah-ah," *and* makes an equally sharp lunge and stomp toward Jackson.

"Down"

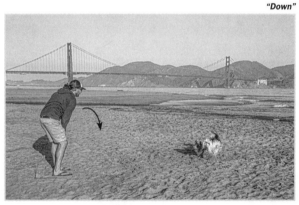

This causes Jackson to hit the brakes (check out the sand spraying up), and Justin immediately commands, "Down."

"Good boy"

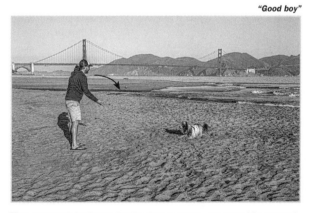

The moment Jackson drops into a down, he gets his reward.

Here is one of my clients warming her dog up for some heeling through the crowds on the beach.

Note that she's using treats to lure her dog. That's despite the fact that in a more controlled indoor setting her dog heels very nicely off the leash with minimal lures of any kind. But again, we're significantly raising the level of distraction so she's going back and warming her dog up with previous, simpler training steps. Again, we're doing everything to set our dogs up for success.

As our practice advanced through the morning's class she was able to transition away from most treats and lures within just a few minutes.

Heeling Warm-Up

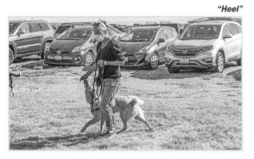
"Heel"

The owner has already transitioned to having her dog target the treat while heeling.

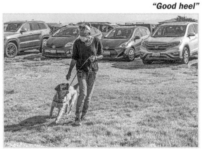
"Good heel"

Notice how nicely she guides her dog through the left turn.

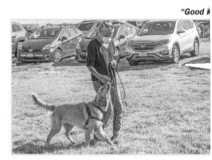
"Good

Then she stops…

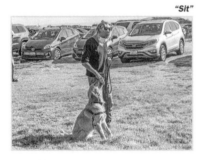
"Sit"

…and lures her dog into a sit.

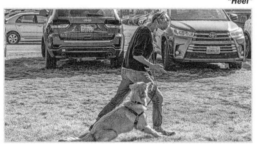
"Heel"

Without giving the treat, she resumes her heel in order to practice down out of motion. Notice the dog's degree of focused attention, and the way her dog literally launches herself to start heeling again. This reflects a ton of practice.

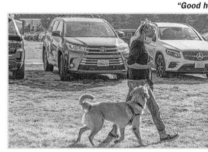
"Good h

Showing great teamwork, her dog beautifu targets the treat.

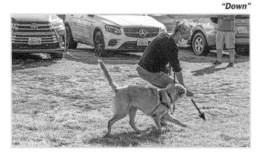
"Down"

This time, the owner moves into down out of motion by driving the treat directly to the ground.

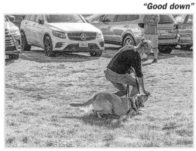
"Good down"

Once her dog hits the ground, she delivers her treat…

…and smoothly transitions to a down-stay.

The Fancy Finish

Here is another client from the same class practicing the fancy finish (see exercise 25). Once again, note the intensity of her dog's focus and the precision of her work.

Starting from a down-stay...

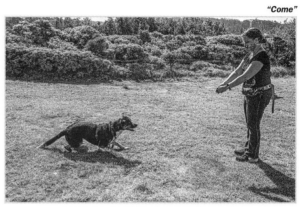

"Come"

...she calls her dog to come...

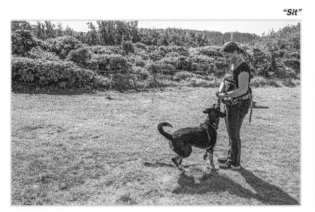

"Sit"

...and immediately into sit.

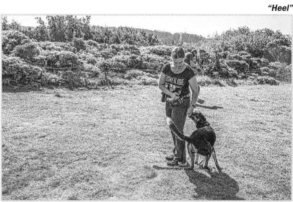

"Heel"

Then, without holding a treat, she uses the heel command accompanied by a hand motion...

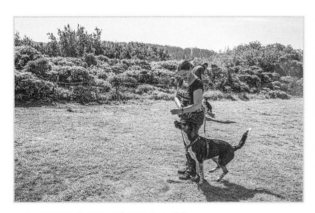

...to get her dog to swing to her side...

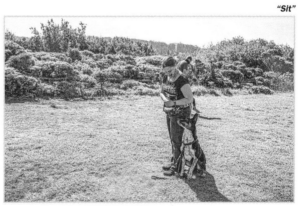

"Sit"

...and finish in a sit. Well done!

This final routine illustrates a number of the exercises described in this book, and it shows the kind of teamwork, enthusiasm, and precision that Integrated Dog Training produces. This is the result of lots of practice, and it represents an almost complete transition from transactional to relational training. There is an almost complete absence of treats throughout this sequence. None were used as lures, and the owner only gave a few occasionally as a reward for a job well done.

Also note that the owner used some different hand signals than the ones in this book. Who cares? Over the course of training and relationship building, dog/owner teams can easily customize their communications to suit themselves. What's important are the results.

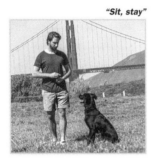
"Sit, stay"

Starting with a sit-stay…

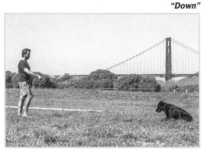
"Down"

…the owner moves fifteen feet away and asks for a down.

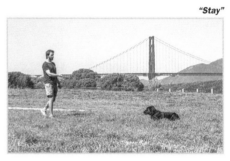
"Stay"

Then he asks for a stay before…

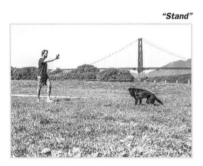
"Stand"

…asking for a stand-stay.

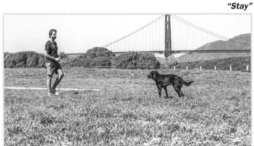
"Stay"

The owner holds the stand-stay for a few moments…

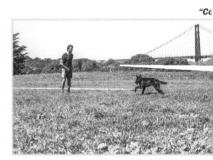
"Co

…then he calls his dog to come…

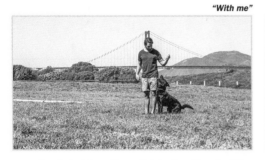
"With me"

…and swings into a fancy finish directly out of the recall.

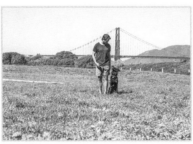

After a short sit, the owner backs away again…

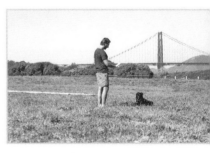

…and puts his dog in a quick down-stay…

"Heel"

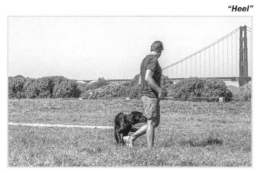

…before moving into heeling *without the use of any treats*.

"Good heel"

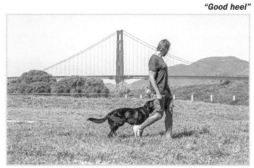

He only uses positive markers while heeling…

"Good heel"

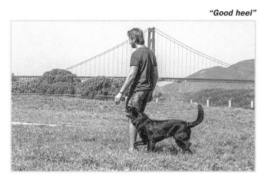

…even through turns before…

"Sit"

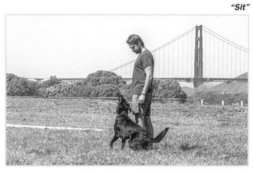

…finishing in a sit.

"With me"

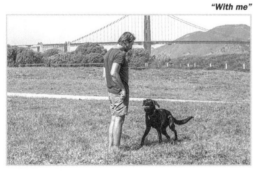

The owner then adjusts his position to his dog, who remains in a sit-stay, and then he calls the dog to come…

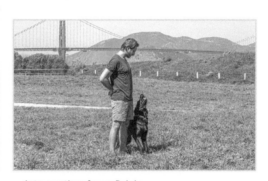

…into another fancy finish.

"High five"

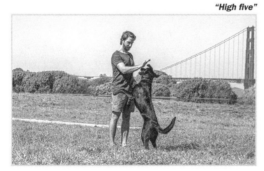

Check out the enthusiasm and attention that the owner gets from his dog in the complete absence of treats.

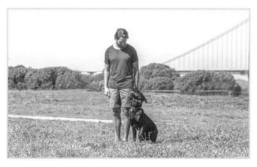

Clearly, a good time was had by all. Bravo!

This book covers a lot of material, and in this section I've organized it into one possible "session plan" for training your dog. This assumes that your dog hasn't had any previous training, and it breaks training sessions into bite-size chunks, so that each session is meant to last only twenty to thirty minutes. By following this — and how much time it will take depends on how much time you put in, on whether you train each day, as well as on how fast your dog learns — you will eventually arrive at the desired result: a well-trained dog and a strengthened relationship.

This program can be used with dogs of any age, including eight- to ten-week-old puppies. However, if you have a puppy, I highly recommend my book *There's a Puppy in the House*. This is a good supplement to these exercises, since it addresses a range of puppy-specific issues that this book doesn't. It's amazing how much puppies can learn well before adolescence, which is when so many people just begin training.

That said, every dog and every owner is different. This is just one of many ways to proceed through these exercises. I intend this as a starting point, but you will have to figure out what works best for you and your dog.

Before starting, I'd like to review a few principles that will enhance your dog's ability to absorb the material and help you integrate this material effectively into your day-to-day relationship.

Short training sessions are ideal for learning, but you can enhance them by pulling a page from the training of high-level working dogs. Such dogs are often crated for an hour or two both before and after a training session. This turns the training session into a period of high connection and interaction wedged between two dull periods, which accomplishes two things. First, after lying around doing nothing much at all, your dog will be excited and ready to work when your session starts. Then,

with nothing to do afterward, your dog will benefit from a process called latent learning.

Latent learning refers to the fact that the brain needs time and a bunch of background processing before it integrates recently learned material into its deeper structures. A period of rest immediately following a high-intensity training session facilitates this process, and it can serve as the dull period prior to the next training session. If implementing such a routine is difficult, or it can only happen sometimes, that's fine, but give it a try and see how your dog responds.

Some people might also find they can't do a training session every day, while others might be able to do more than one. Either is fine; you should go at a comfortable pace that fits your life. However, in between formal sessions, throughout the course of the day, constantly look for moments, lasting only a few seconds or a minute, to practice the techniques you've already introduced. *I can't overstate the importance of such two-second training sessions.* Why? Because they make training relevant to your dog's day-to-day life. Once your dog learns anything new, I strongly encourage you to ask her to perform that exercise in exchange for things that mean something to her. Keep it simple: Ask for a sit-stay before putting food down, or ask for a down-stay prior to opening the front door to go for a walk. In addition to making obedience relevant, this also teaches dogs *that they have to do for you before you do for them.* It's like teaching a young child to say please before giving them something they want. This deepens behaviors and uses them first to introduce and then to reinforce important social hierarchies.

Another way to enhance the success of your training sessions is to strategically deprive your dog of food prior to your sessions. I mentioned this in the sidebar "What If My Dog Isn't Interested in Treats?" (page 2). A hungry dog will find treats more appealing, and some people go so far as to not feed

their dogs any breakfast. Then, they provide food during training throughout the day and make up any shortfall of daily calories with an appropriately sized dinner. Strategically depriving a dog of food serves the same dual purpose as crating before and after training — it significantly increases your dog's motivation during training and deepens learned behaviors.

Finally, end every session with success, especially if you've been struggling with a particular behavior during the session. Close by asking your dog to do something she knows how to do well and lavishly reward her several times. This sends your dog into the latent-learning period with positive memories and in a good mood. This also seeds a positive anticipation of the next session.

Creating a Training Plan

The session plan that follows includes everything in this book. However, it is just an outline. I provide some brief guidance, but direct the reader to the exercises themselves for complete instructions. When there, please be sure to review all introductions, notes, and sidebars for additional information.

Most importantly, this plan is not a set of commandments from on high. It's a suggested template that you should intelligently apply to your own circumstances and your own dog. While I've divided the material into seventeen "sessions," don't expect to get through it in seventeen days. In all likelihood, your dog will progress through some exercises faster than you expect, and she will progress through others slower than you want. You might have to repeat a particular session plan several times before your dog is ready to move on. You might even have to break individual lessons into smaller segments depending on how fast your dog learns or how much time you have available. And you might need to repeat each lesson multiple times. No problem. Don't feel pressured to accomplish anything within a particular time frame. Evaluate your dog and the time you have available for practice and adapt accordingly. Don't beat yourself up if you can't keep up with the pace you

expect or want. Some dogs might make it through this program in a month, but most will take two, three. It doesn't matter.

Instead of worrying about time, focus on progress. Once your dog learns an exercise, always try to take things to the next level by working in increasingly challenging circumstances. Never rest on your laurels.

Lastly, some exercises involve mild compulsion (particularly exercises in parts 7 through 10). Remember, compulsion and aversive control should only be used *if needed*. If your dog responds reliably to positive methods, then skip these exercises.

Thank you for reading this book. It's my sincere hope that I've been able to effectively communicate to you what I've learned over many years. As I've said, this is certainly not the only way to train a dog. Nor is it necessarily even the best way. But it's a way that's worked fabulously for me and thousands of clients over nearly thirty years of training. And I'm sure that if you apply its principles with diligence and sensitivity, it will work that way for you as well. I wish you the best in that endeavor.

Session 1

- Read the introduction. Feel free to read it to your dog as well. ☺

Session 2

- Introduce exercises 1 through 3: sit, down, and down to sit.
- Introduce off, but only using the gentle version in exercise 50, "Introducing Off."

Session 3

- Start every session by spending a few minutes practicing what you learned last time. This will warm your dog up, instill confidence, and create a positive mood.
- Introduce exercises 4 through 7: sit to stand, stand to down, down to stand, and "Building a Routine." DO NOT overlook stand to down, which will be important later for distance downs and emergency stops.
- Introduce recalls with exercise 26.

Session 4

- After practicing what you've already learned as a warm-up, introduce hand signals up to stage 1, or exercises 8 and 9.
- Introduce exercise 29, down-stay. This is the first and mildest introduction to the concept "you must."
- Introduce exercise 27, "Recalls when Playing with Other Dogs," to add complexity to recalls.
- Reinforce off by introducing exercise 51, "Using a Mild Shove to Teach Off."

Session 5

- Introduce exercise 10, "Hand Signals Stage 2: Giving the Treat from the Opposite Hand."
- Introduce heeling with exercise 15. If you have a small dog, see exercise 22. If your dog swings wide when going into a sit, see exercise 21.
- Introduce exercise 30, sit-stay.
- Continue practicing exercise 27 and adding complexity to recalls.

Session 6

- Introduce exercise 11, "Hand Signals Stage 3: No Treat in the Signal Hand."
- Expand on heeling by introducing exercises 16 and 17, adding turns and teaching your dog to target the treat.
- Introduce exercise 32, stand-stay.
- If your dog is fully inoculated, do the "Short-Leash Recall Warm-Up" sequence within exercise 58.
- *If needed*, reinforce off by using a squirt bottle; see exercises 52 and 53.

Session 7

- Continue practicing the hand signals in part 2. As needed and wanted, introduce exercise 12, "Down to Sit: Adding a Foot Nudge," and exercise 13, "Down without Bending Over"; these address two areas where people sometimes have issues.
- Continue practicing heeling but only using the exercises you've already introduced. Heeling is a very demanding exercise, so make sure your dog is solid at each level before moving on to the next one. Continue basic heeling for several sessions.
- If already introduced, continue practicing outdoor recalls.

Session 8

- Introduce adding distance to downs with exercise 14.
- Introduce exercise 31, "Circling Around Your Dog in Stay," but only practice "Circling in Sit-Stay."
- Continue practicing heeling but only using the exercises you've already introduced.
- Whether indoors or outdoors, introduce exercise 59, "Back-and-Forth Recalls."

Session 9

- Continue practicing exercise 14, and keep adding distance and extending the time between rewards.
- If your dog is doing well with heeling, introduce exercises 18 and 19, or moving the treat to the other side of your body. If not, don't worry; keep practicing basic heeling until it feels appropriate to move ahead.
- Continue practicing exercise 31, "Circling Around Your Dog in Stay," and add "Circling in Down-Stay."
- Introduce exercise 23, "Down Out of Motion."

Session 10

- Continue practicing exercise 31, "Circling Around Your Dog in Stay," and add "Correcting Mistakes: Step on the Leash" and "Stepping Over in Sit-Stay."
- Introducing exercise 33, "Stand-Stay with Leash and Body Exam."
- Continue to practice heeling using the exercises you've already introduced.

Session 11

- Introduce using the ball as a motivator, along with other toys and games, including any of the exercises in part 6.
- *If needed*, introduce off using a leash correction, exercise 54.
- Introduce exercise 24, "Heeling from Different Positions."
- Introduce exercise 55, "Combining Off and Stay."

Session 12

- Introduce the "fancy finish" to the left, using the left-side section in exercise 25.
- Introduce "Using an Accomplice for Off-Stay" in exercise 55.
- *If needed*, introduce "Using Leash Corrections with Off-Stay," in exercise 55.

Session 13

- Introduce exercise 20, "How to Transition to Off-Leash Heeling."
- Start building longer, more varied routines out of the exercises you've learned so far; see exercise 34.
- Introduce exercise 43, "The Pay Attention Exercise"; beforehand, review the type of equipment you prefer.

Session 14

- Introduce the "fancy finish" to the right, using the right-side section in exercise 25.
- Introduce using the leash to demand behaviors, which includes any of the exercises in part 7.
- Introduce combining off with recalls; see exercises 57 and 60.
- Introduce exercise 58, "The Pay Attention Exercise — Redux."

Session 15

- Introduce exercise 28, "Recalls into Fancy Finishes."

- Introduce exercise 47, "Emergency Stop with a Body Block."
- Introduce exercise 56, "Combining Off and Heel."

Session 16

- As always, begin by reviewing and practicing what you've learned so far, while building longer routines (as in exercises 7, 34, 66, and 71).
- Then finish by working on emergency stops. *If needed*, add compulsion with a leash (exercise 48), and introduce exercise 49, "Emergency Stops at a Distance."

Session 17

- If your dog seems ready, introduce exercise 61, "Eliminating the Leash in Outdoor Recalls."
- If your dog is ball crazy, introduce the exercises in part 12, "Using the Ball to Develop Distance Commands."
- At this point, feel free to mix up your sessions based on your dog's strengths and weaknesses. Keep reinforcing the basics while raising the bar on performance, and adapt each session to developing circumstances. The program is now fully in your hands.

Continuing Training

- Training never really ends. Eventually, all the exercises will be learned, and your goal is to ask for them in relation to things that are important to your dog and to transition them into increasingly distracting situations, such as those in part 13, "Taking It to the Streets." However, the ultimate goal is to integrate training into everyday life so well that neither you nor your dog notice when it starts or ends. Never stop training, but most of all . . . keep up the good work!

In any large-scale project, there are many people required to pull it together and make it happen. This one was no different, and a few people deserve special thanks.

First among them is Jason Gardner, executive editor at New World Library, who has patiently shepherded this project from its inception to its conclusion, including trudging through the many changes and edits required to produce this book. Thanks also to Tona Pearce Myers and Tracy Cunningham for their work with the photos and layout.

Special recognition should also go to Britta Stratton, my photographer, who spent many hours over many months helping me shoot these photos and editing them. And another thanks goes to Sarah Harrison for being my very capable assistant through the many photo sessions it took to produce this. Lastly, there are the many dog owners who allowed me to use their dogs as models.

Thanks very much to all of you, without whom this book could not have happened.

affection. *See* physical affection or praise

age, xi, 161

agency: and aversive control, xiv, xv, 89, 126; and corrections, timing of, 112, 114, 117; and off command, xvi; in Pay Attention Exercise, 93

aggression, xii, xiii, 75

air, compressed, 116. *See also* squirt bottles

alpha, concept of, xii, 75

Animals in Translation (Temple), 30

attention. *See* Pay Attention Exercise; relational vs. transactional training

auditory aids. *See* clicker training; verbal cues or markers

aversive control: definition, xiv; and distance training, 32; in dog training, xii, xiv–xv, xvi, xvii; and leash training, 89; and off command, 109, 110–19, 123–25; as optional, 162; as self-extinguishing, xv, 126; and stays, 62, 63, 70. *See also* corrections

back-and-forth exercise, 54, 132–33. *See also* recalls, outdoor

back-leading harnesses, 97. *See also* collars and harnesses

ball training: and ball retrieval, 80–81, 140; for downs and emergency stops, 141–43; and heeling, 77–79, 145; and motivation, increase of, 139, 140; and off command, 120; overview, 75, 139; and recalls, 146, 148; routines for, 76, 147–48; sits and downs, 76, 140; and stays, 144; training plan, 164; vs. treats, 2

beginning exercises: down, 4–5; down to sit, 6; down to stand, 8; overview, 1; routines for, 9; sit, 2–3; sit to stand, 7; stand to down, 8; and words, timing of, 3, 4

behavioral theory, 23

behind-the-leg trick, 27–28. *See also* hand signals

Bekoff, Marc, xii–xiii

BioThane leashes, 130. *See also* leash training

body blocks: description, xiv–xv, 63; and distance training, 32; and emergency stops, 104–5; and stays, 62, 63, 70. *See also* corrections

body exams, 31, 68, 71, 72

bridles, 94. *See also* collars and harnesses

cattle dogs, 30

checking in, xv, xvii, 3, 122. *See also* Pay Attention Exercise

chest-leading harnesses, 89, 97–98

clicker training, 15, 18, 42

collars and harnesses: and command training, 84, 86; flat collars, 84, 89, 91, 101–2; harnesses, chest-leading, 97–99; head collars, 89, 94–96, 118, 119, 125; and off command, 118, 119, 125; overview, 89; prong, 89, 95, 99–102; and recall training, 52, 53

come command. *See* recalls

commands: for downs, 87; vs. exercises, xvi, 1, 57, 83; and hand signals, 11; and heeling, 39; overview, 83; for sits, 84–86; for stands, 88; and stays, 57, 64; and success, importance of, 6; training plan, 163. *See also* off command

compressed air, 116. *See also* squirt bottles

compulsion: and commands, 84; definition, xiv; in dog training, xii, xiv; and down to sit, 24, 26; and emergency stops, 105–6; and off command, 111–12; as optional, 162; and stays, 57–59, 62, 69, 71. *See also* corrections

conditioning, operant, 23

conflicting drives, 81

corrections: and commands, 84, 85; and distance training, 32; in dog training, xii, xiv–xv, xvi, xvii; and emergency stops, 104–6; and leash training, 89, 92; level of, evaluation, 106, 109, 123, 131, 162; and off command, 109, 111–19, 123–25; and recalls, outdoor, 131, 134; and stays, 57–59, 62–63, 66, 69–71; timing of, 112, 114, 123, 125, 134. *See also* negative markers

crates, 161

desensitizing, systematic, 94–95

distance downs: and ball training, 141–43, 146; and emergency stops, 103–4; preparation for, 25, 31, 44, 45